LOOK HERE

First published in 2010 by
The British Museum Press
A division of The British Museum Company Ltd
38 Russell Square
London WC1B 3QQ

britishmuseum.org/publishing

Reprinted 2013, 2014, 2015, 2016

A catalogue record for this book
is available from the British Library

ISBN 978-0-7141-5083-3

Designed by Victoria Wharton Pencil Ltd
Printed in China by RR Donnelley Asia Printing Solutions Limited

LOOK HERE

Axelle Russo

THE BRITISH MUSEUM PRESS

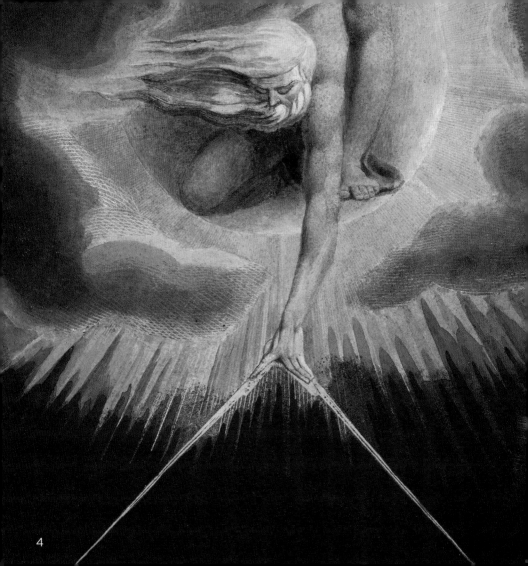

4

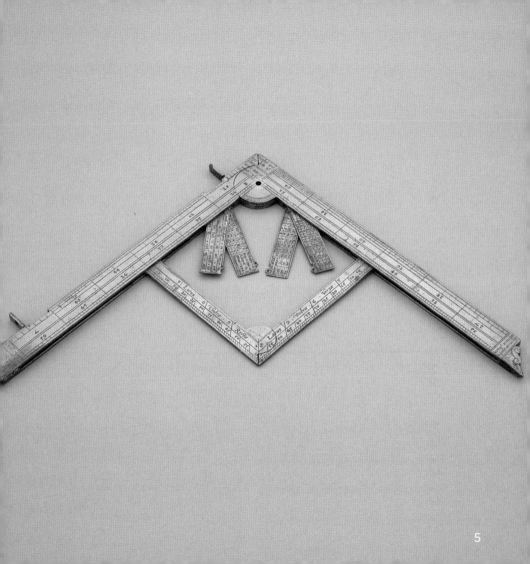

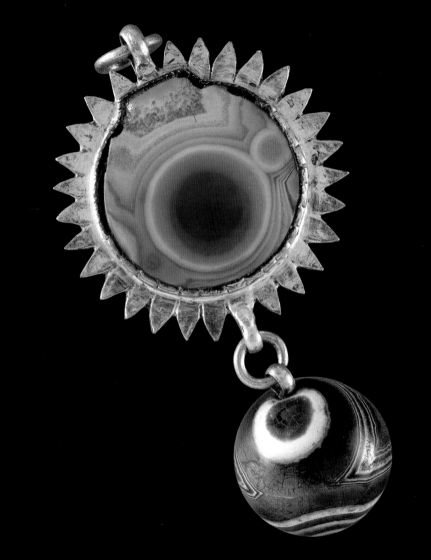

6

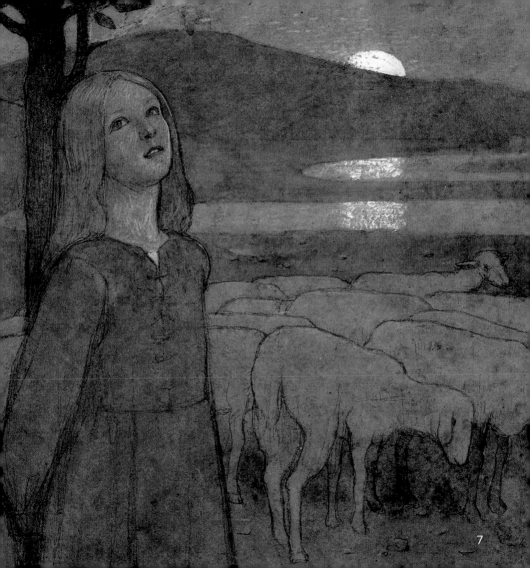
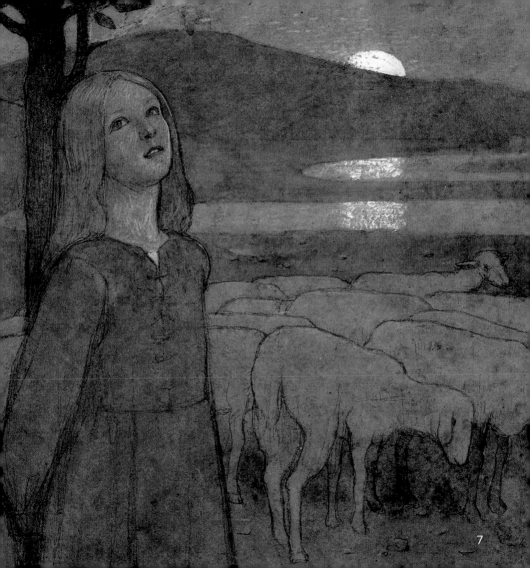7

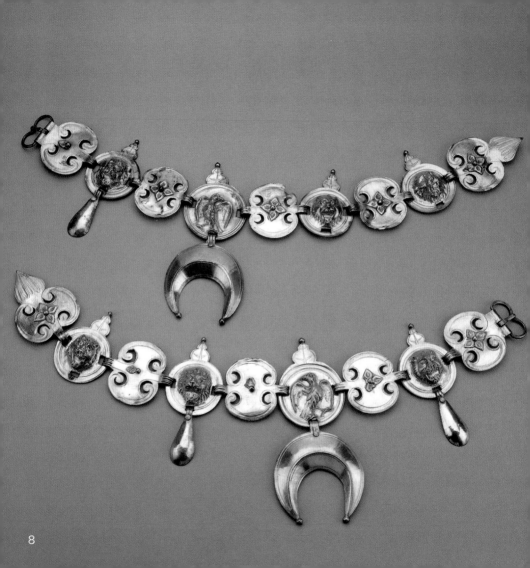

8

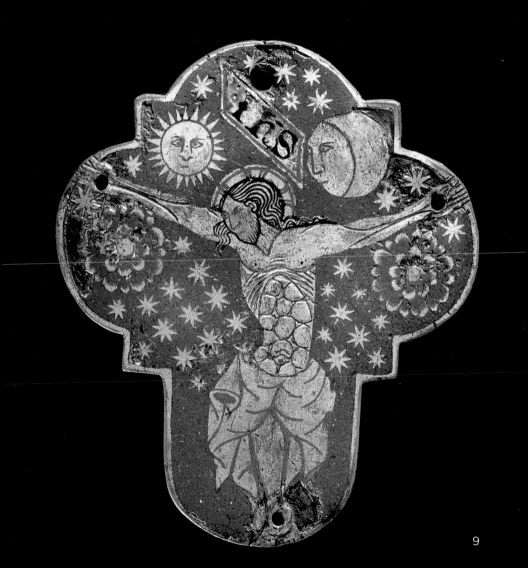

9

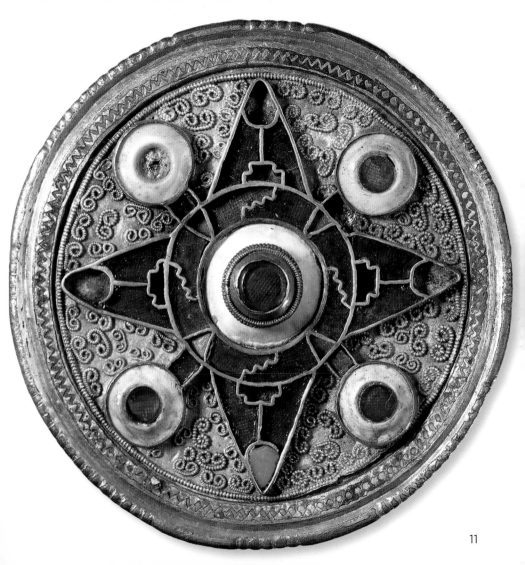

11

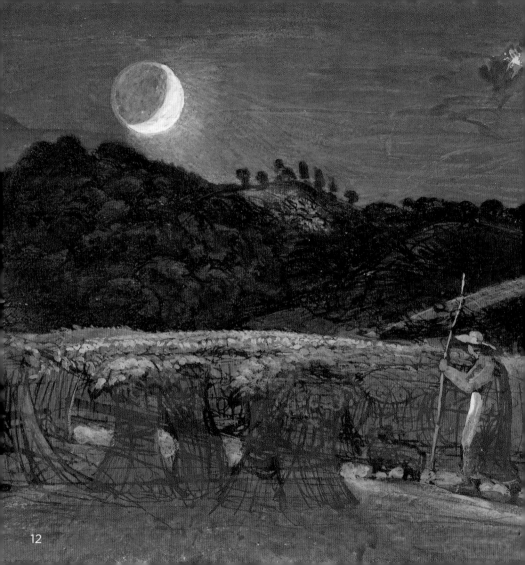

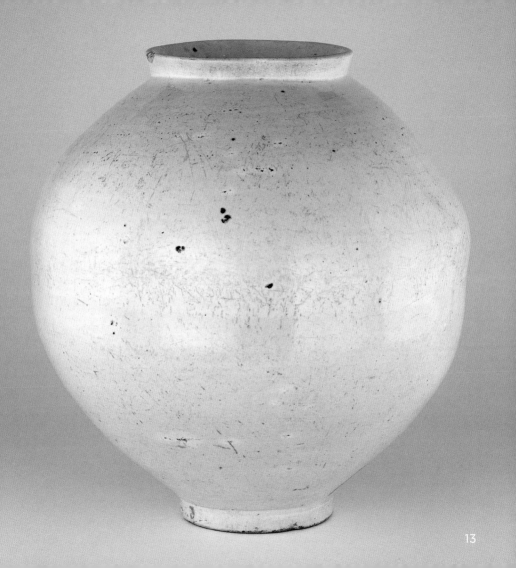

13

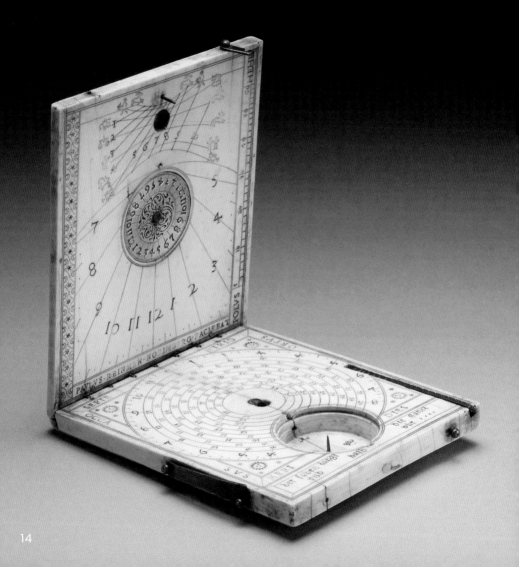

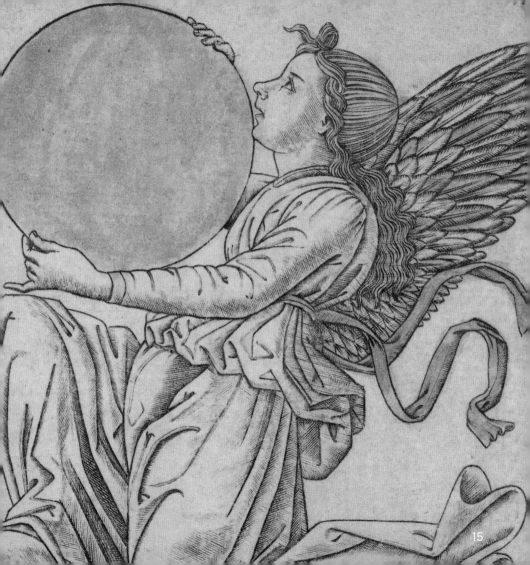
15

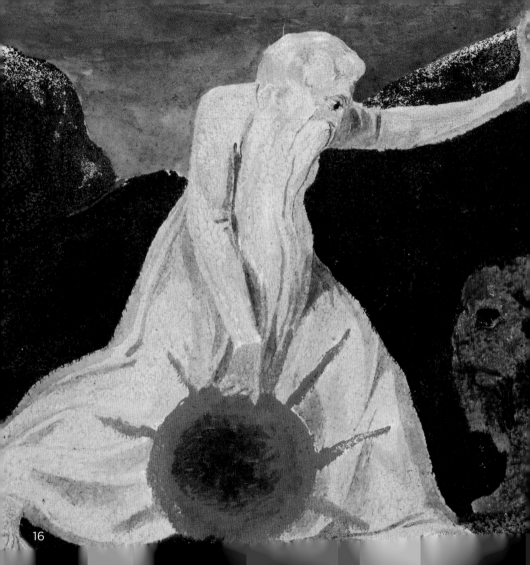

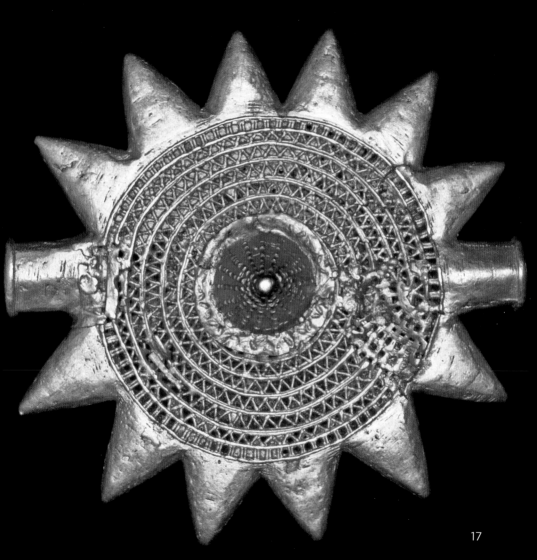

17

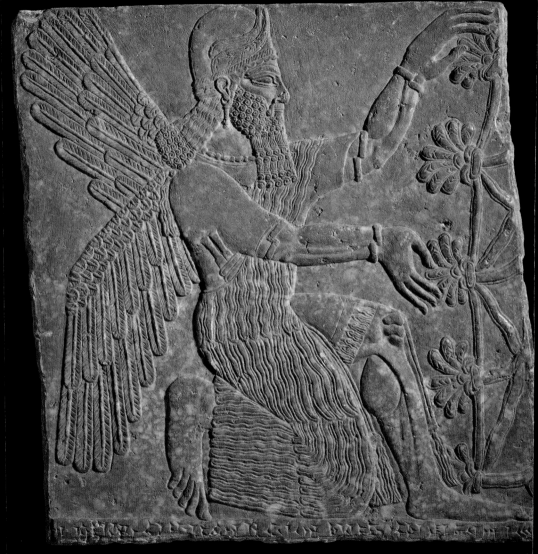

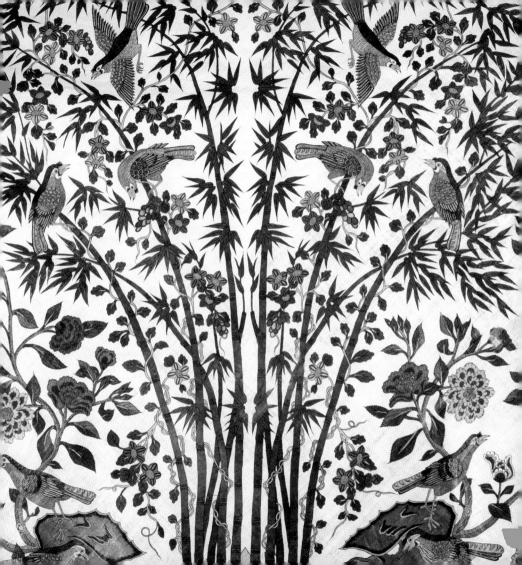

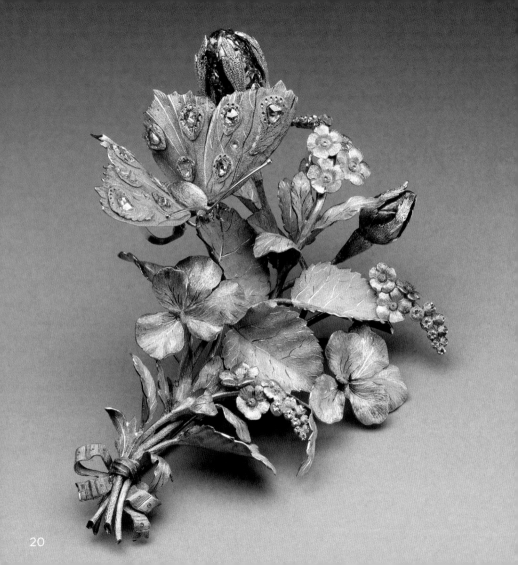

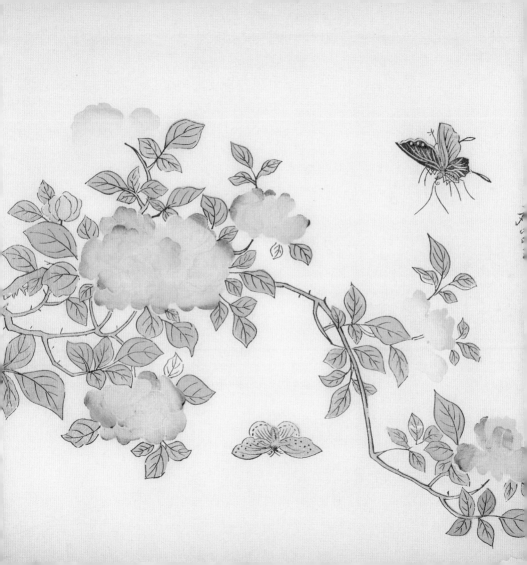

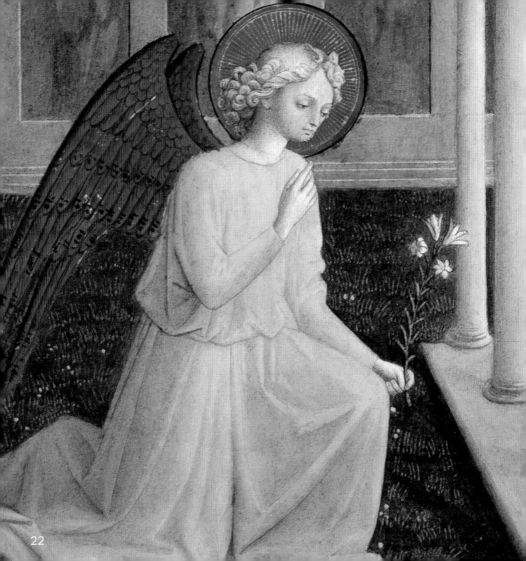

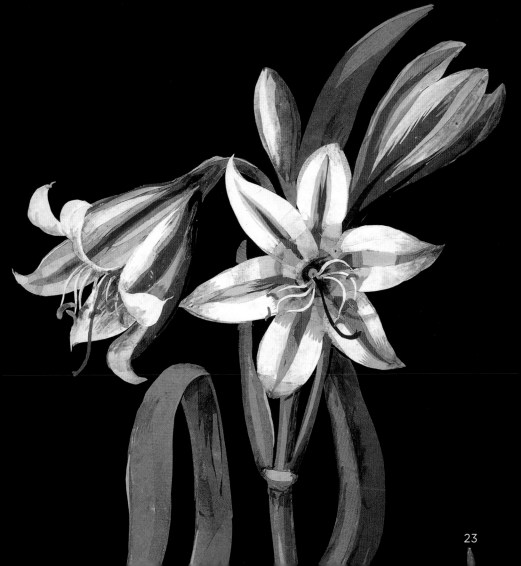

23

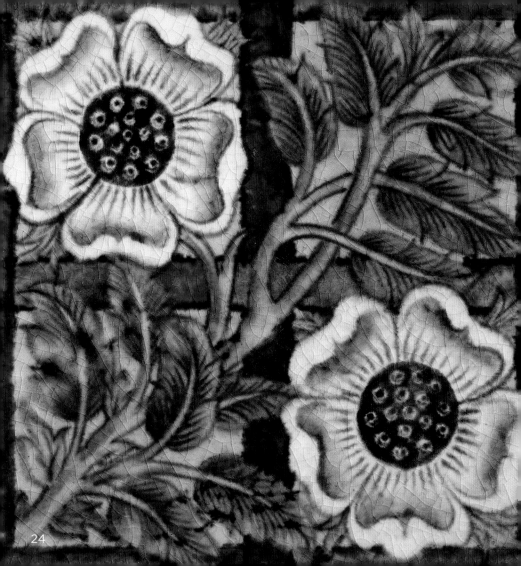

24

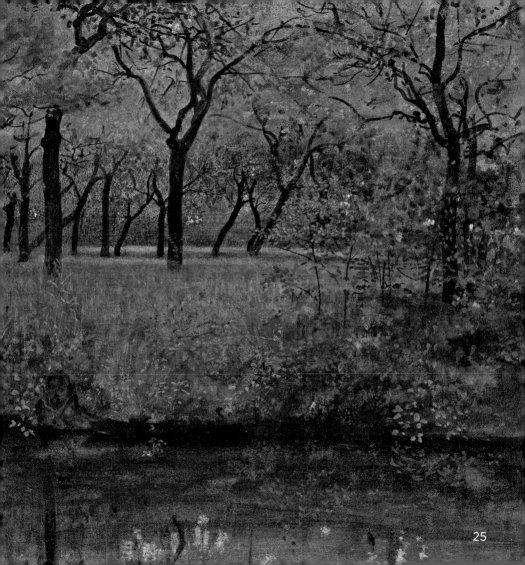

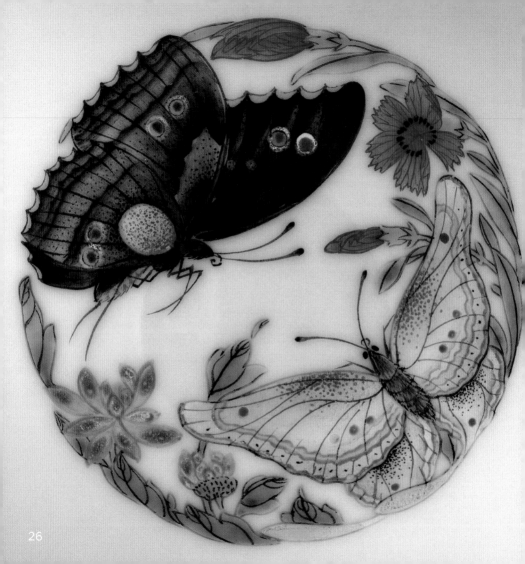

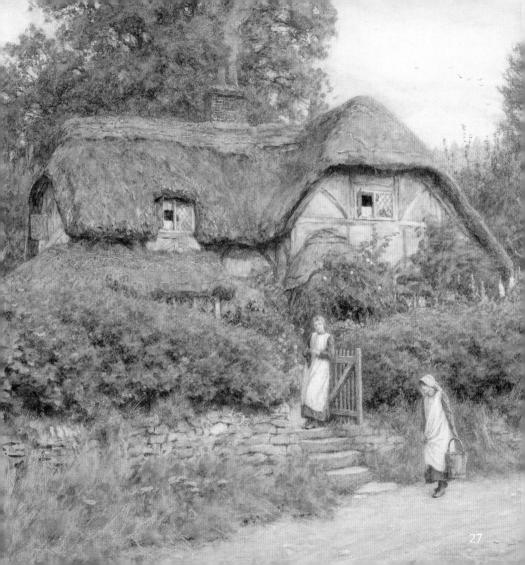

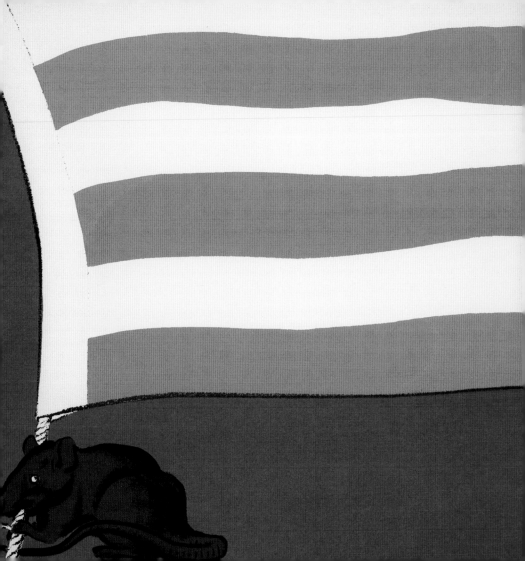

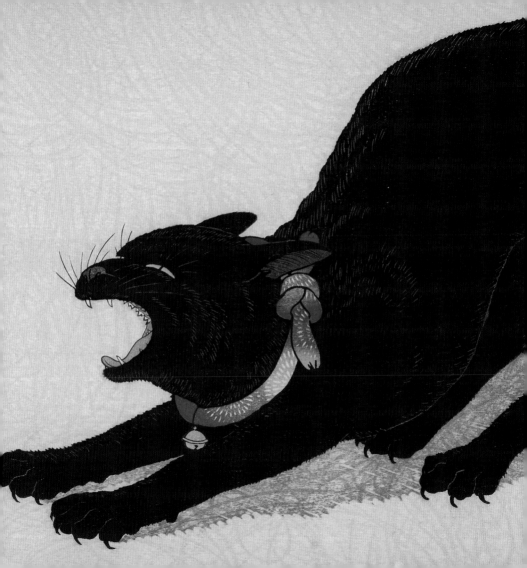

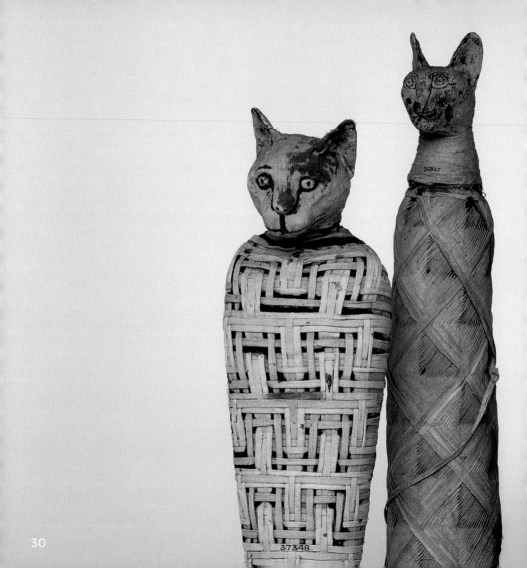

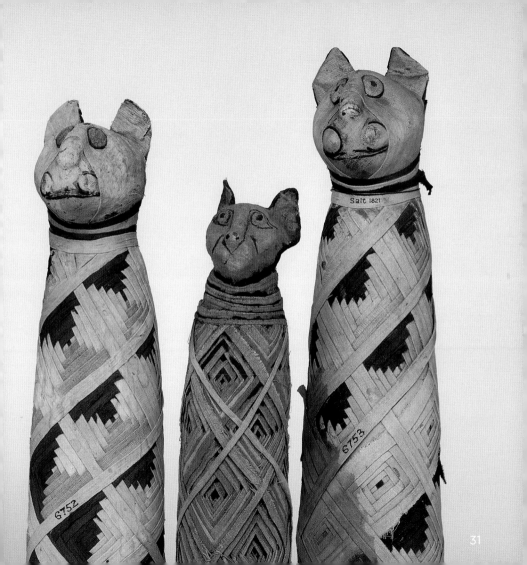

6752

Salt 1821

6753

31

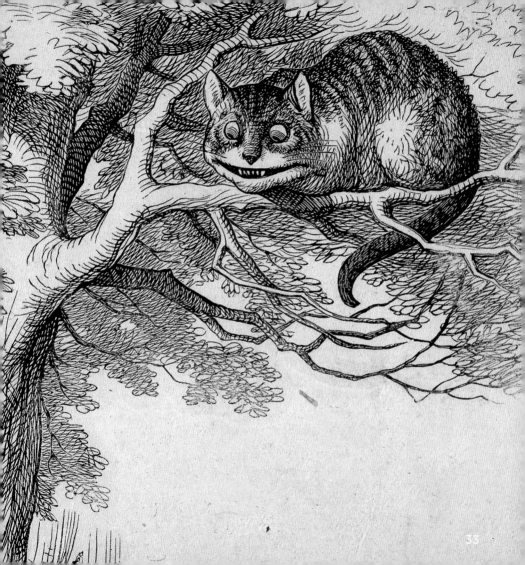

Les Vieilles Hi[...]

Poésies
de Jean Goudezki

mises en musique
par
Désiré Dihau

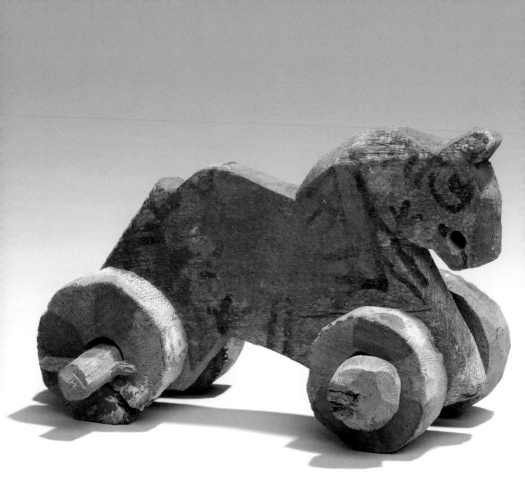

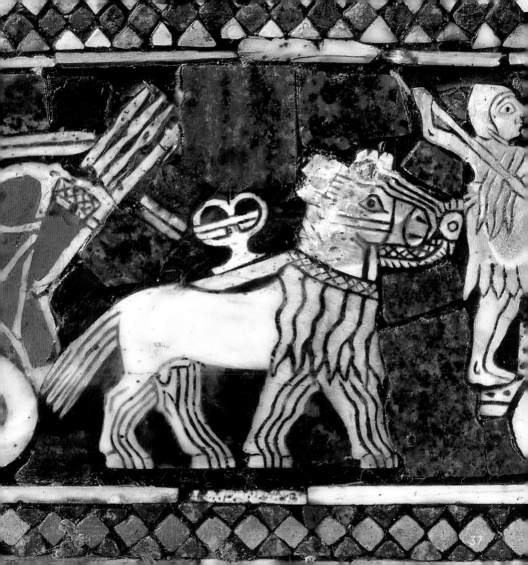

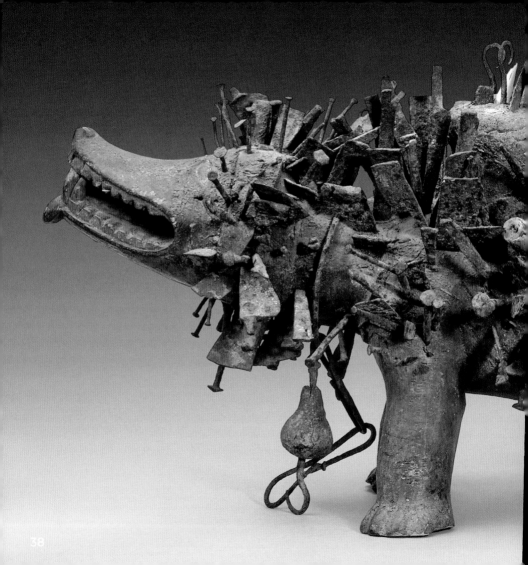

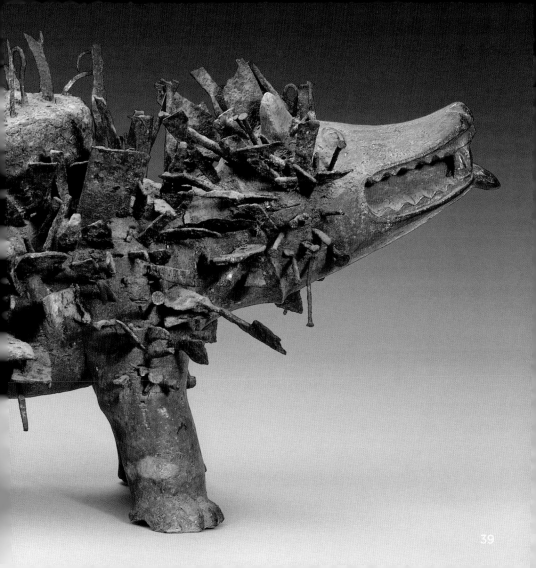

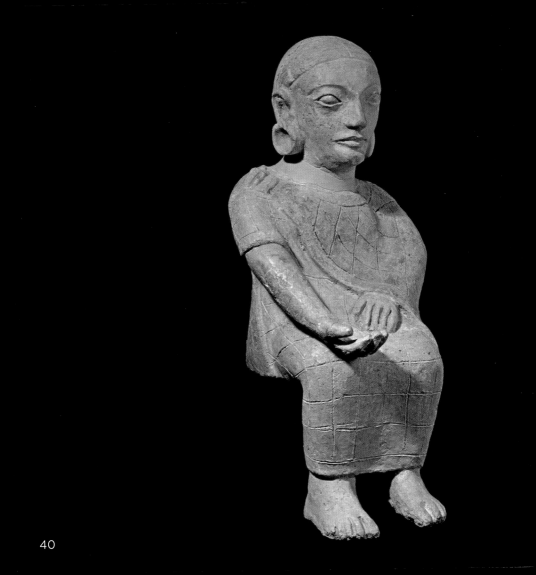

40

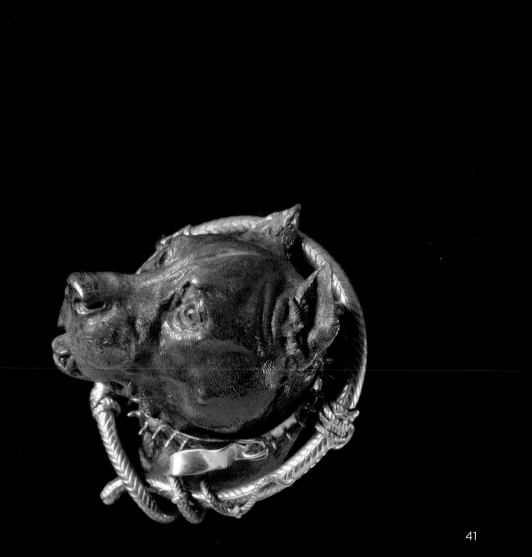

41

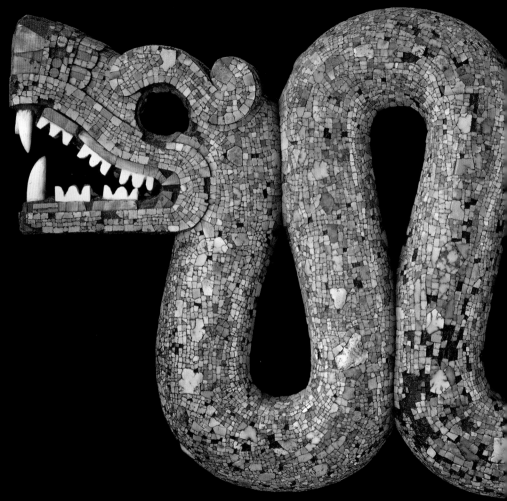

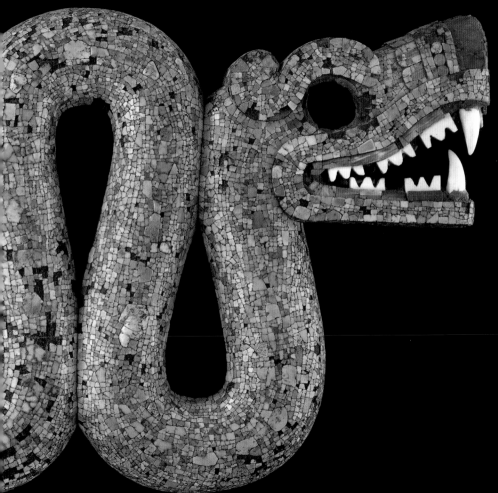

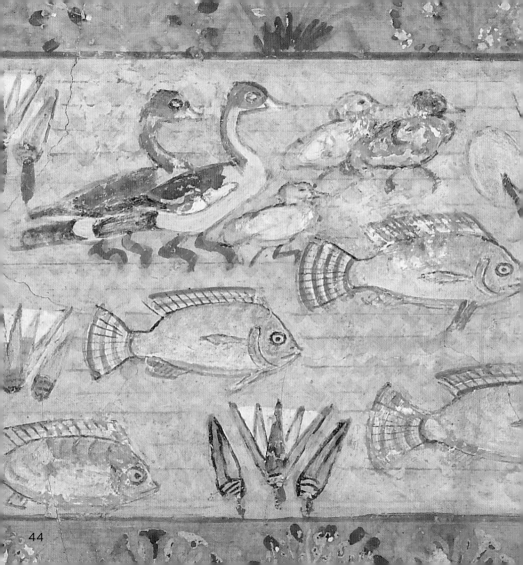

44

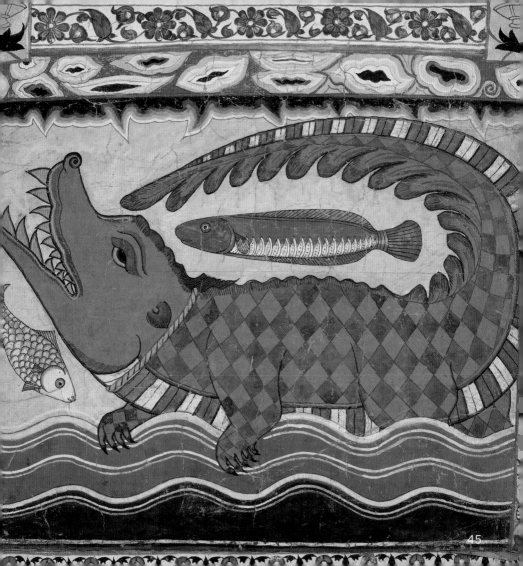

45

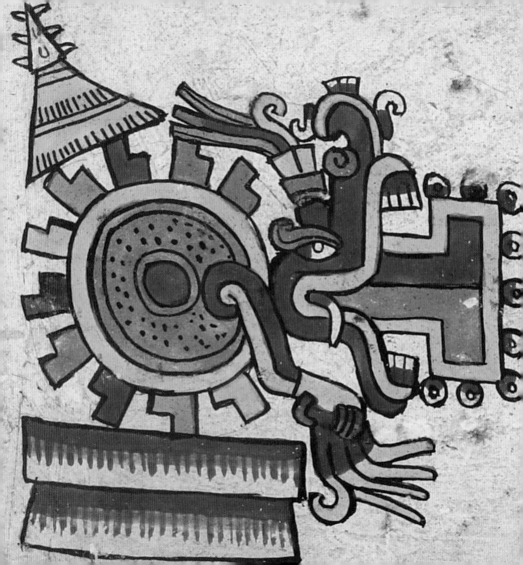

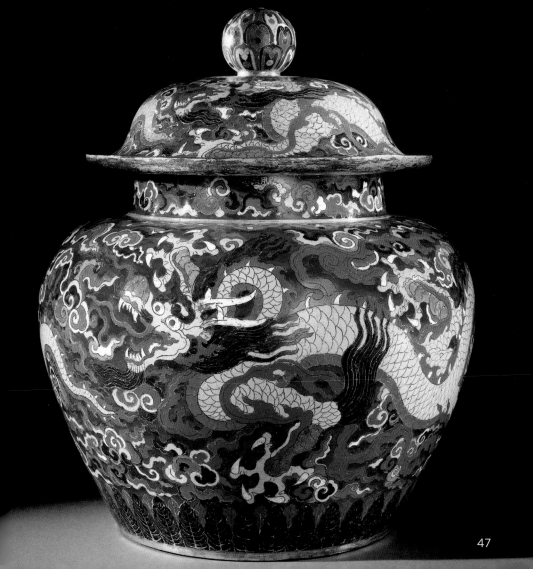

47

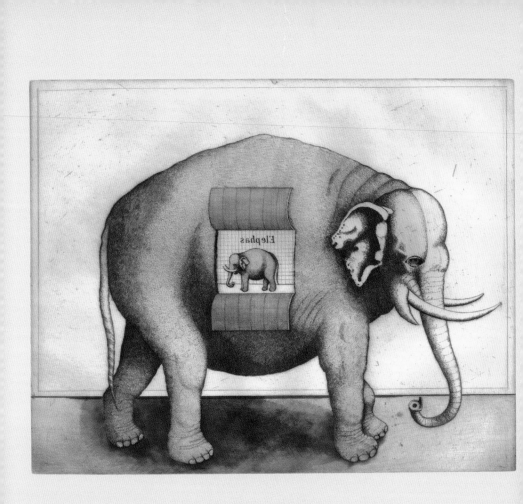

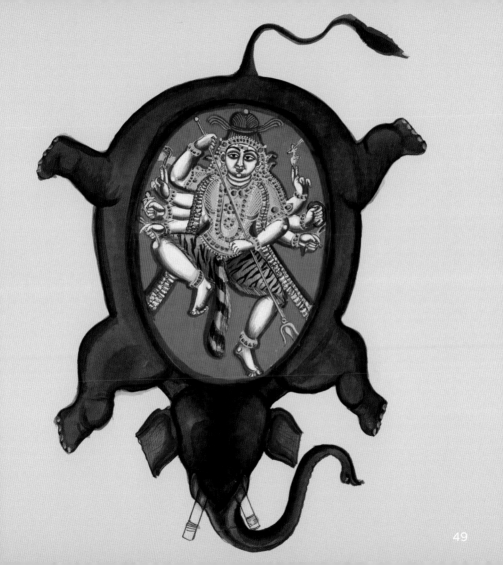

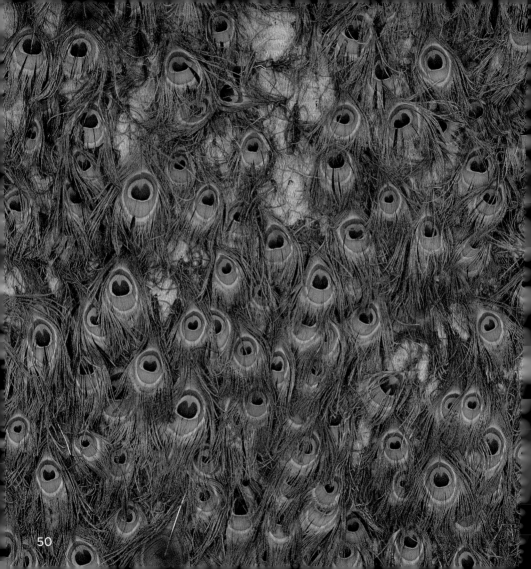

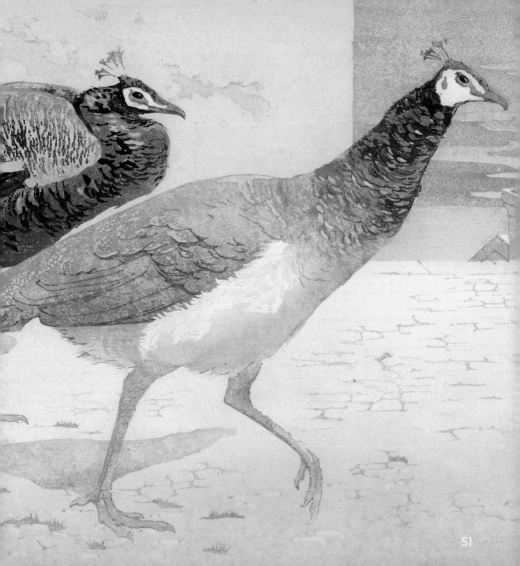

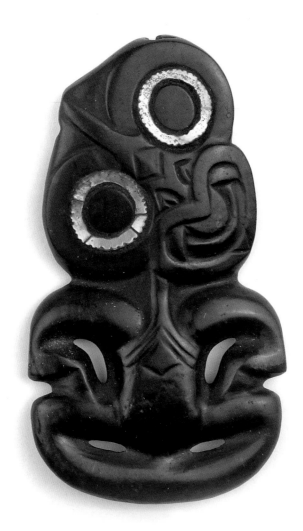

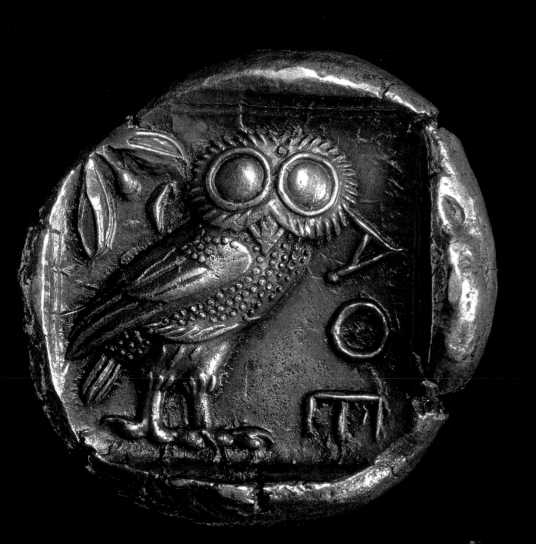

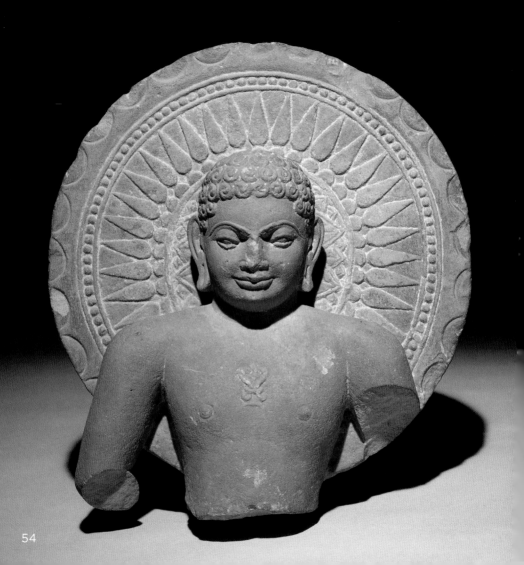

54

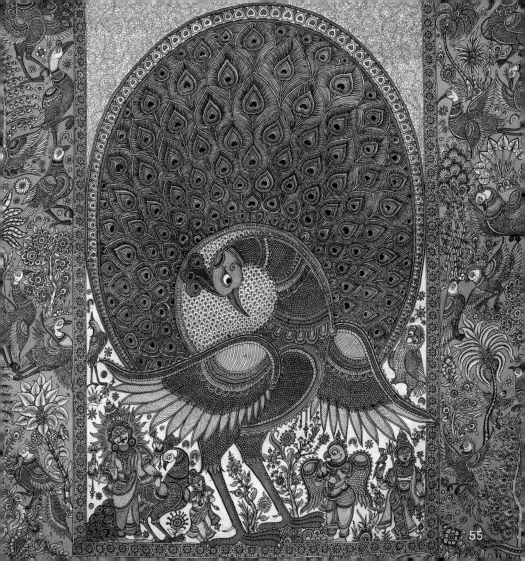

55

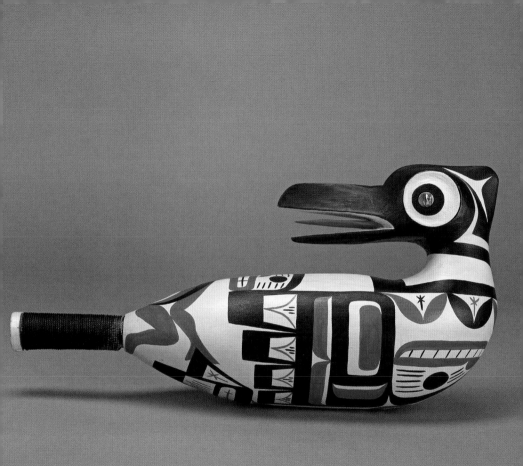

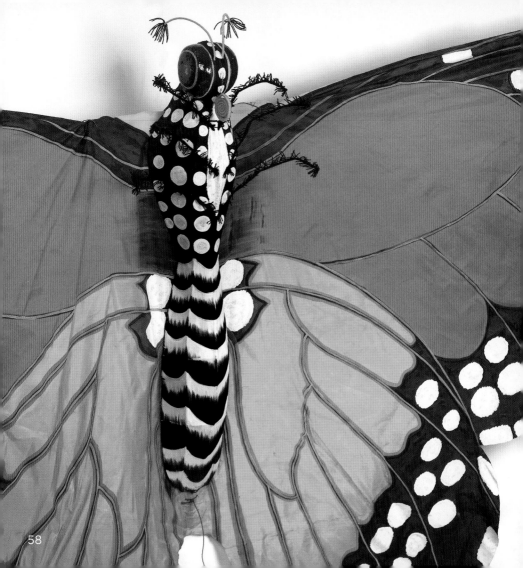

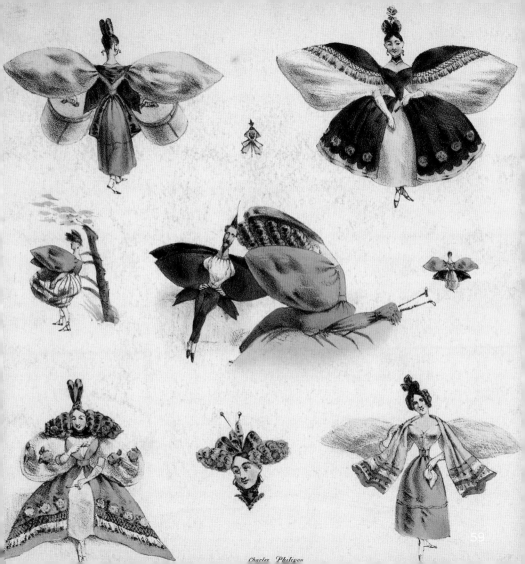

59

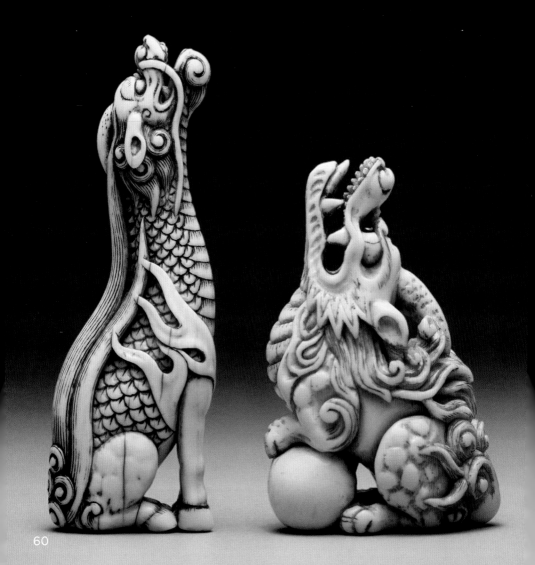

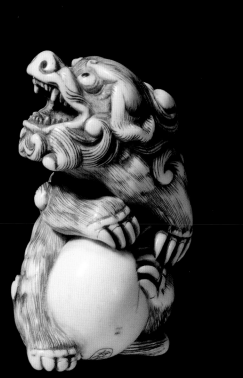

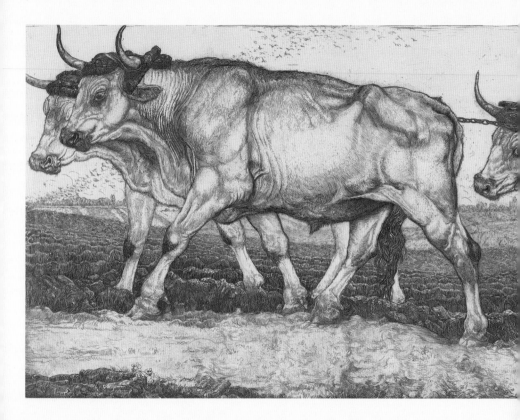

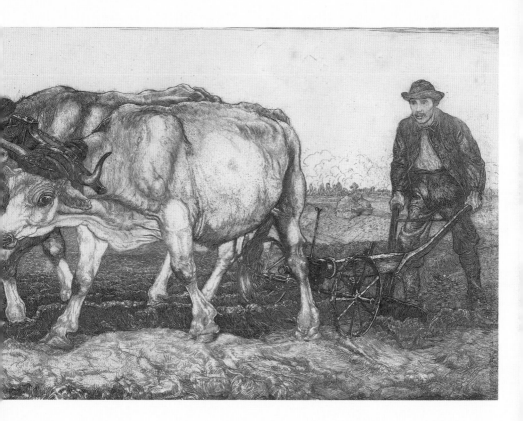

63

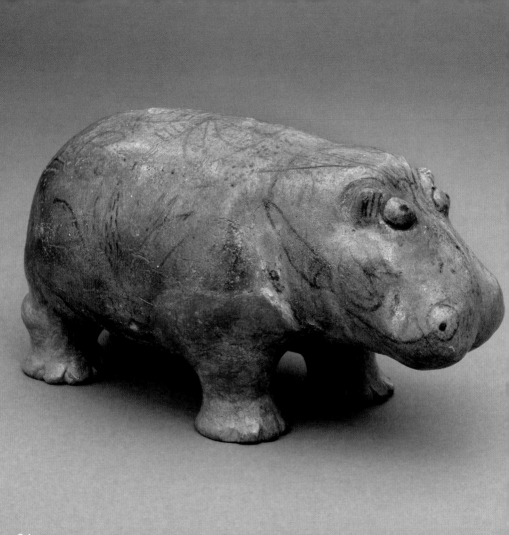

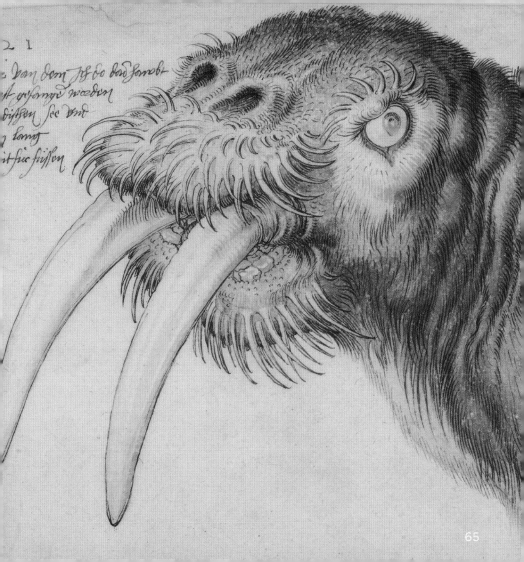

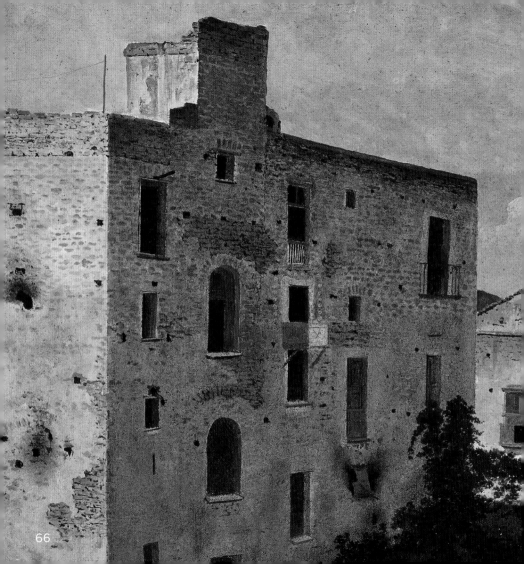

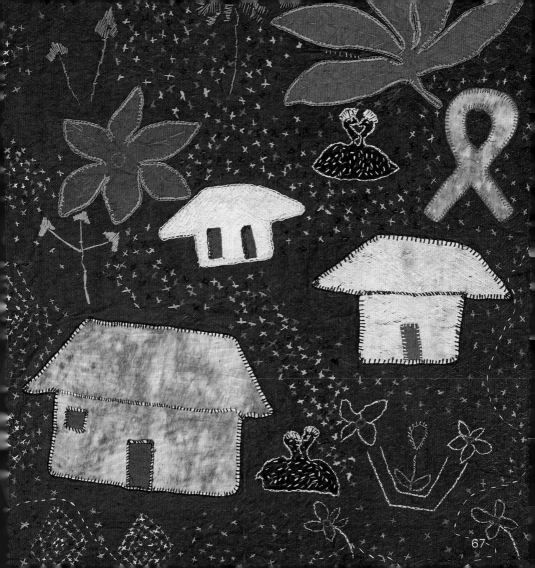

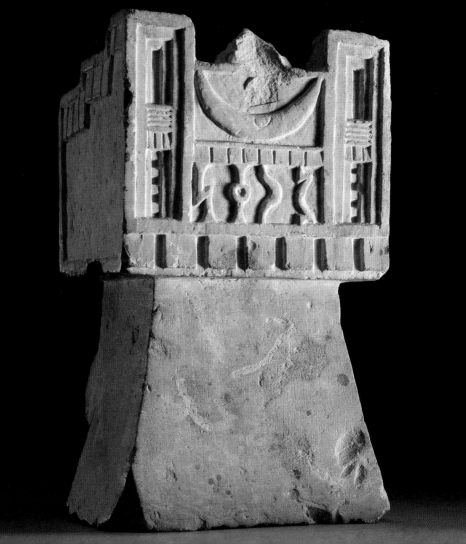

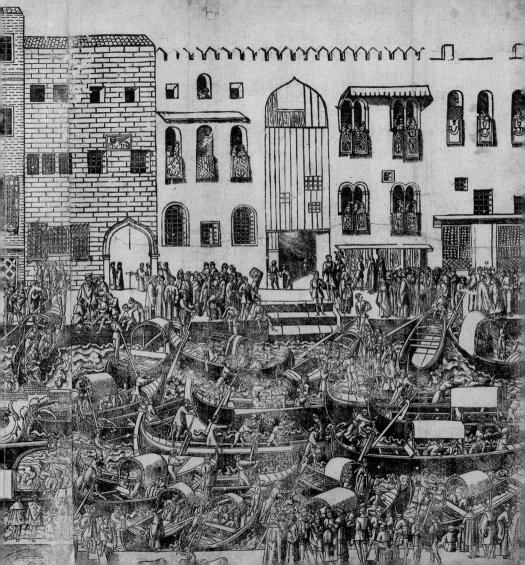

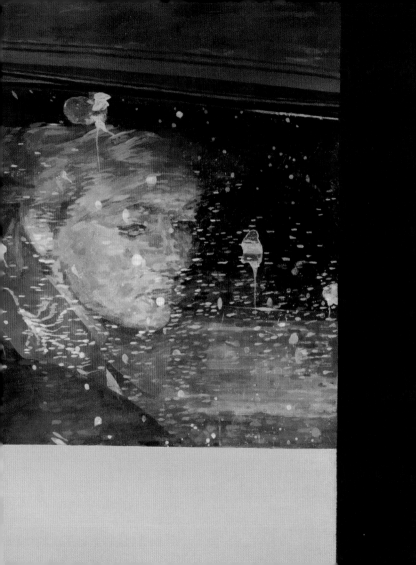

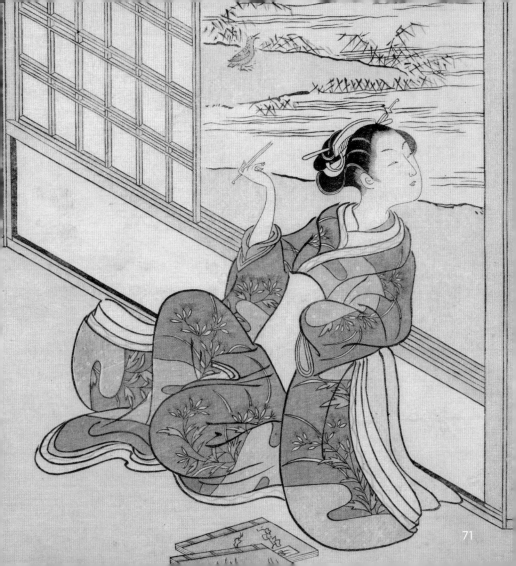

71

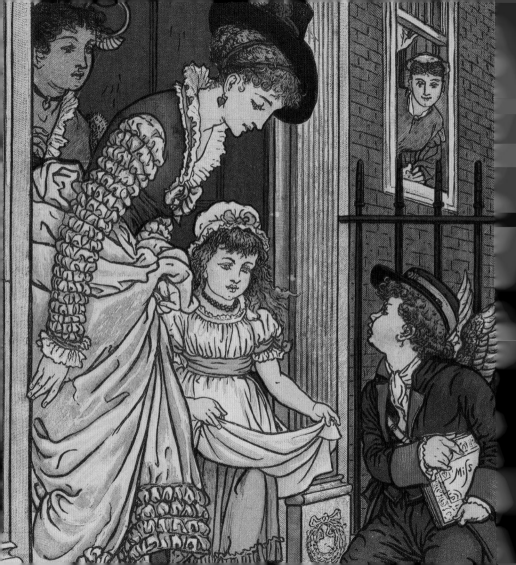

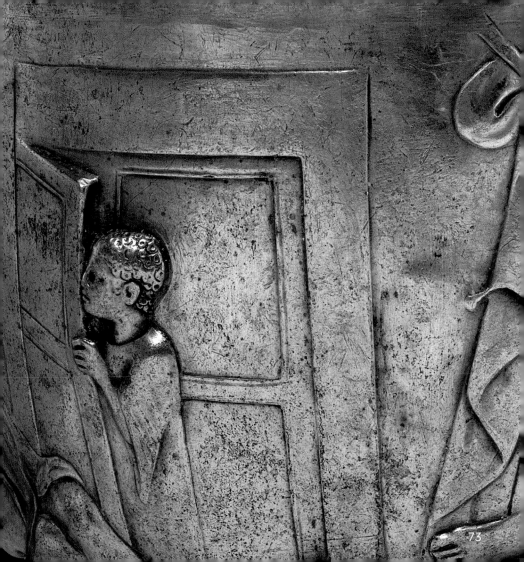

73

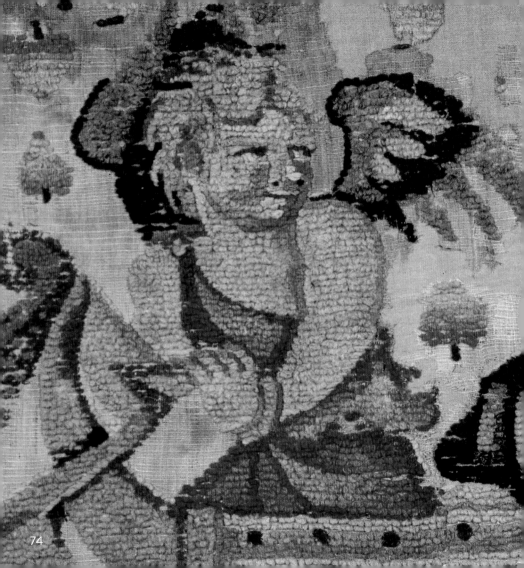

74

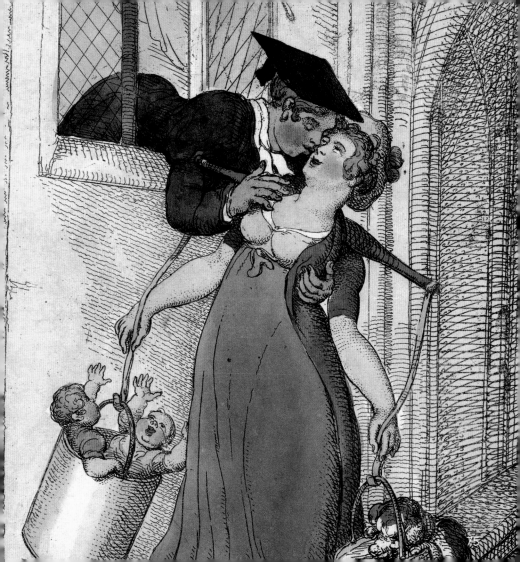

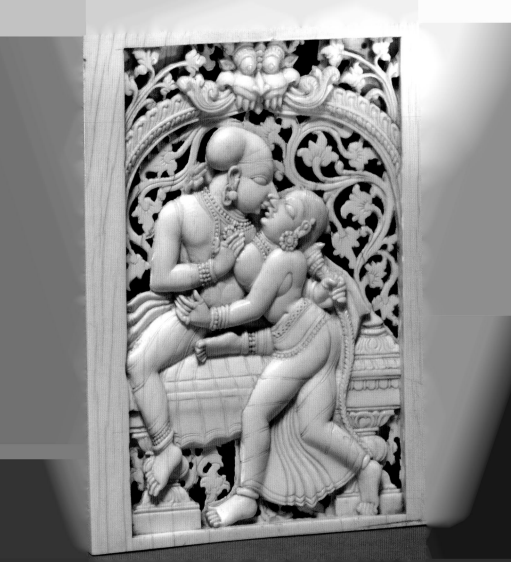

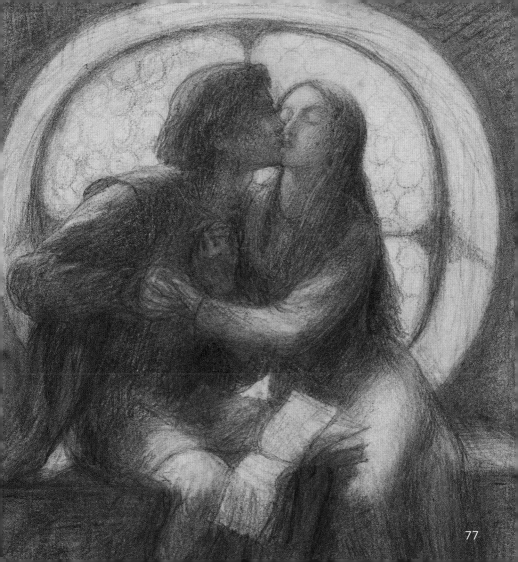

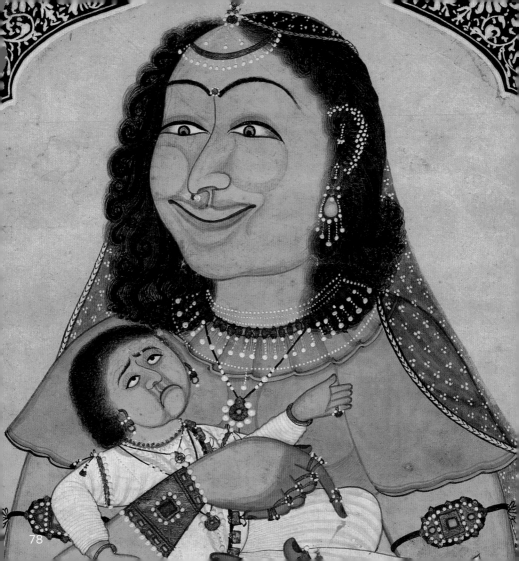

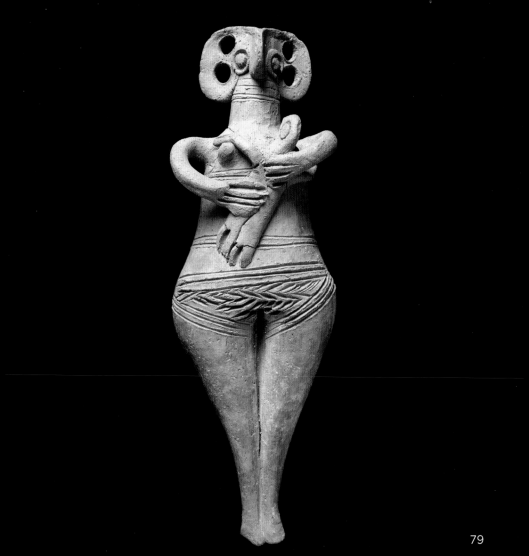

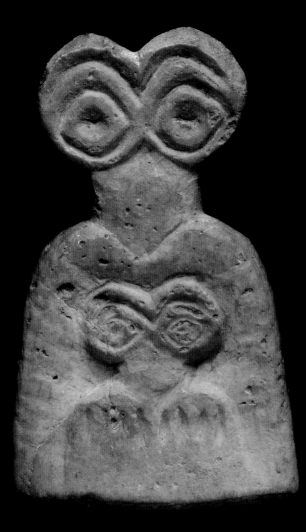

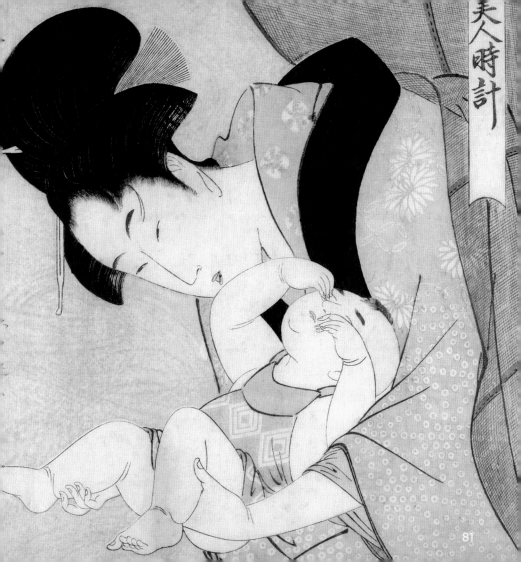

81

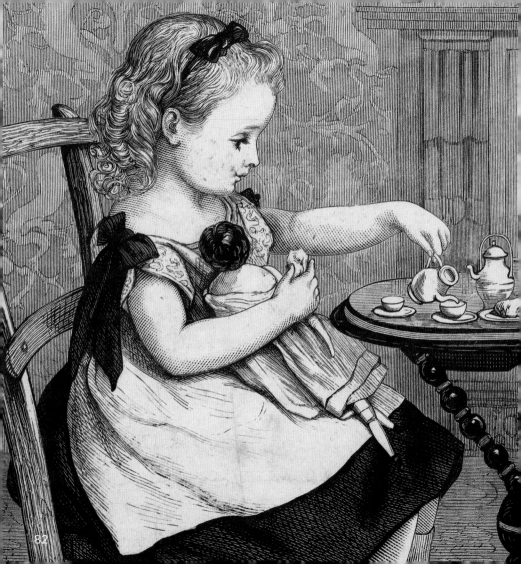

82

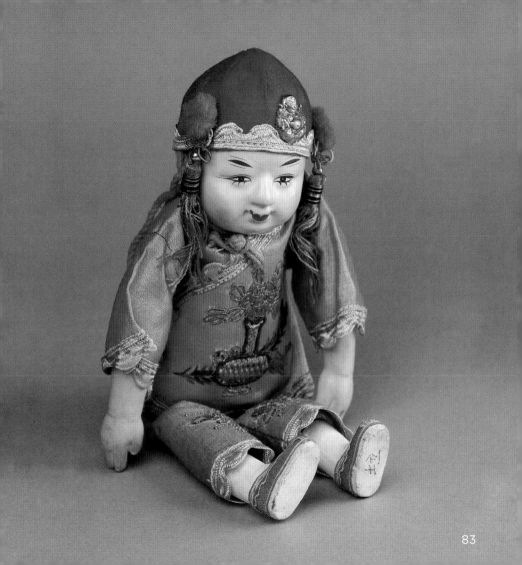

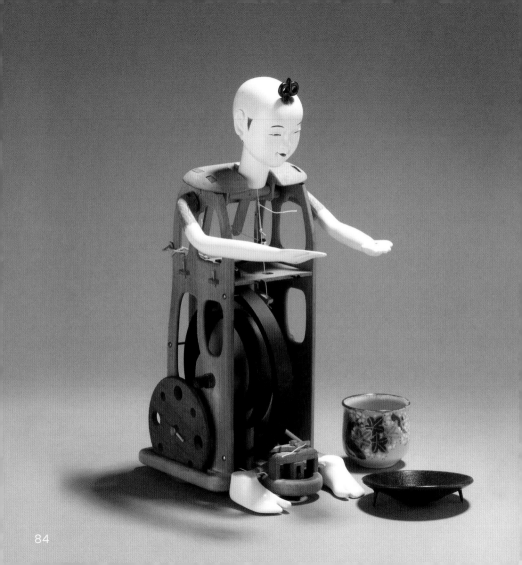

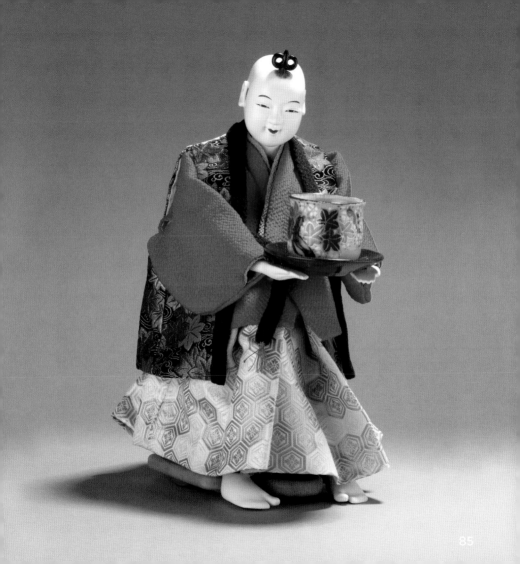

85

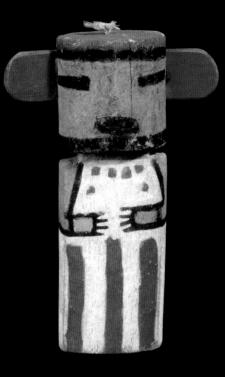

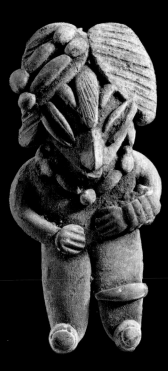

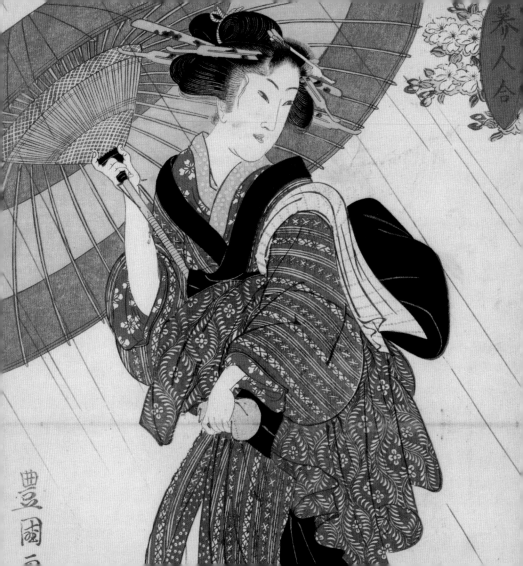

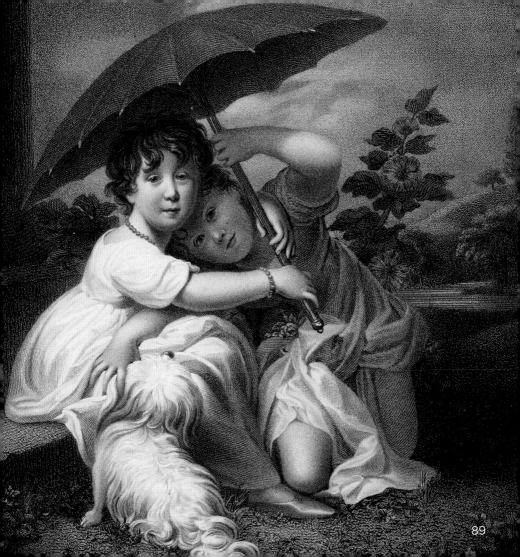

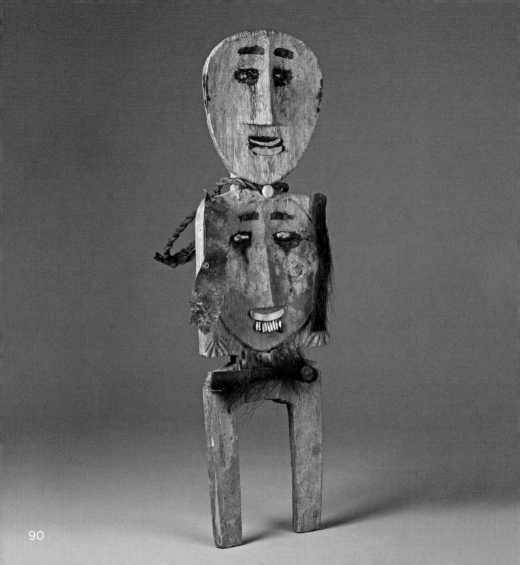

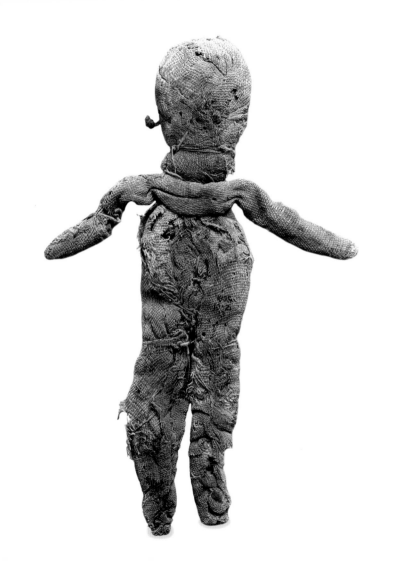

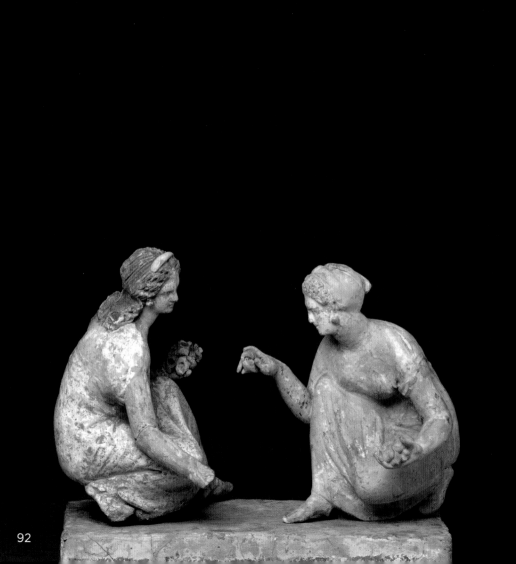

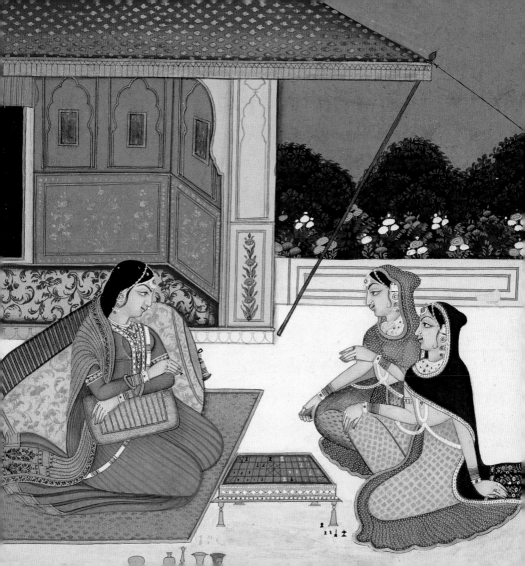

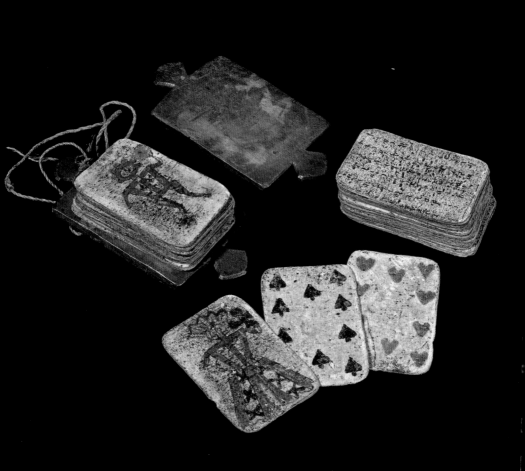

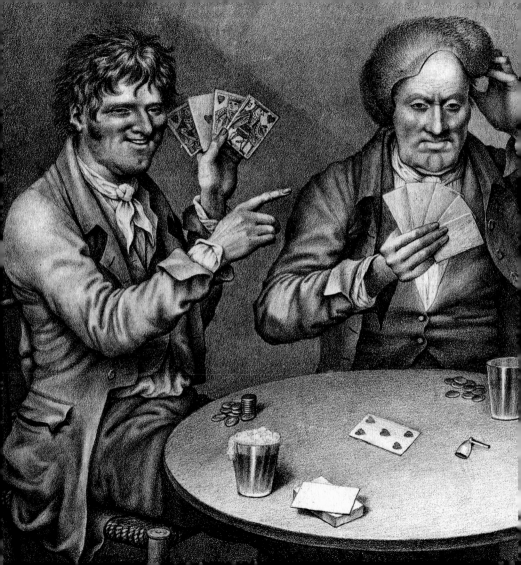

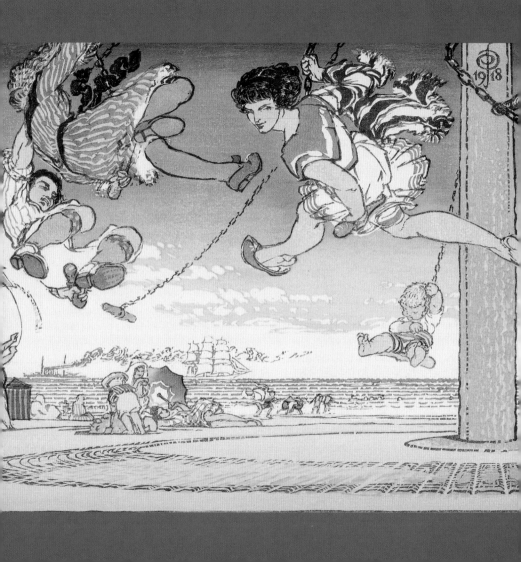

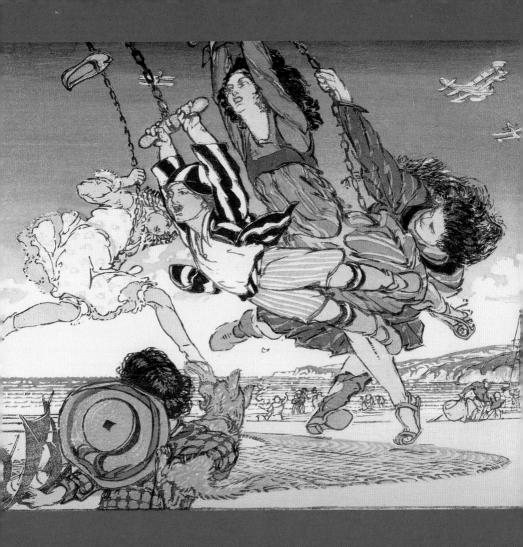

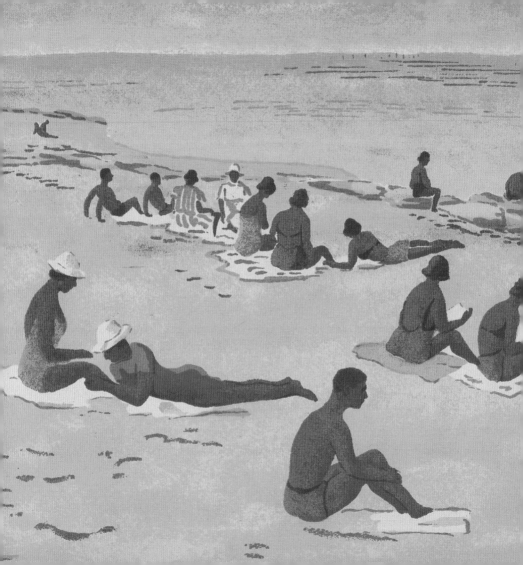

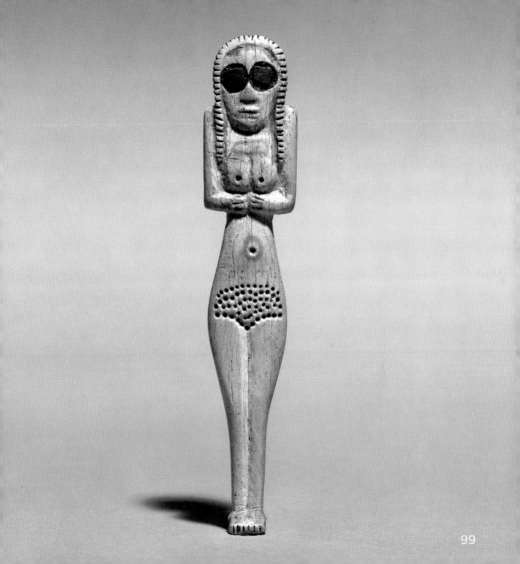

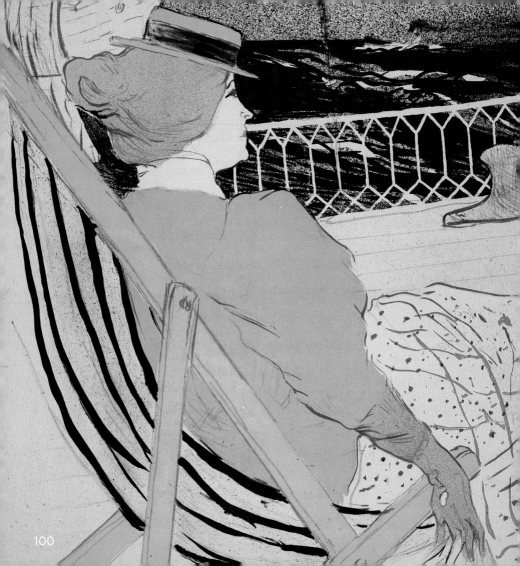

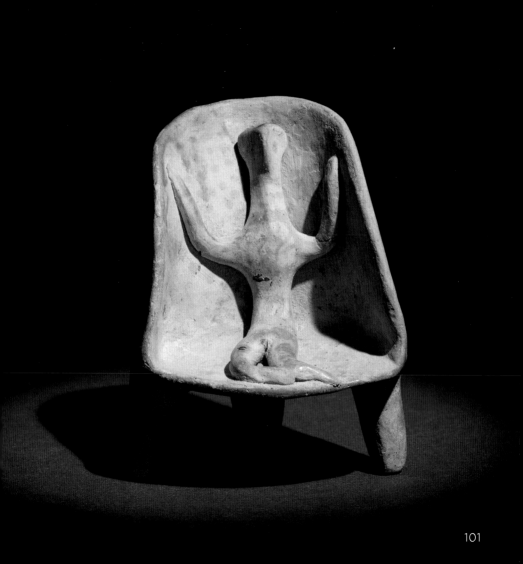

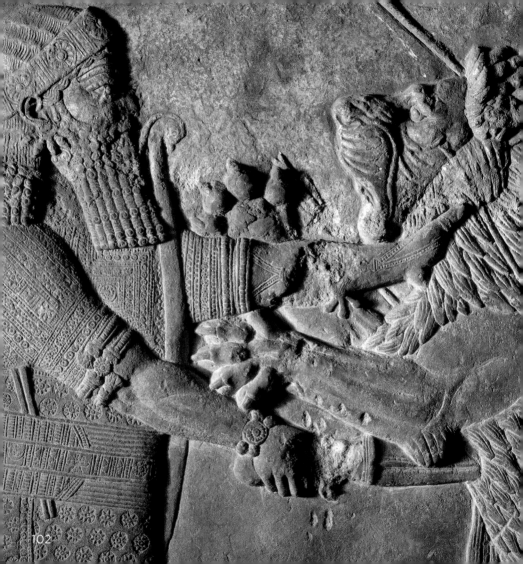

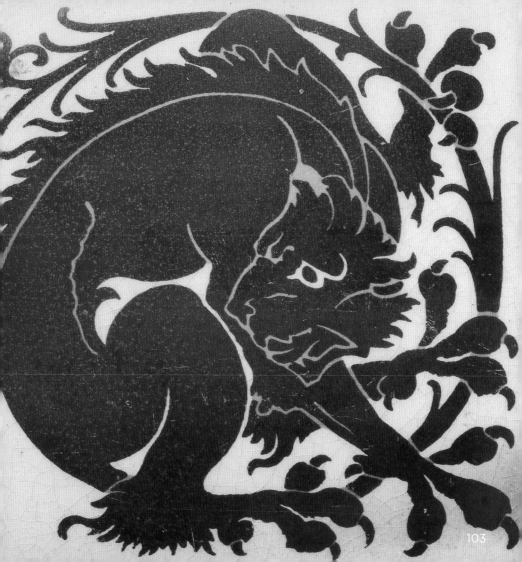

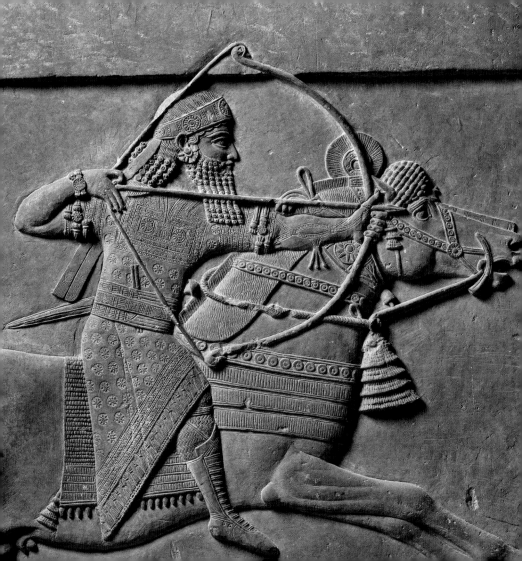

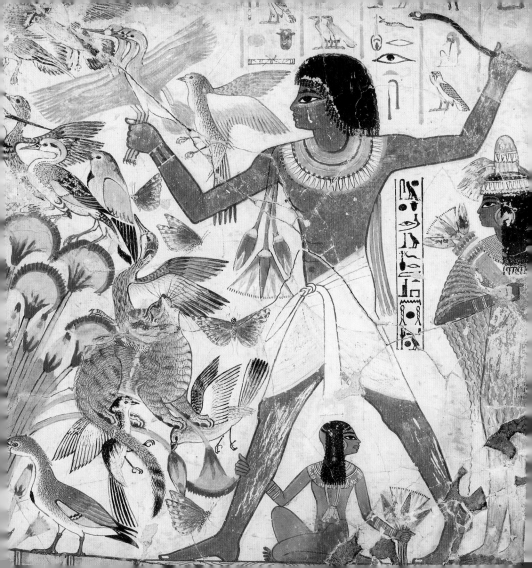

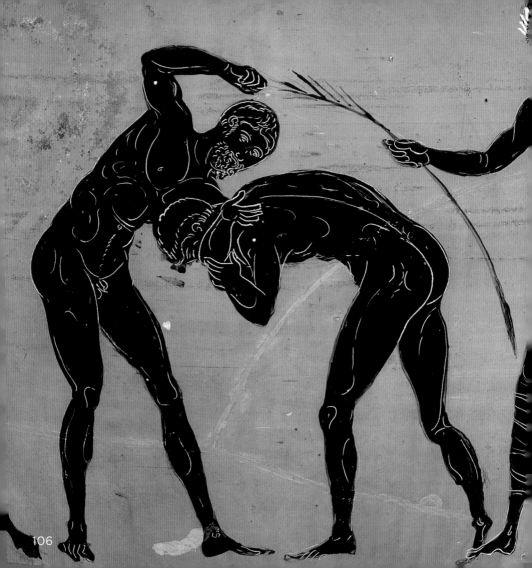

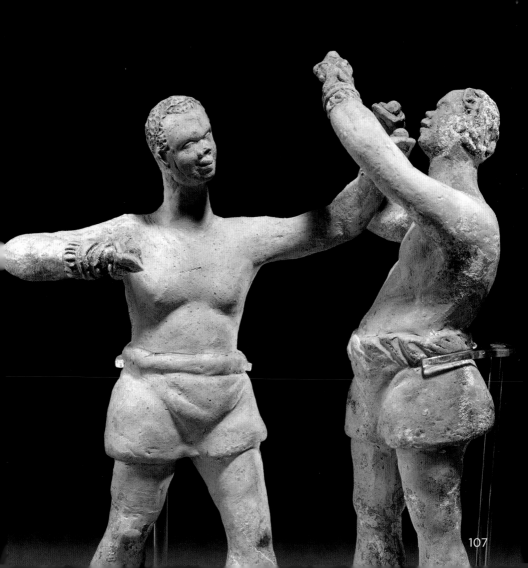

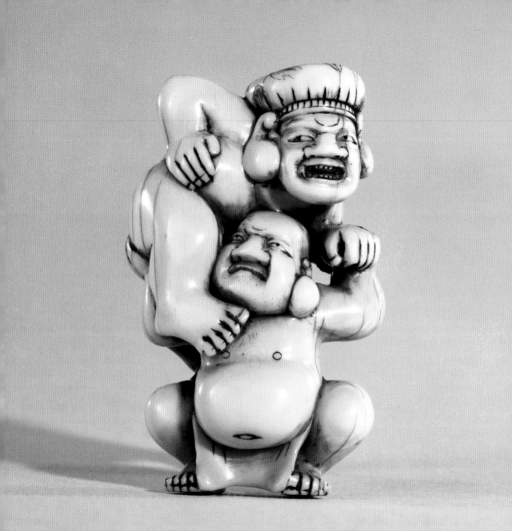

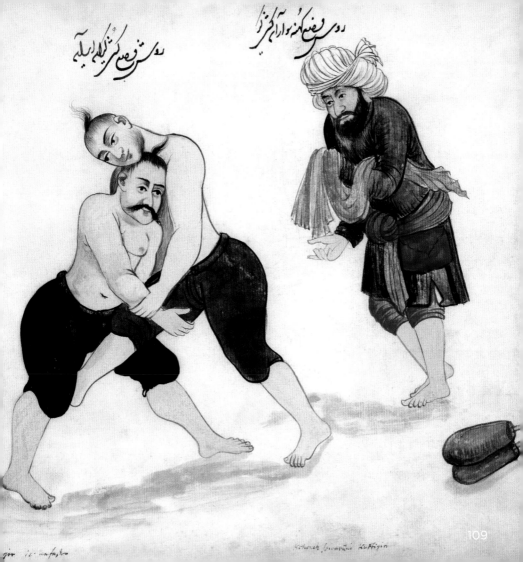

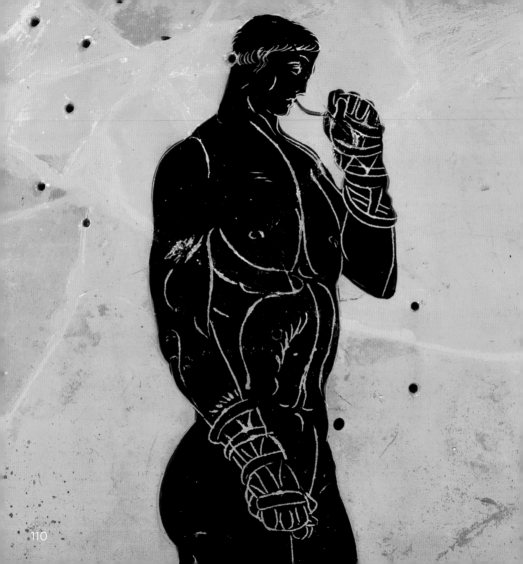

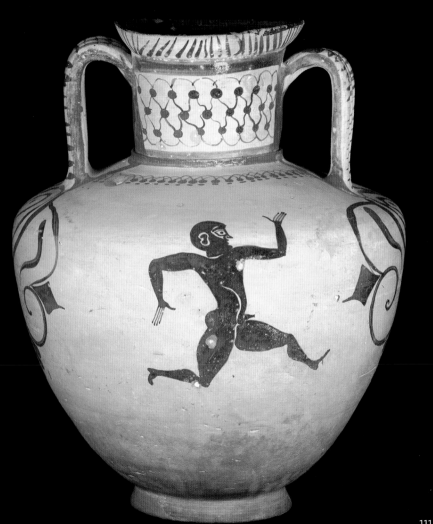

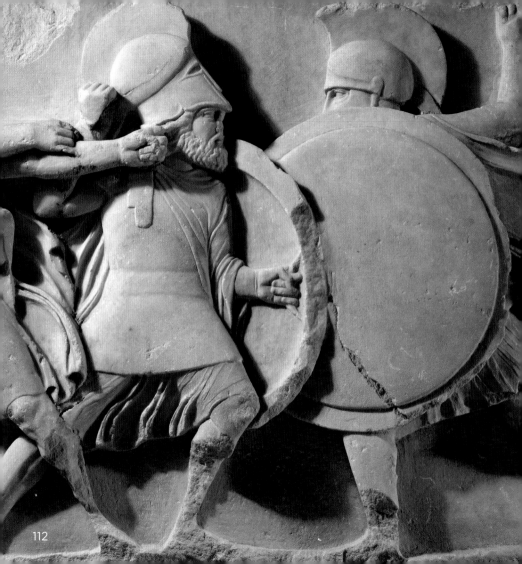

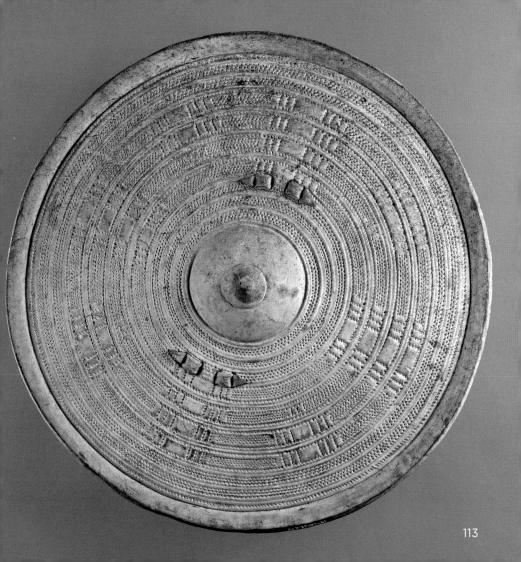

113

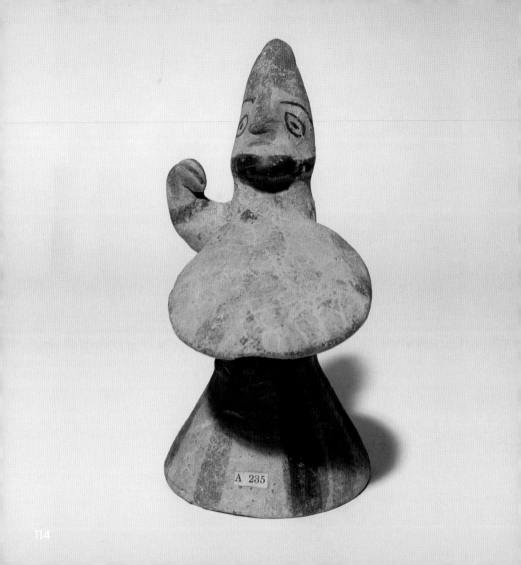

A 235

114

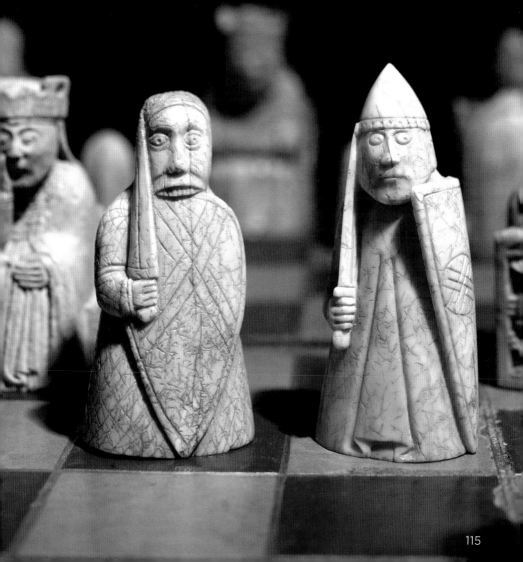

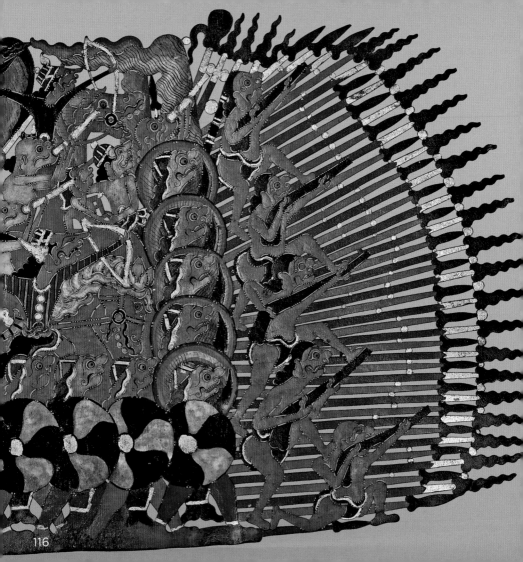

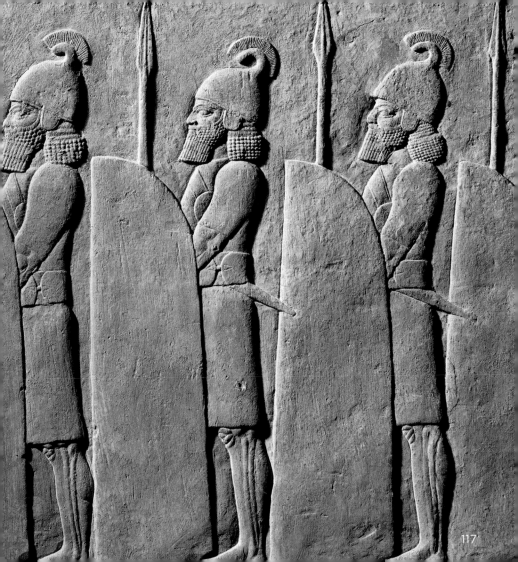

117

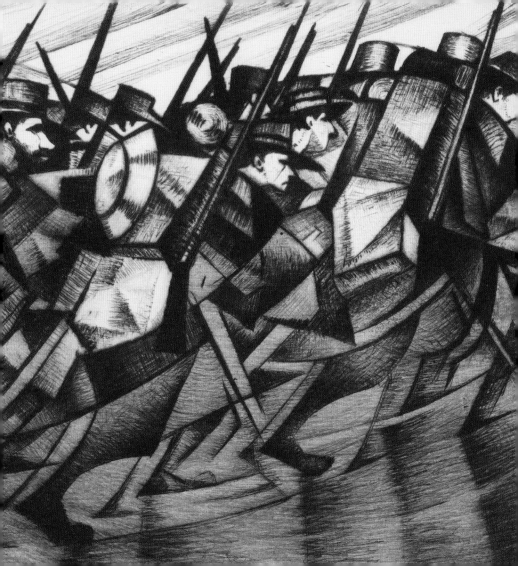

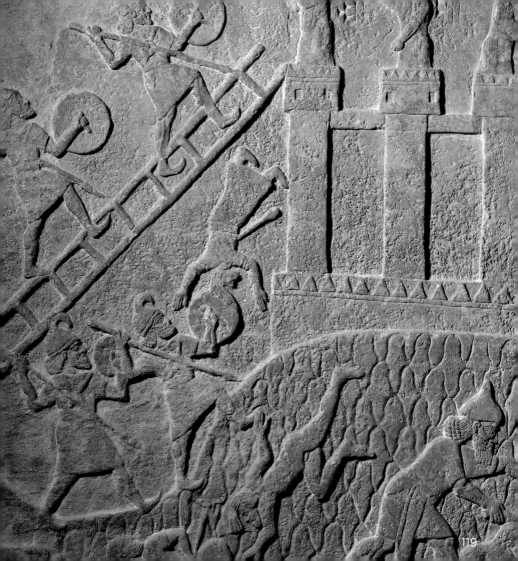

119

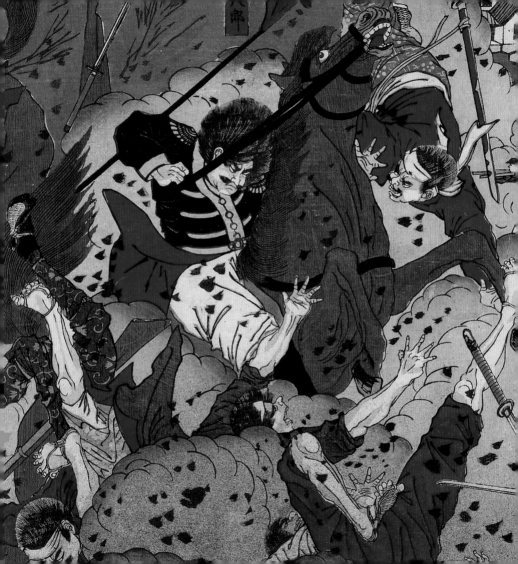

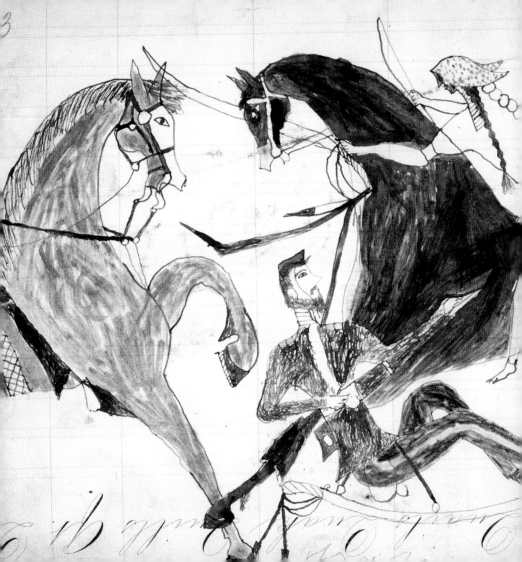

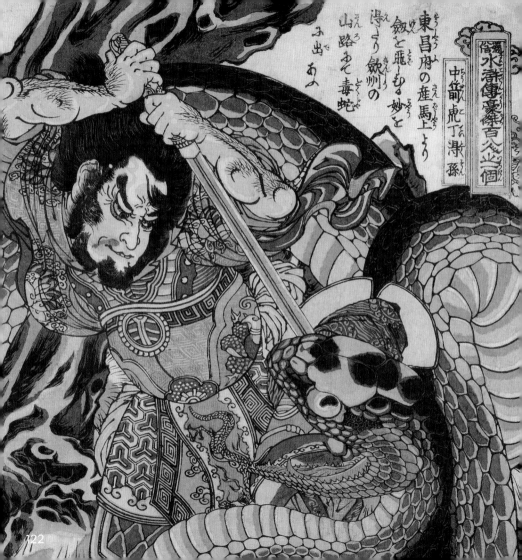

中箭虎丁得孫

東昌府の産馬上より
劍を飛しむる妙を
得より欽州の
山路あそ毒蛇
を出あぬ

122

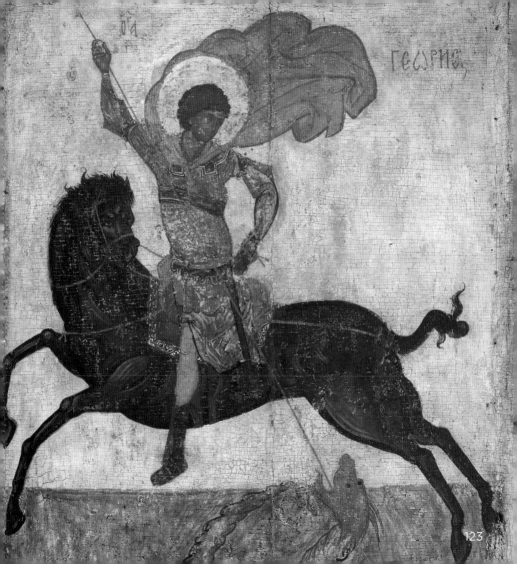

123

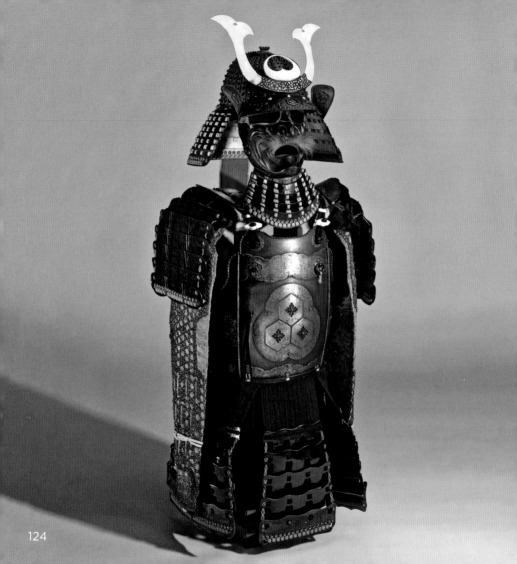

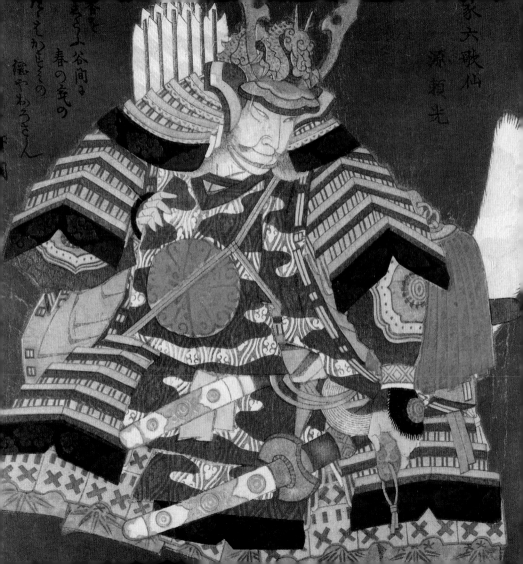

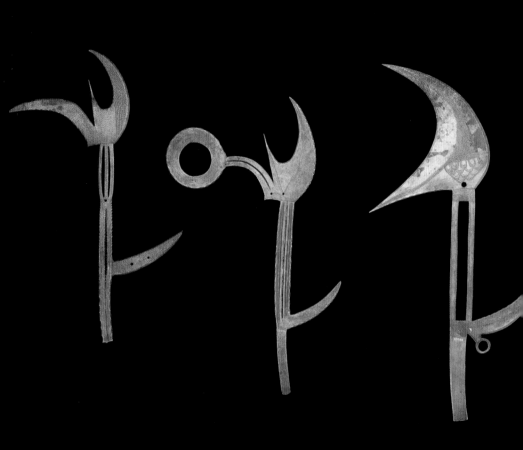

126

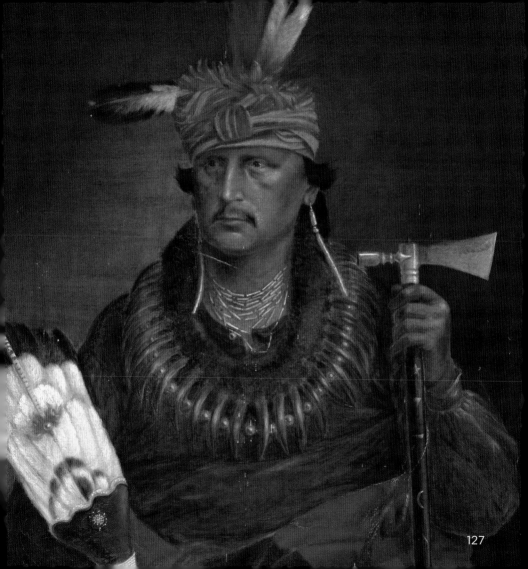

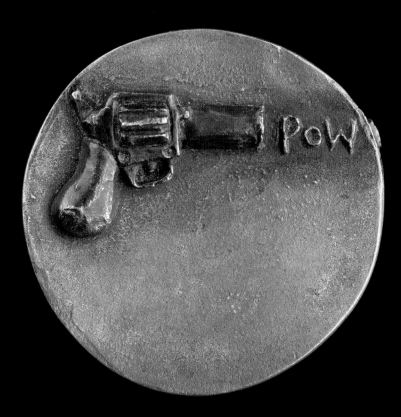

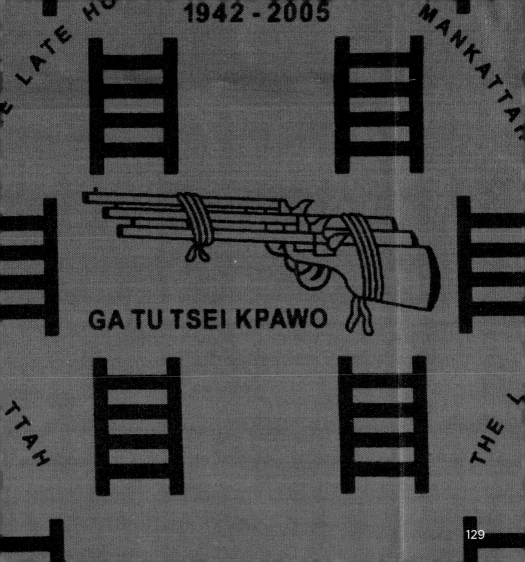

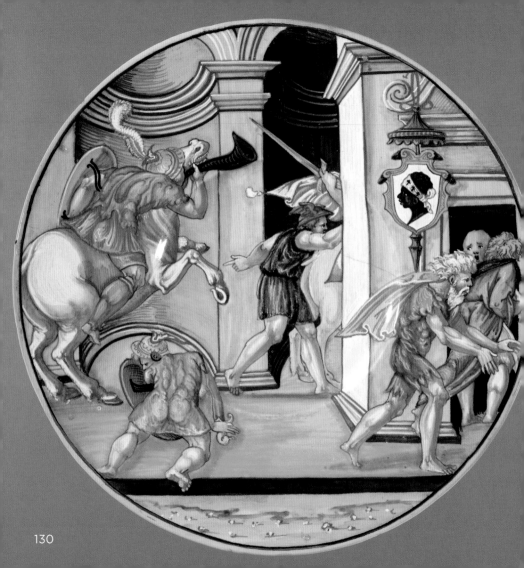

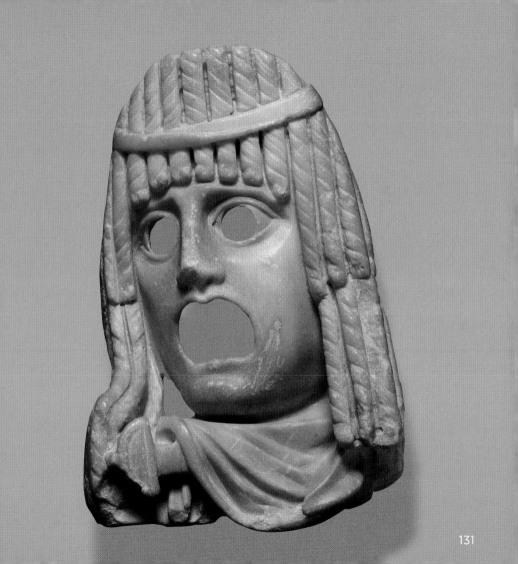

131

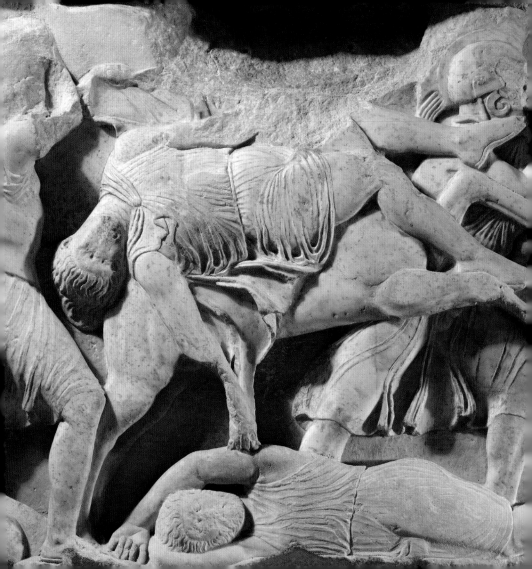

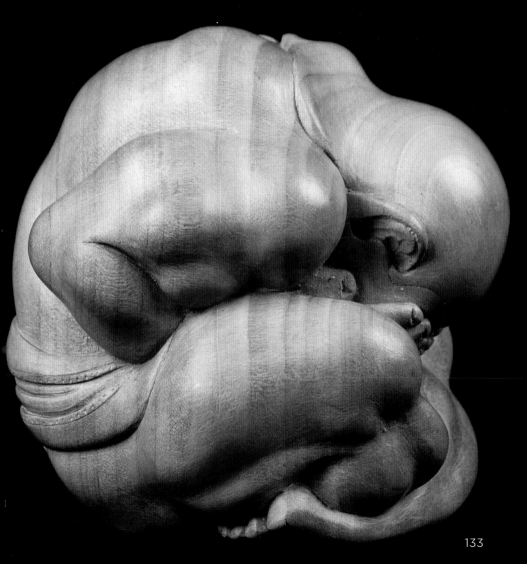

133

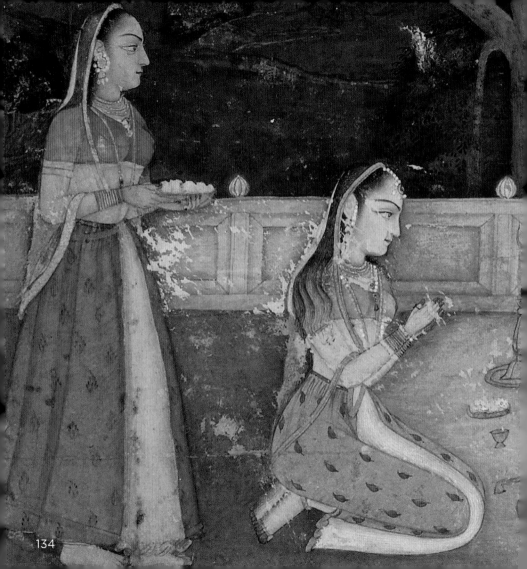

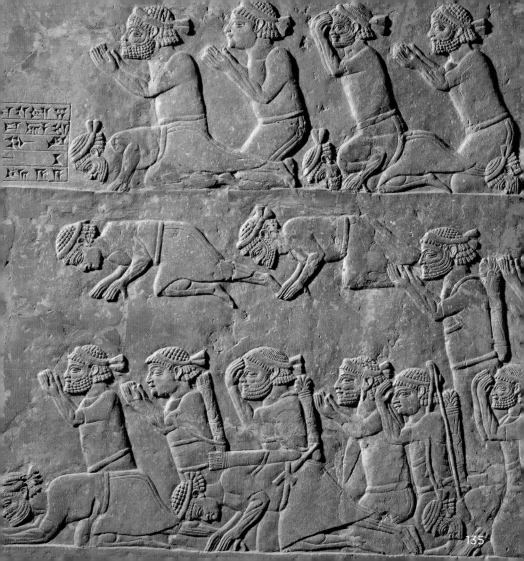

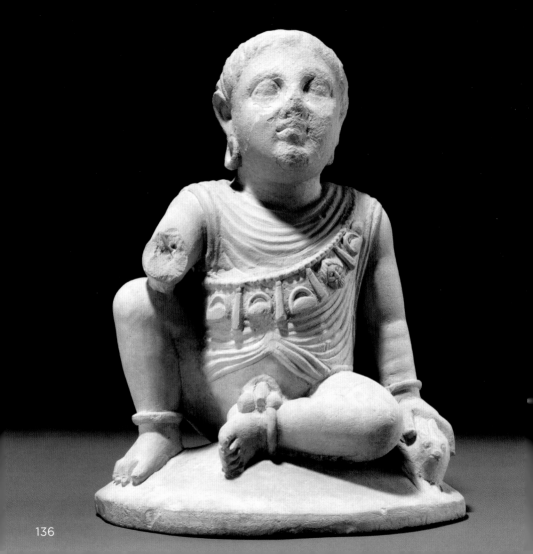

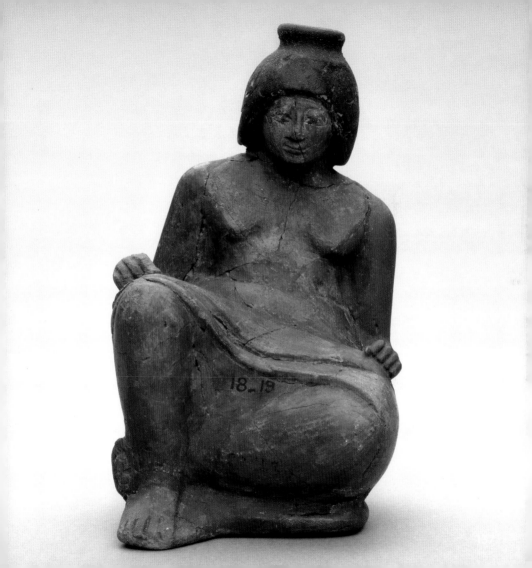

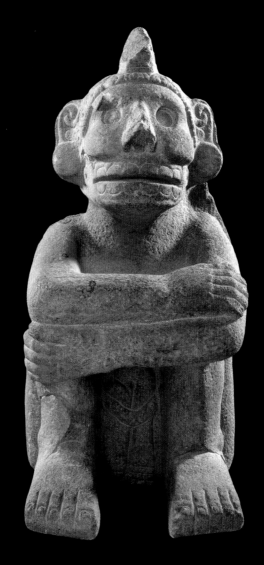

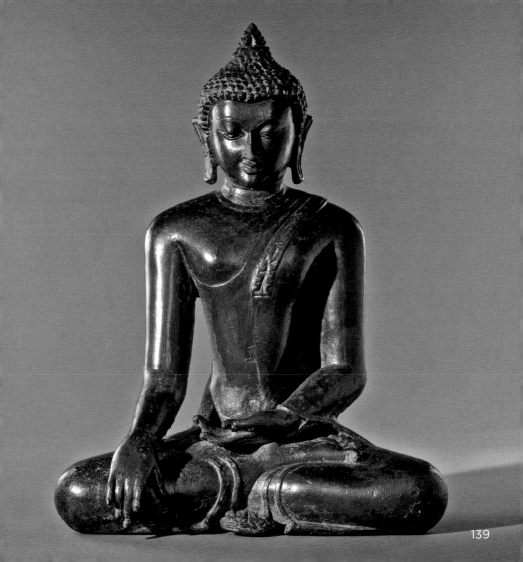
139

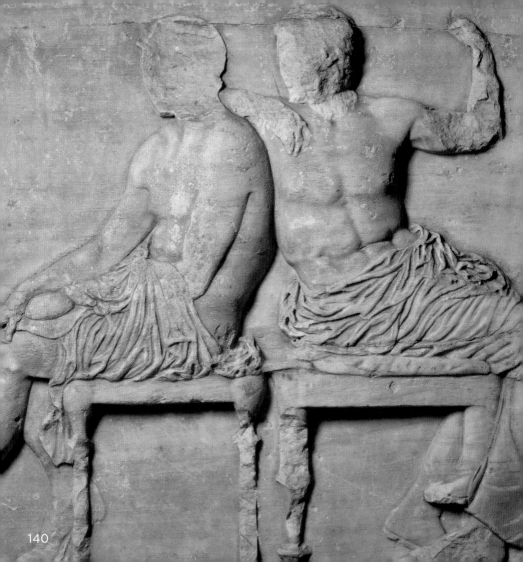

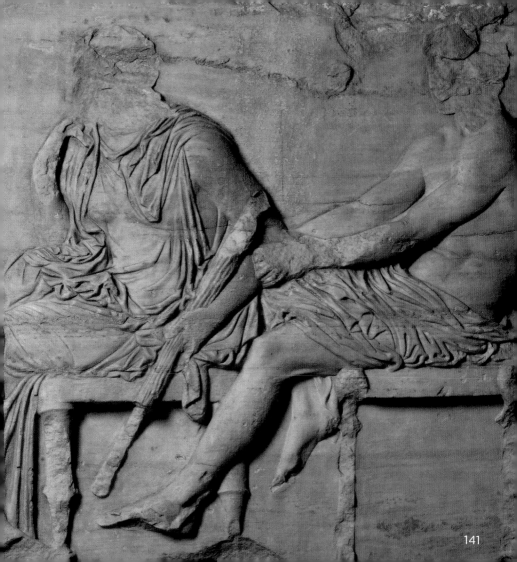

141

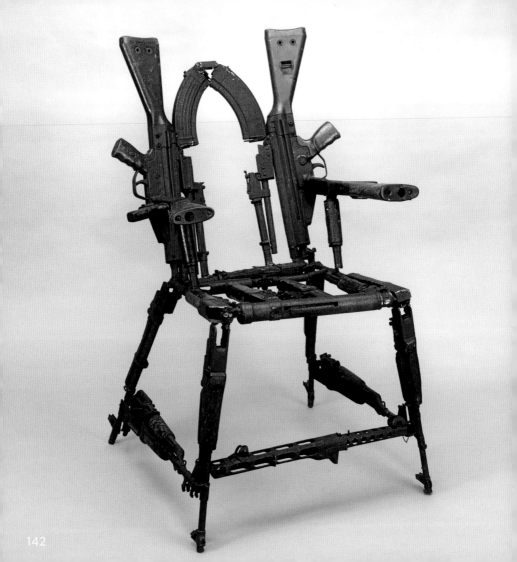

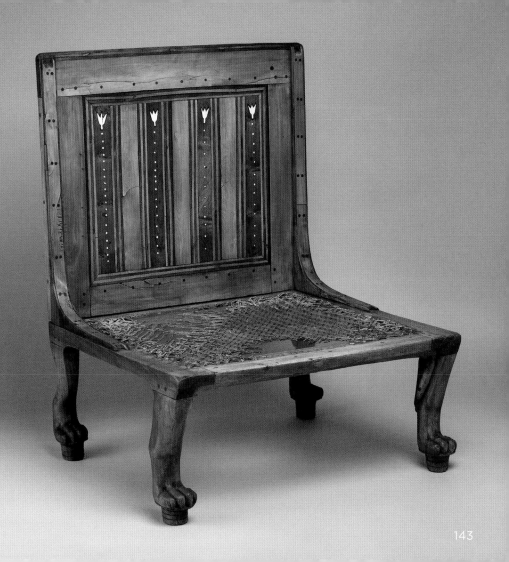

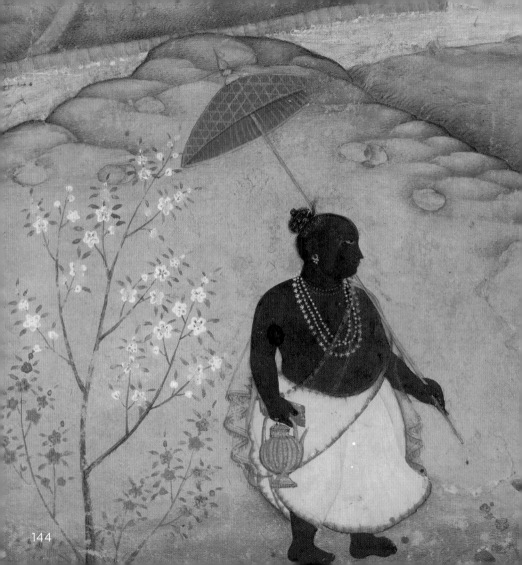

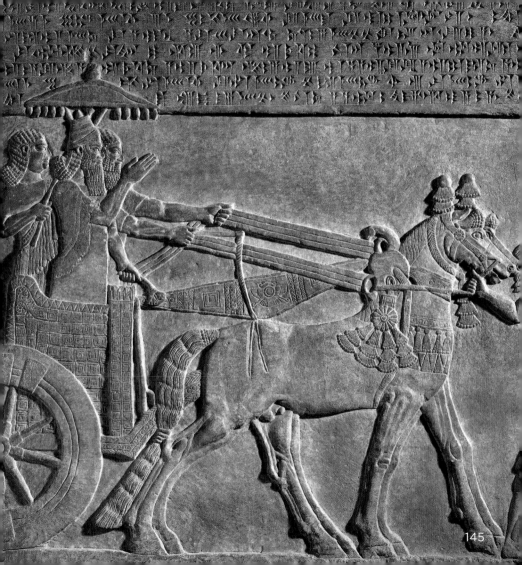

145

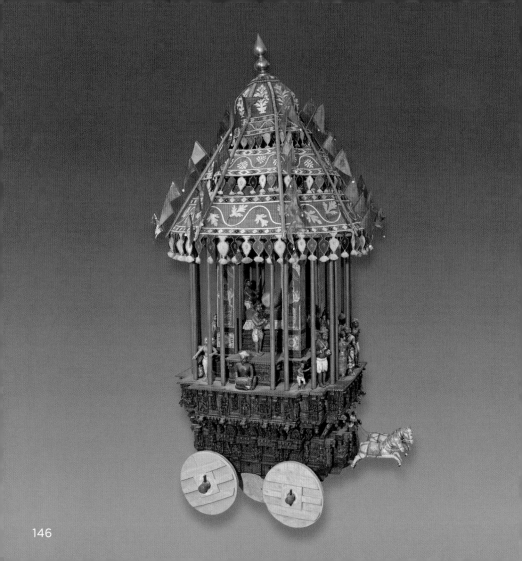

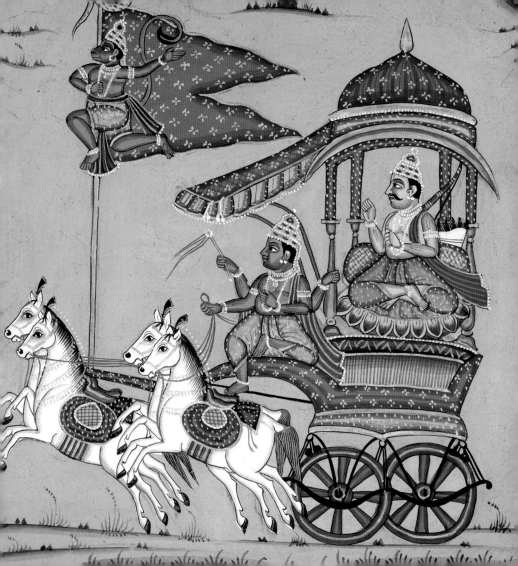

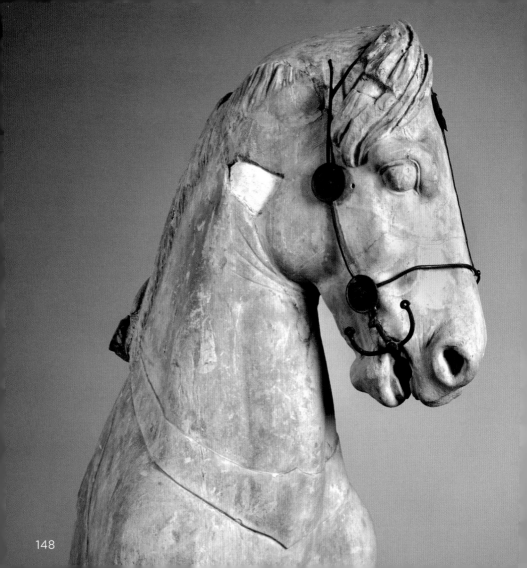

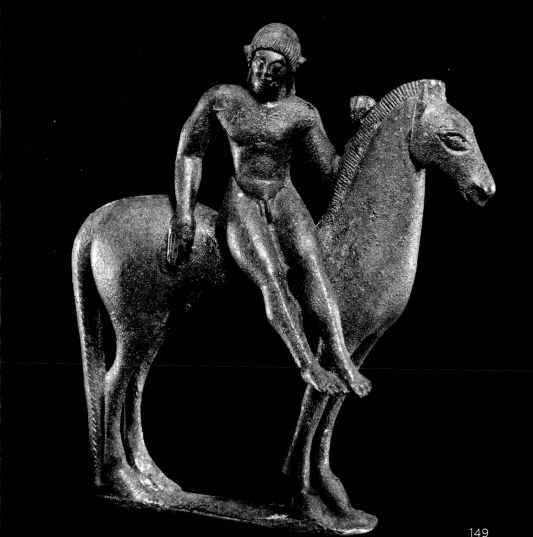

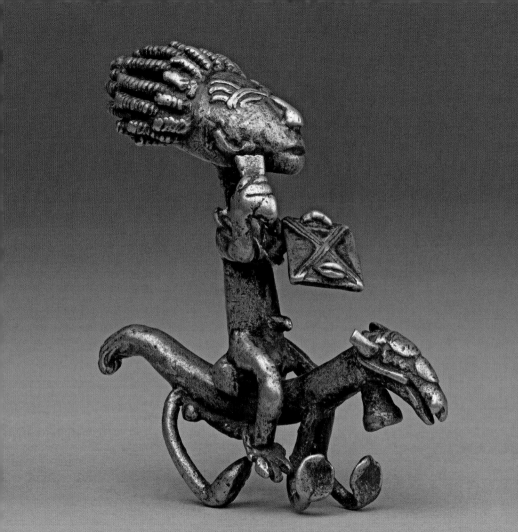

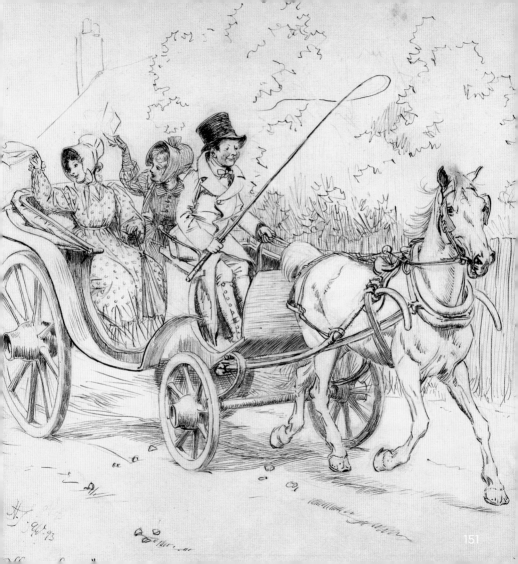

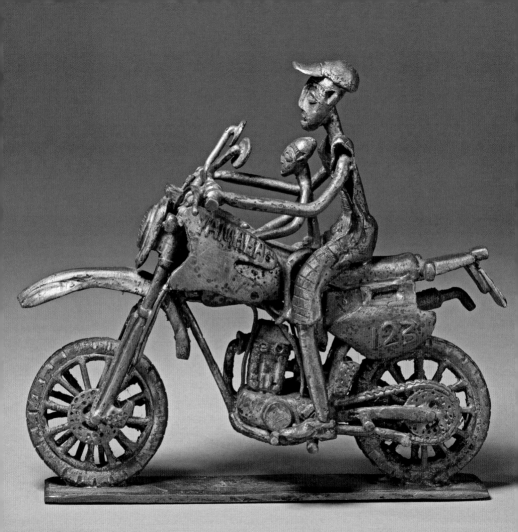

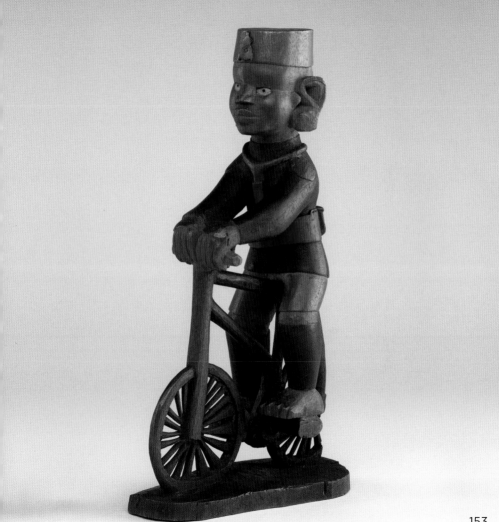

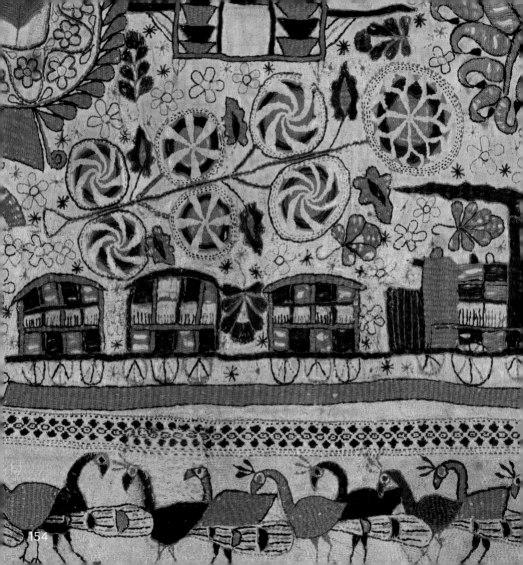

154

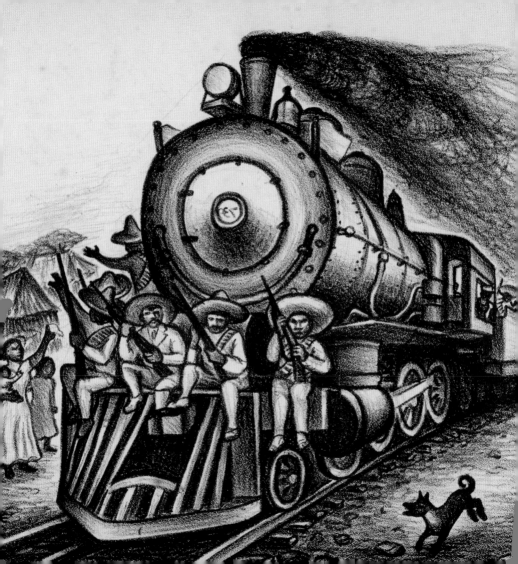

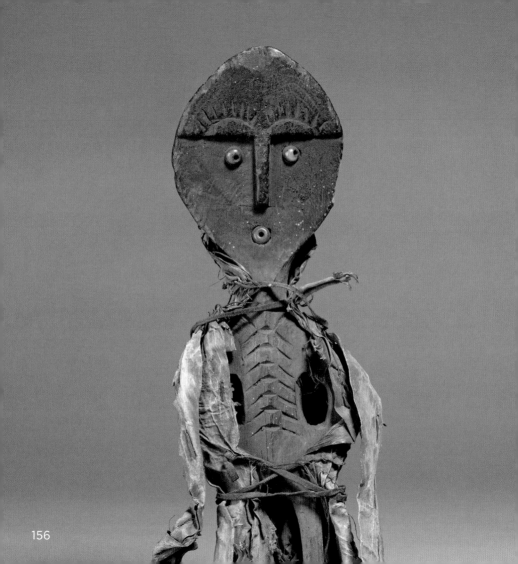

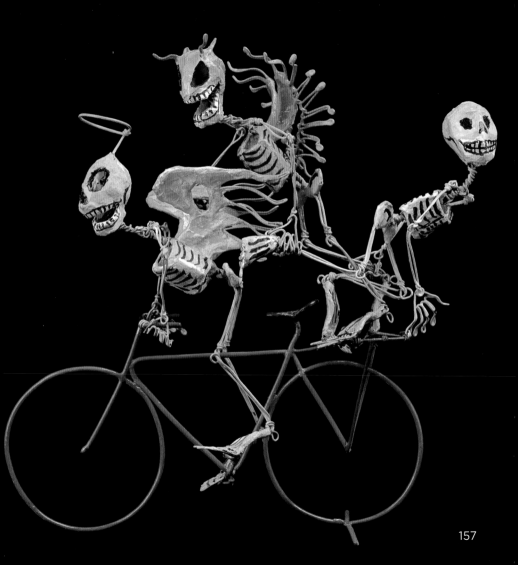

157

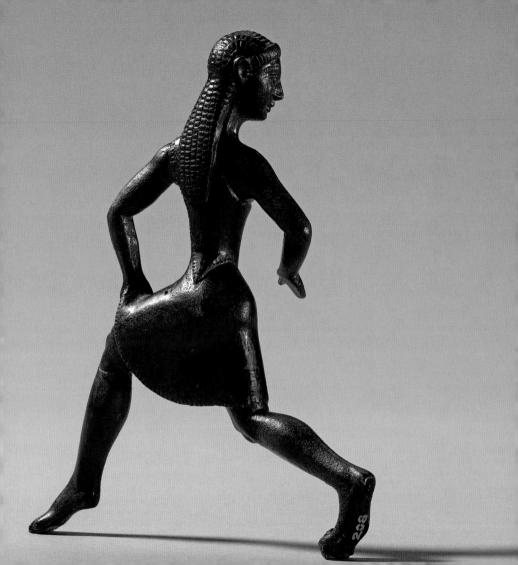

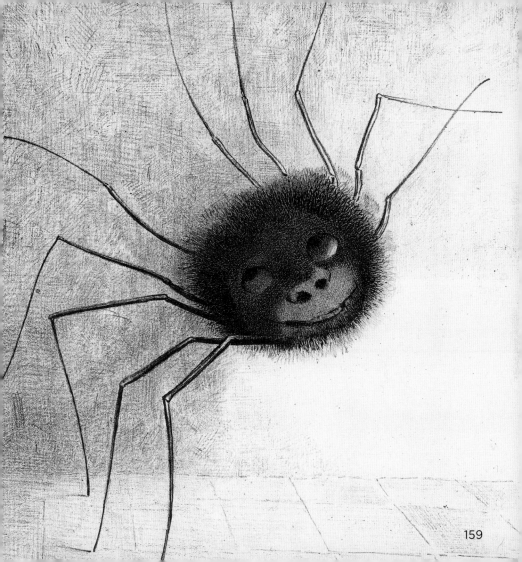

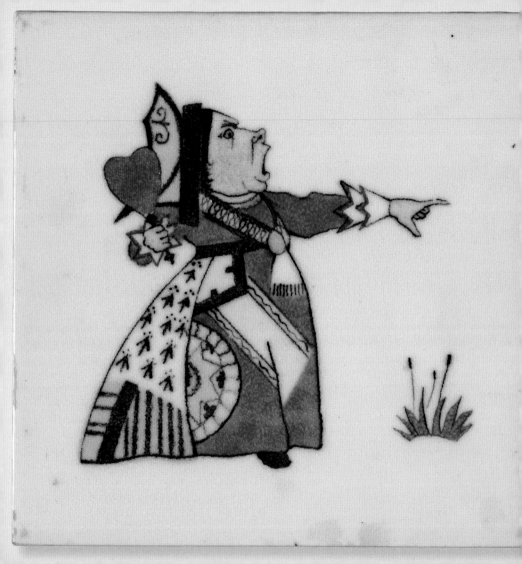

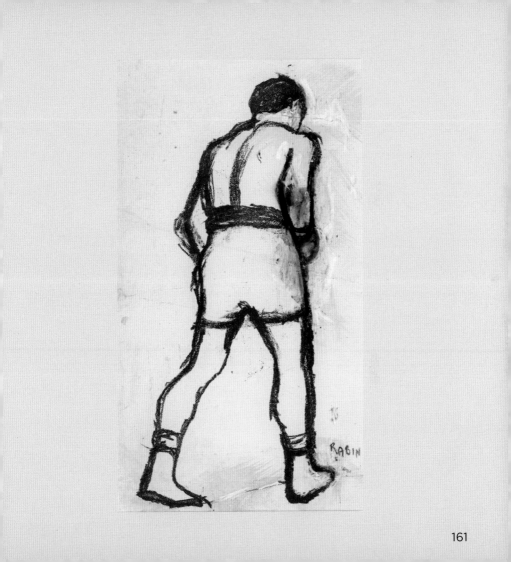

161

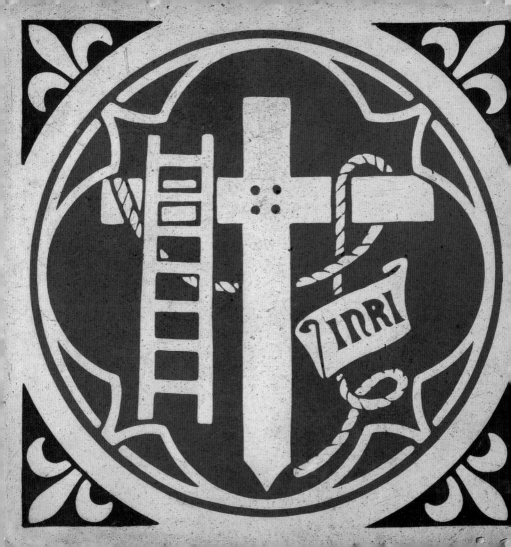

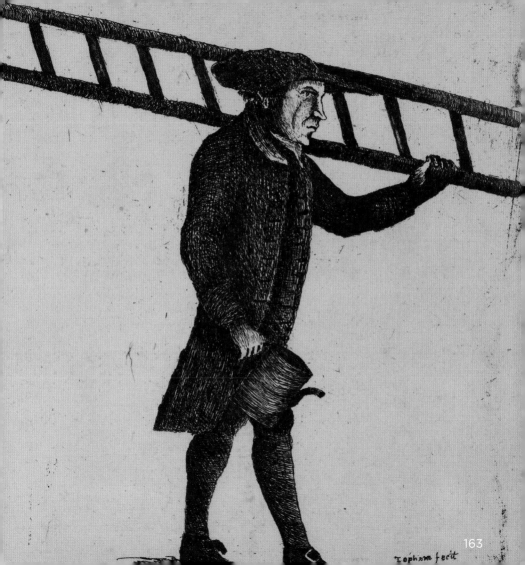

163

Topham fecit

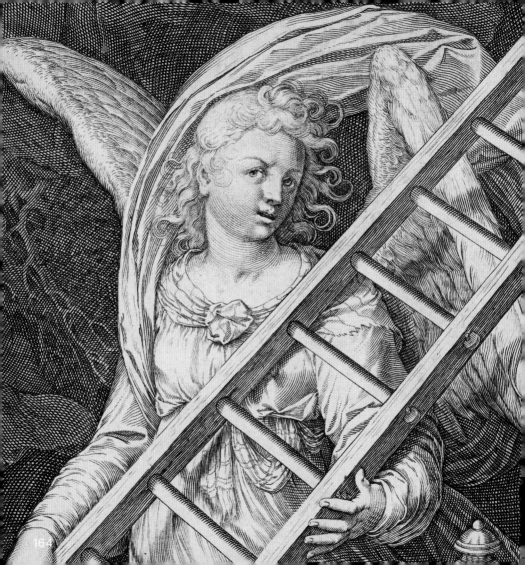

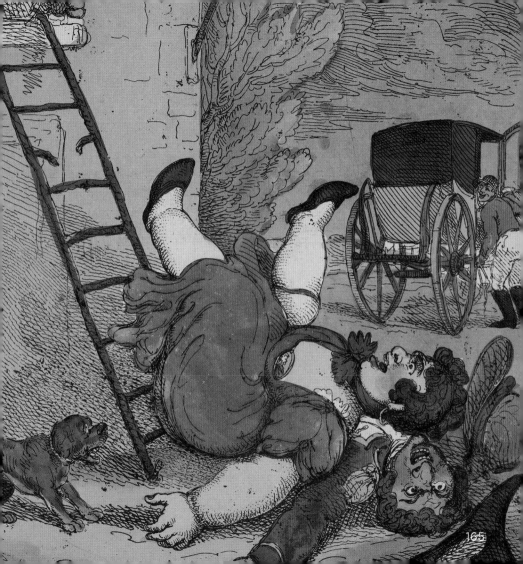

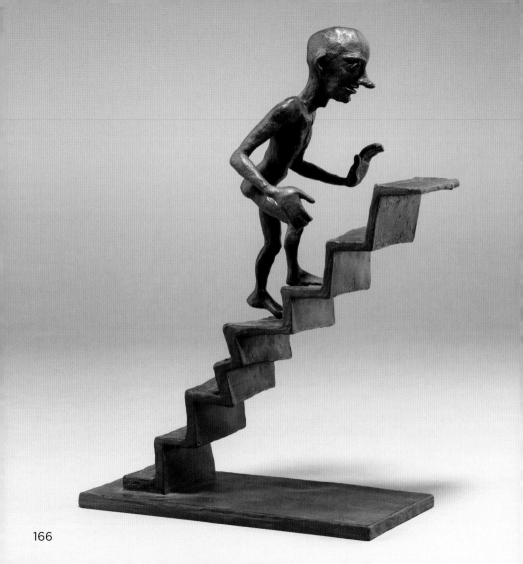

166

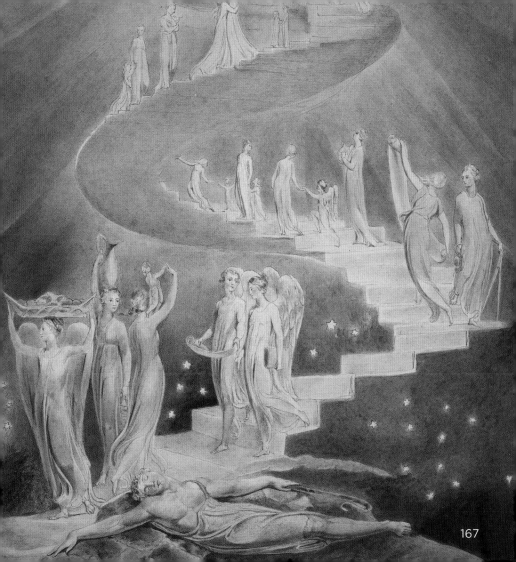

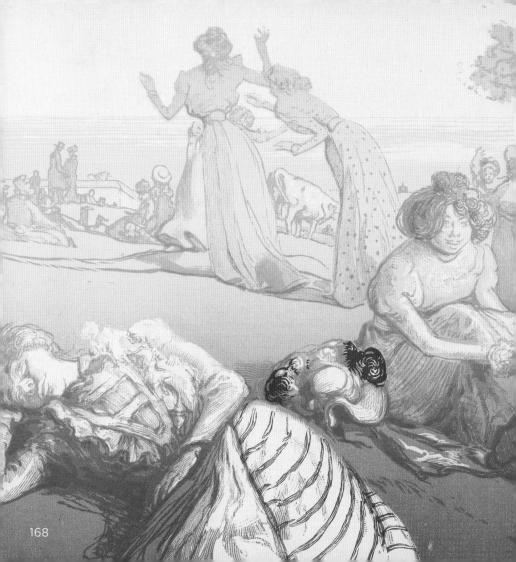

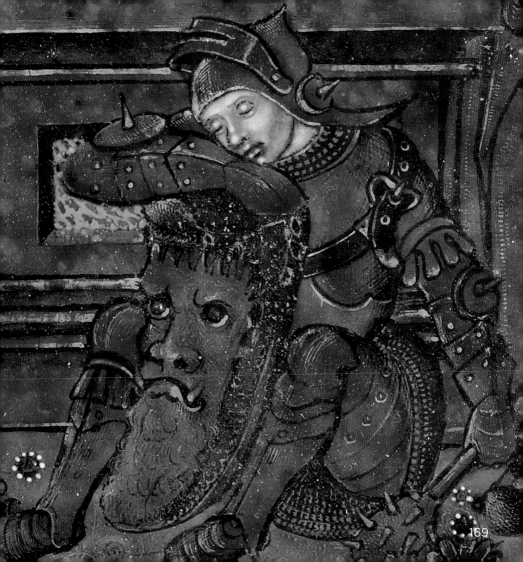

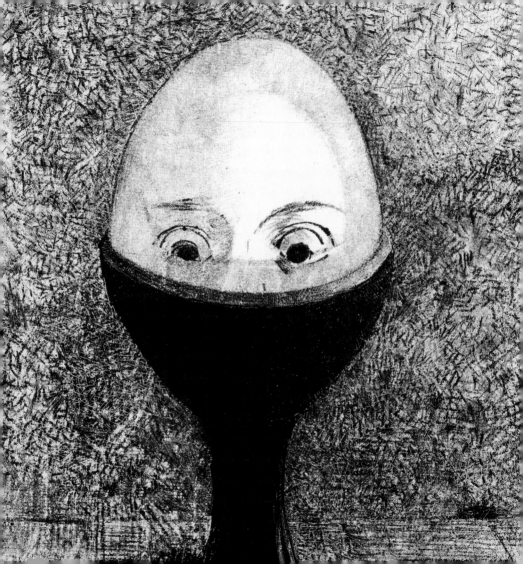

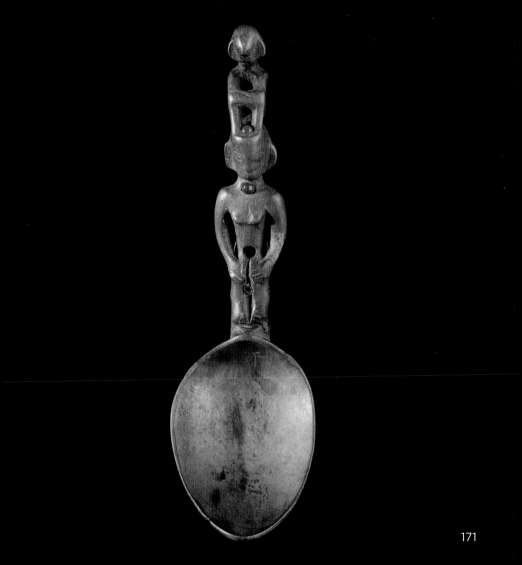

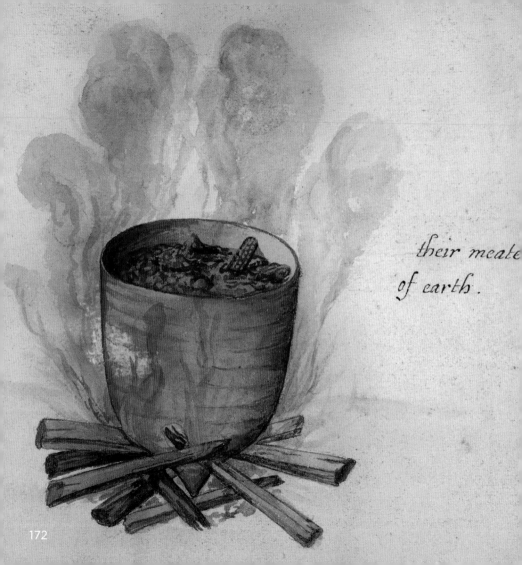

their meate
of earth.

172

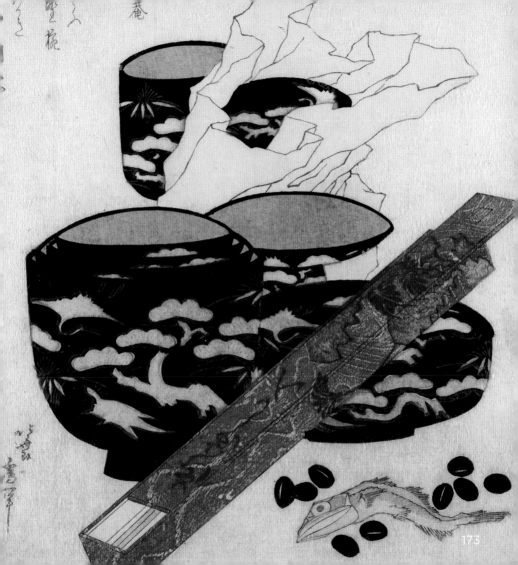

173

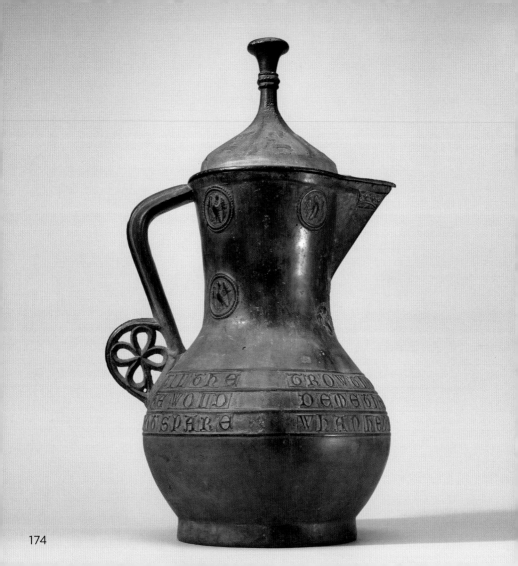

174

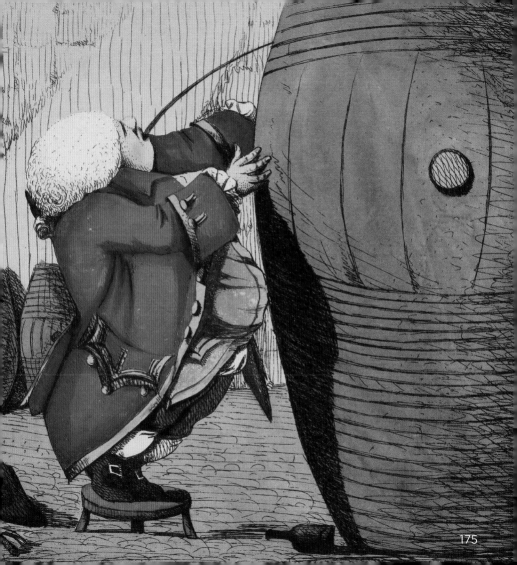

175

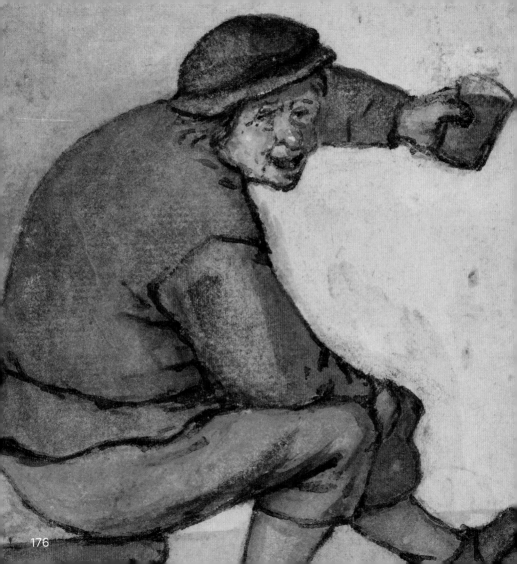

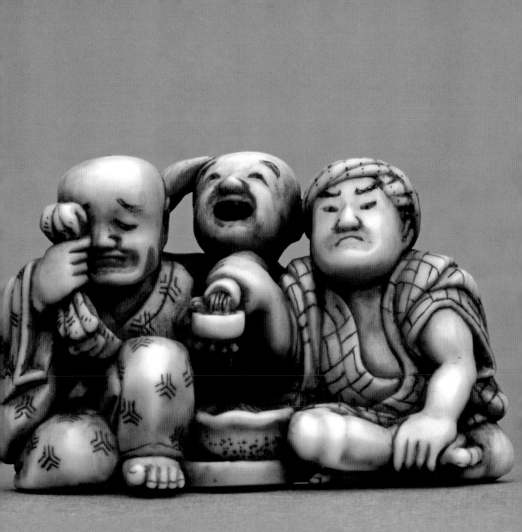

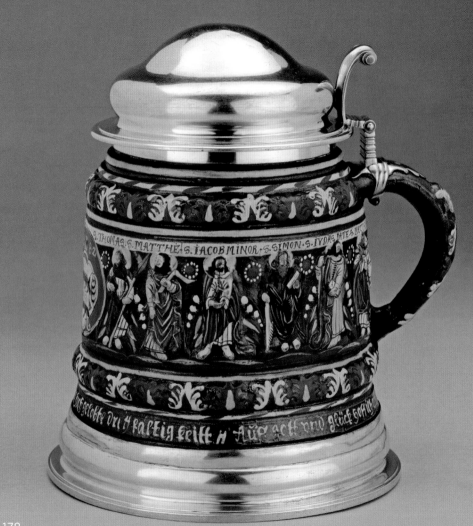

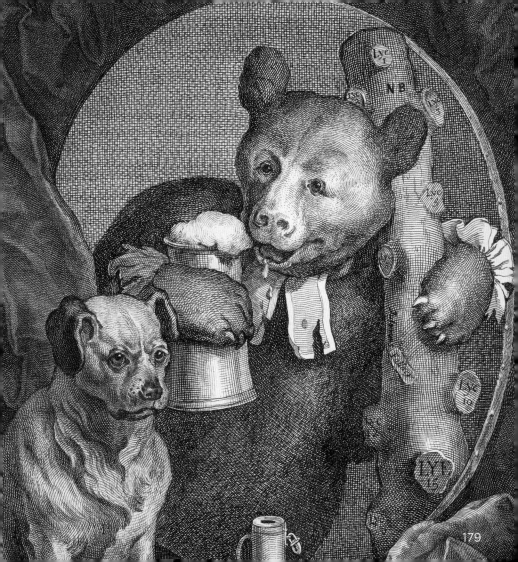

179

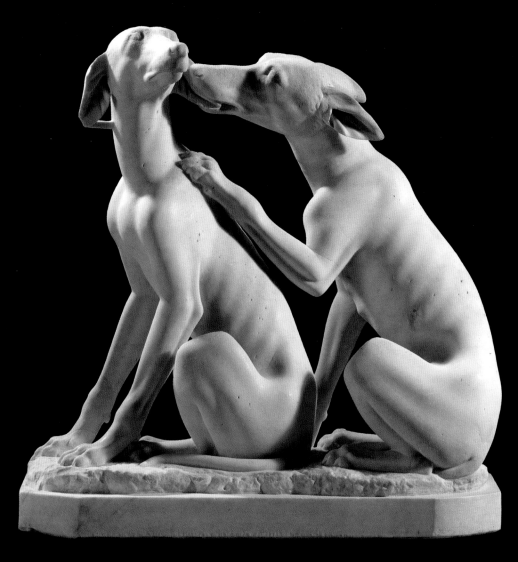

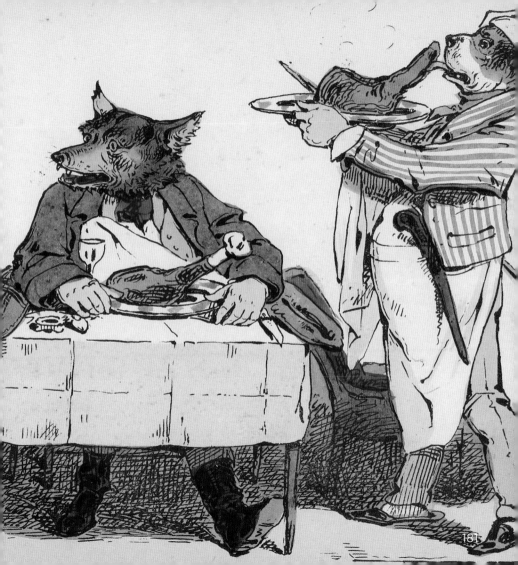

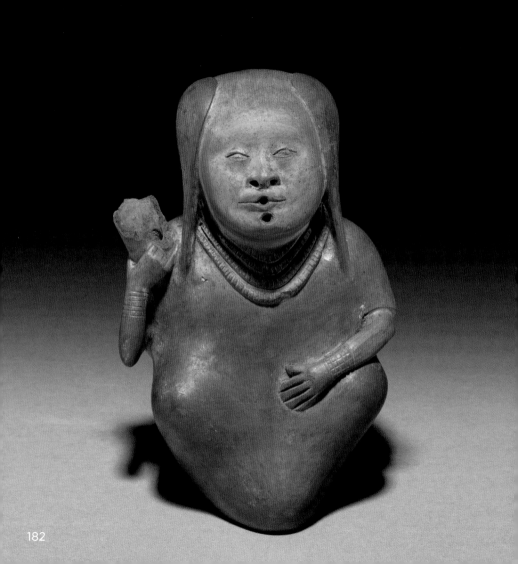

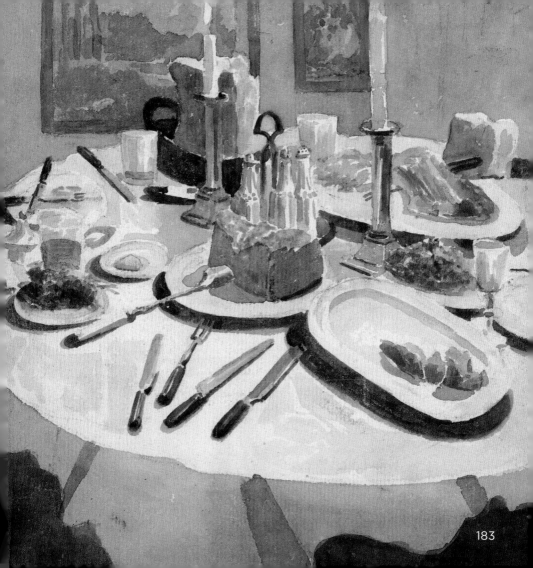

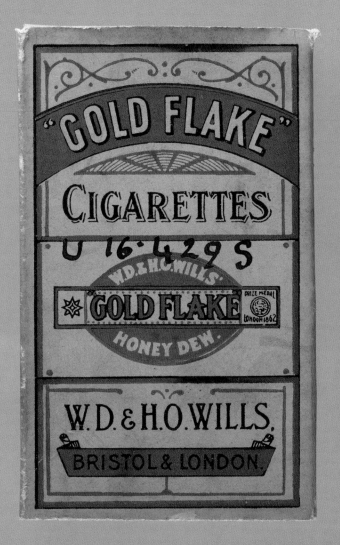

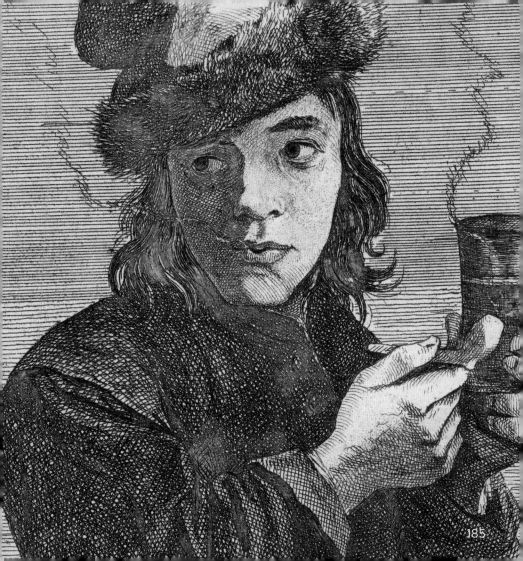
185

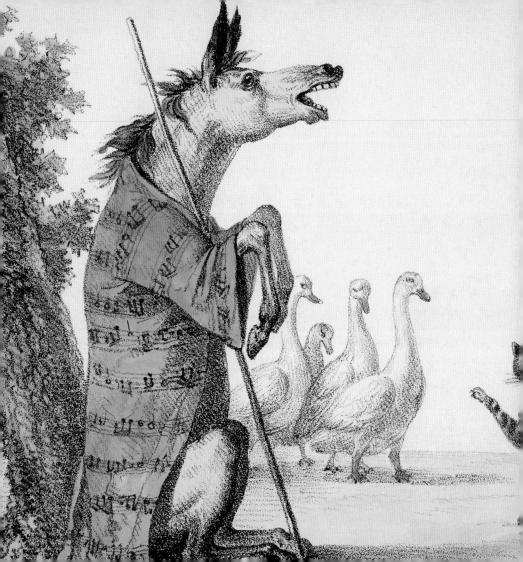

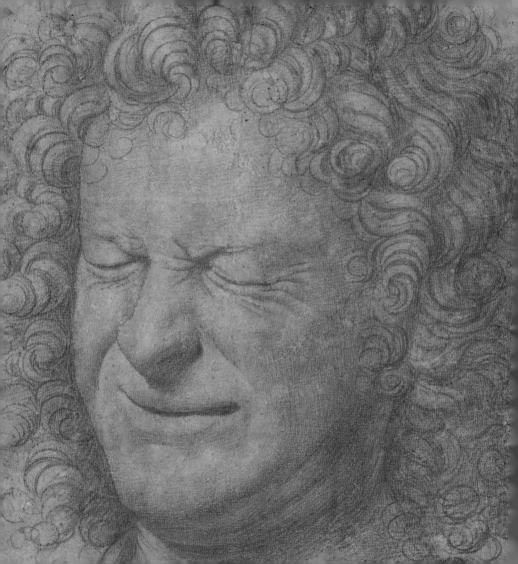

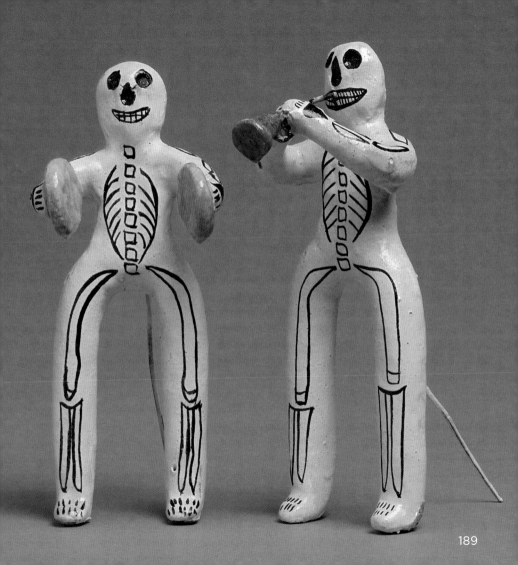

189

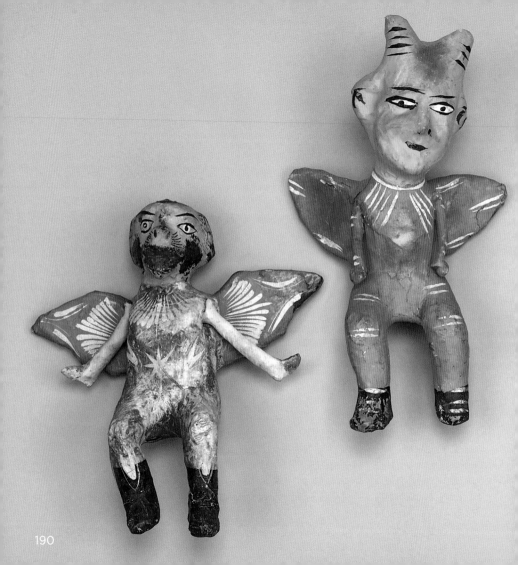

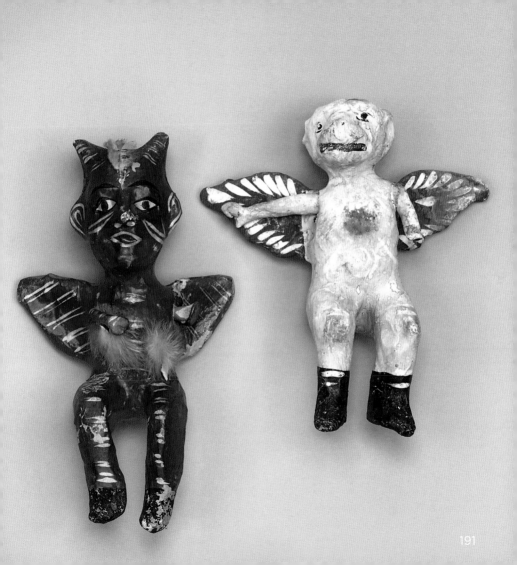

191

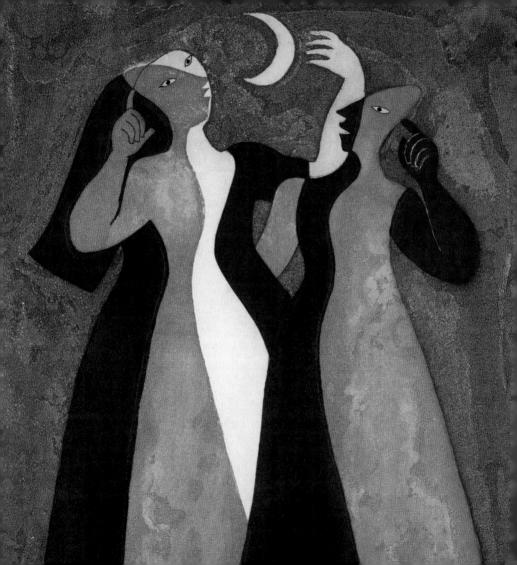

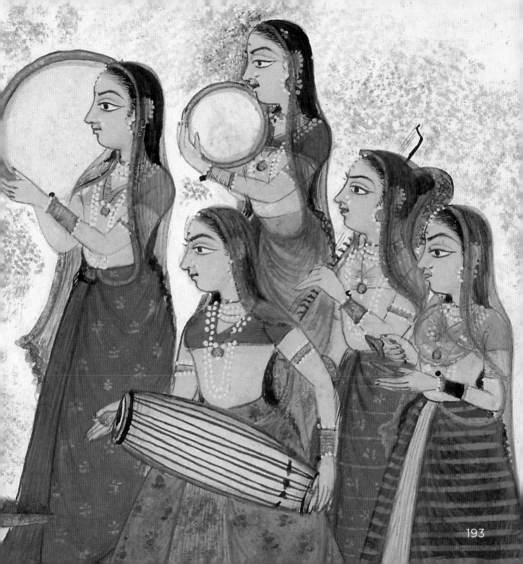

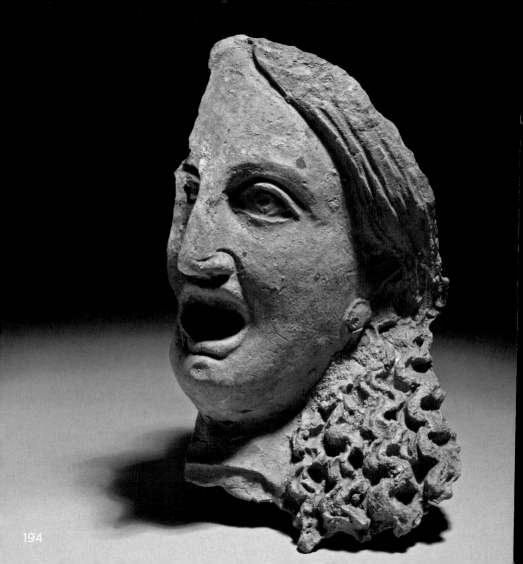

194

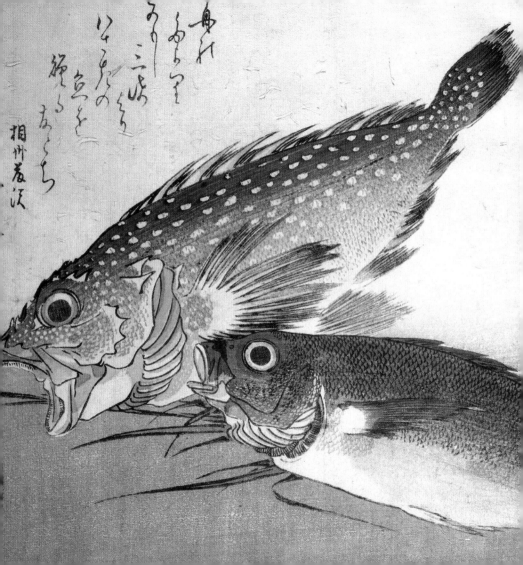

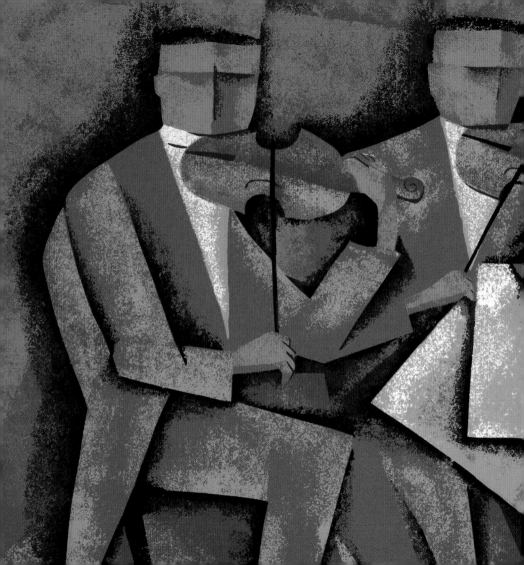

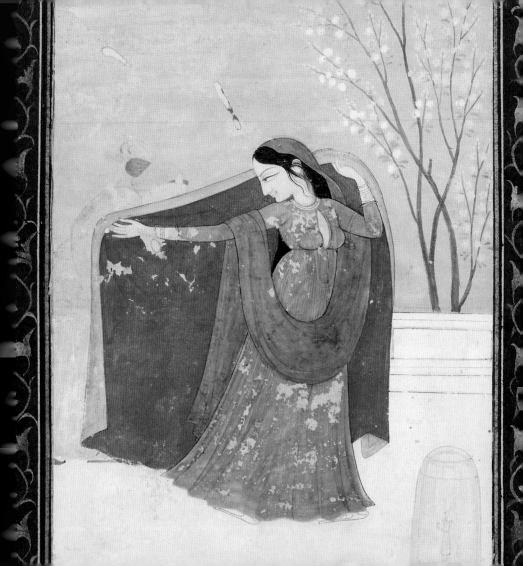

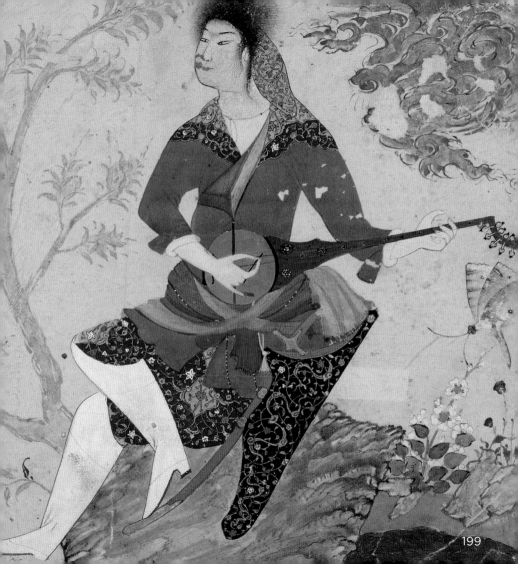

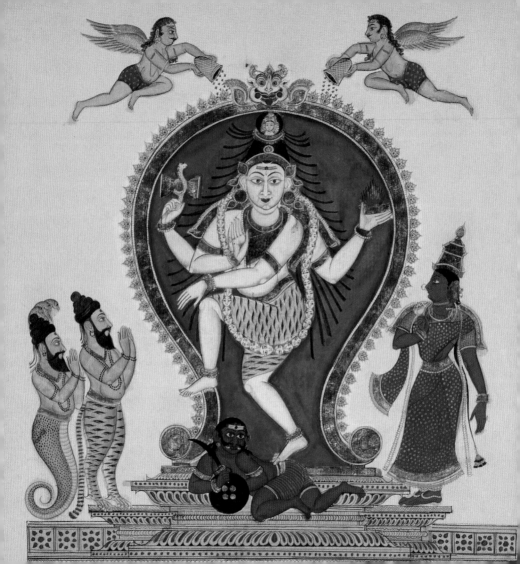

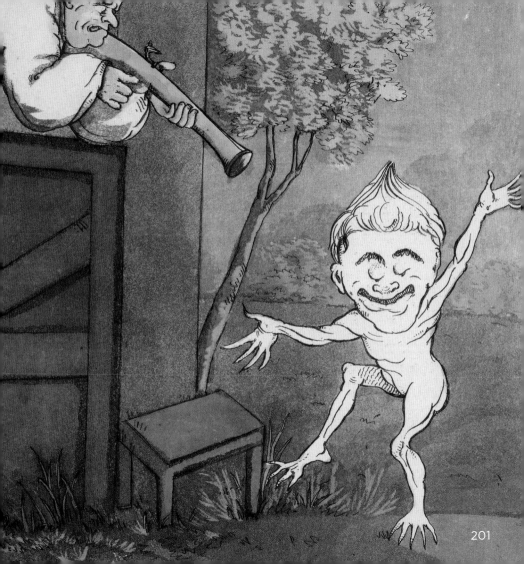

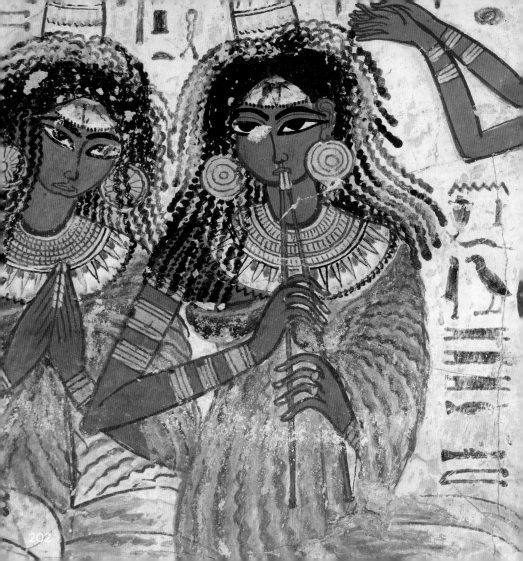

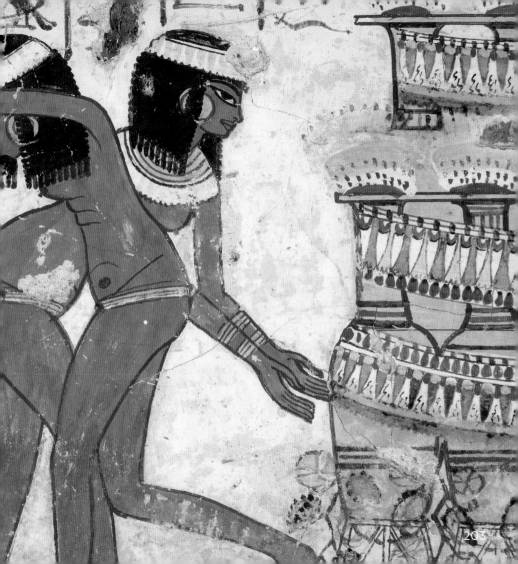

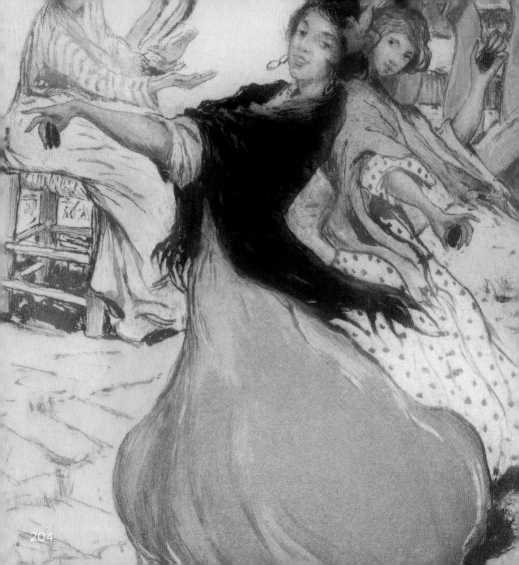

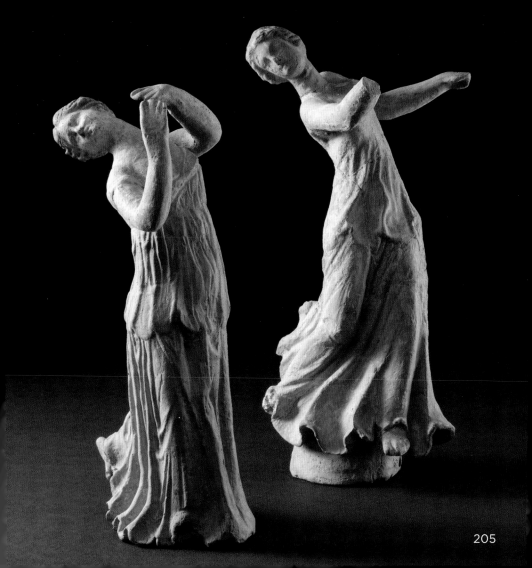

205

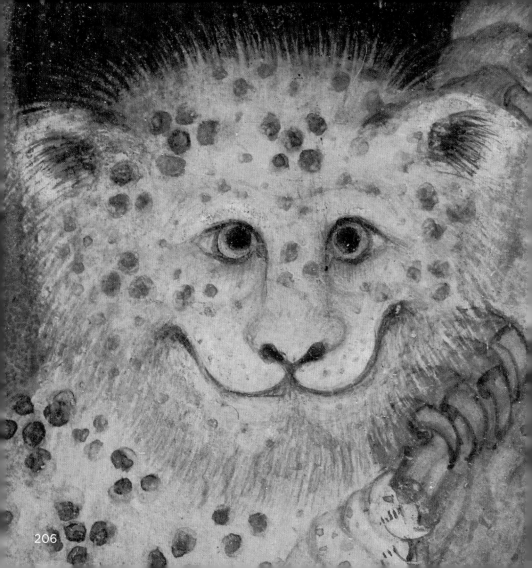

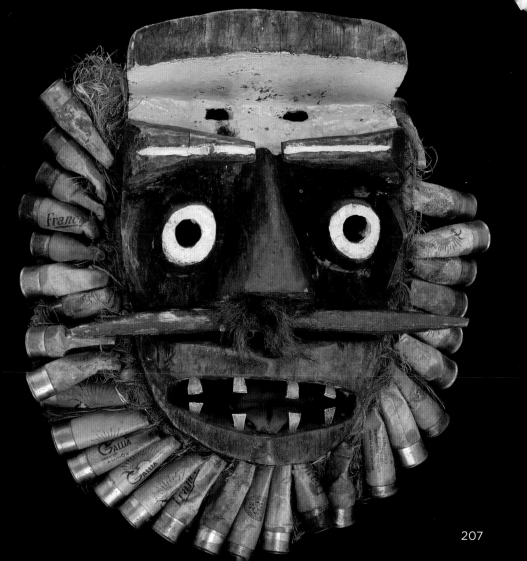

207

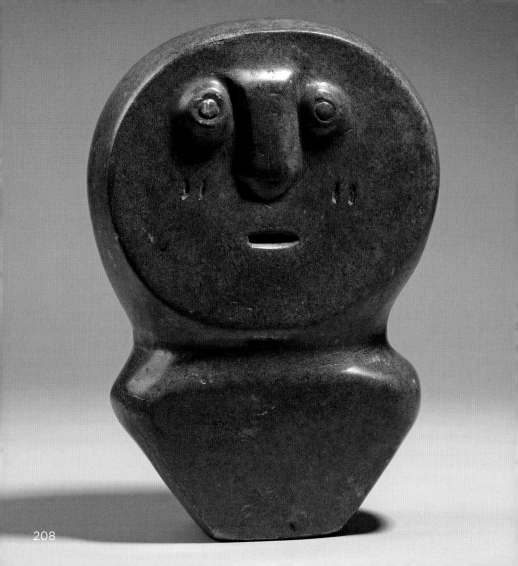

208

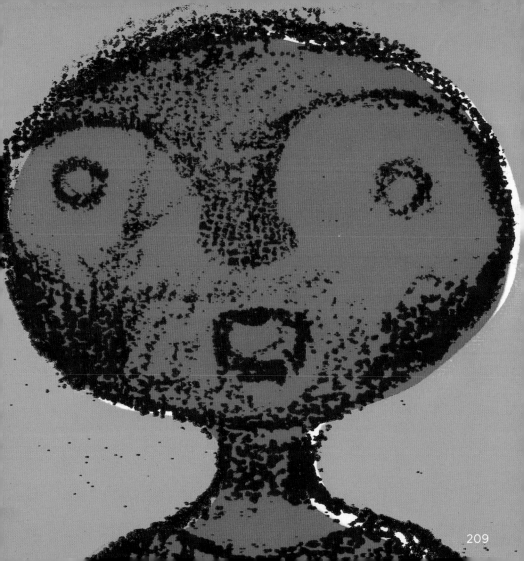

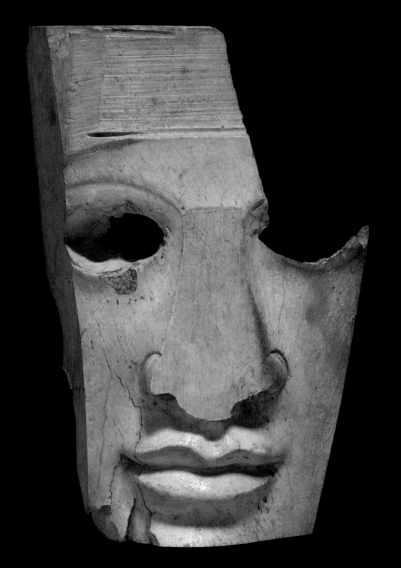

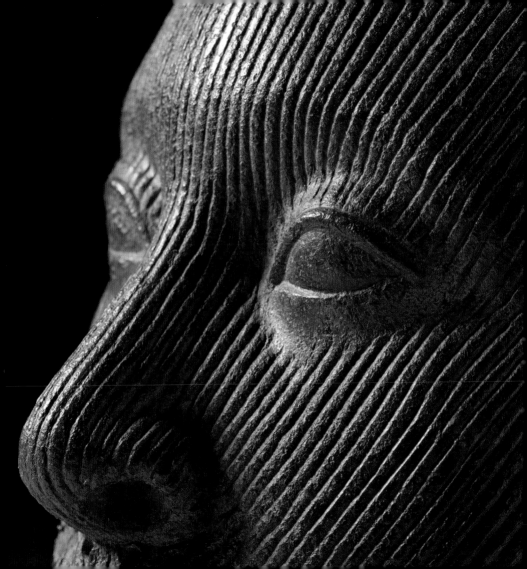

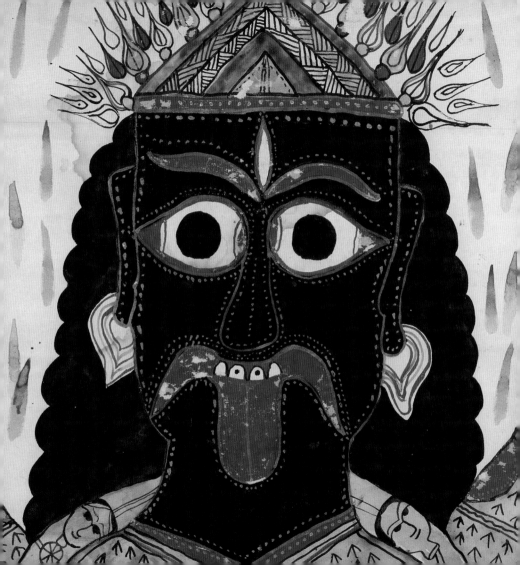

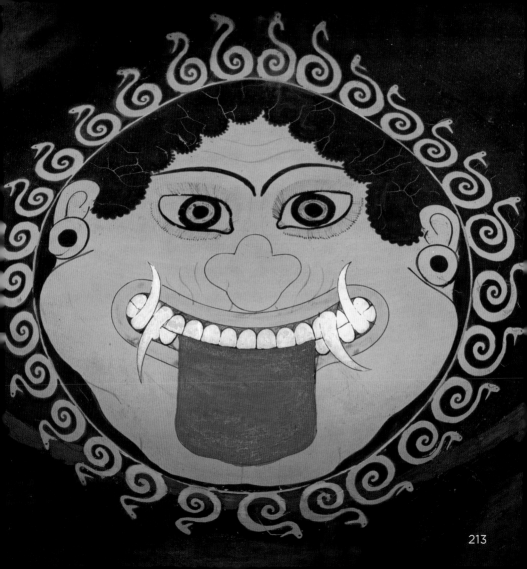

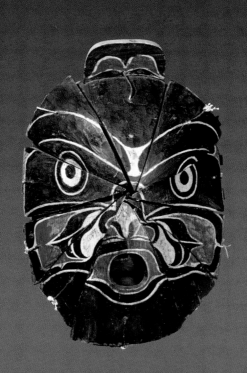

214

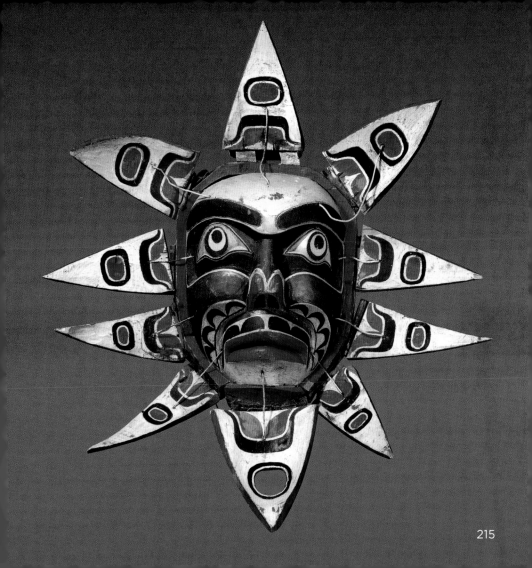

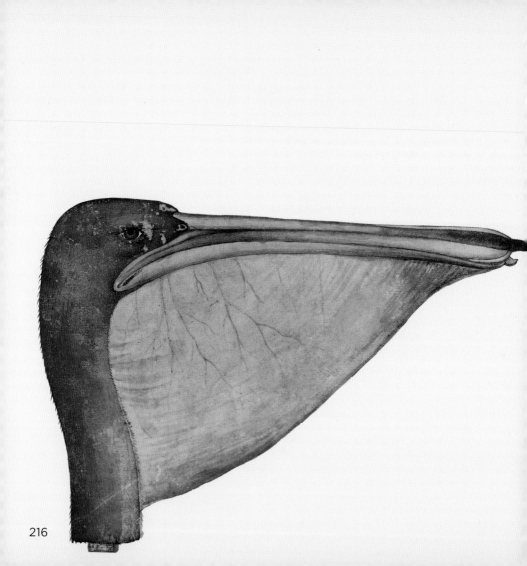

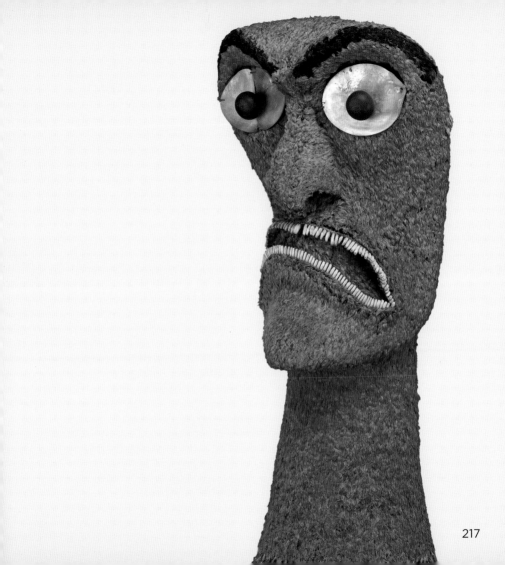

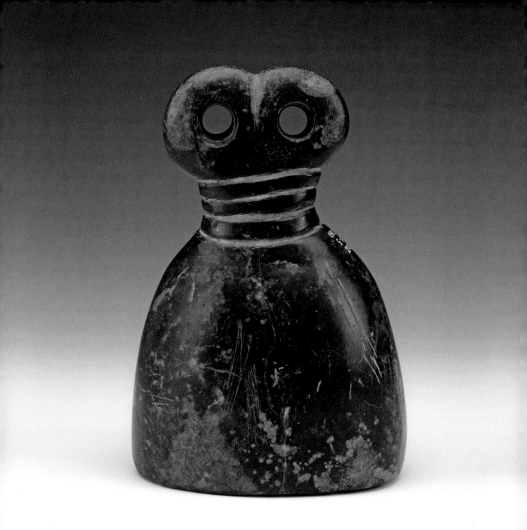

218

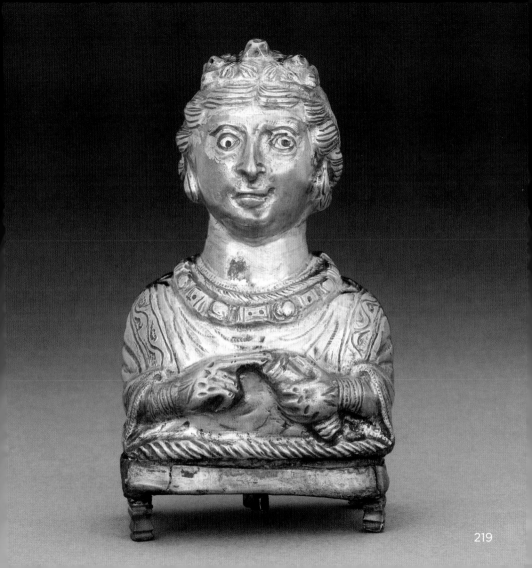

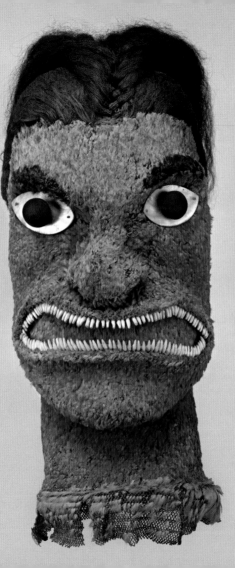

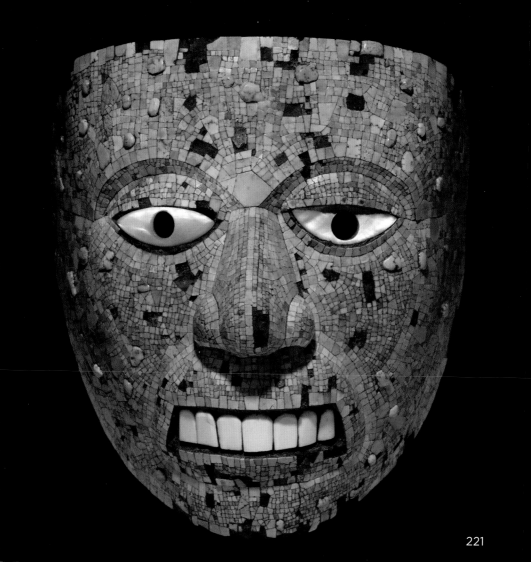

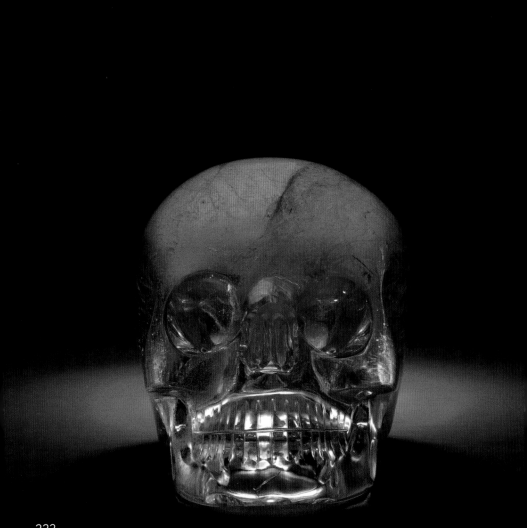

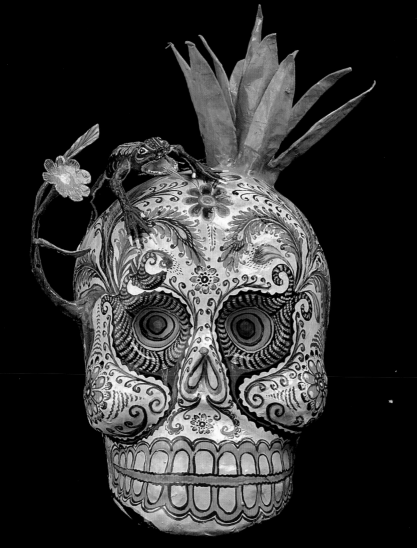

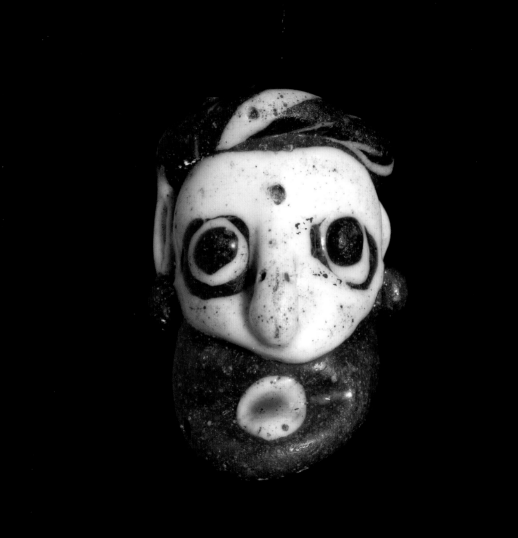

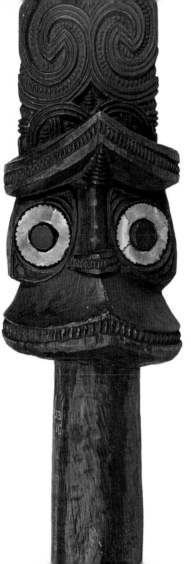

225

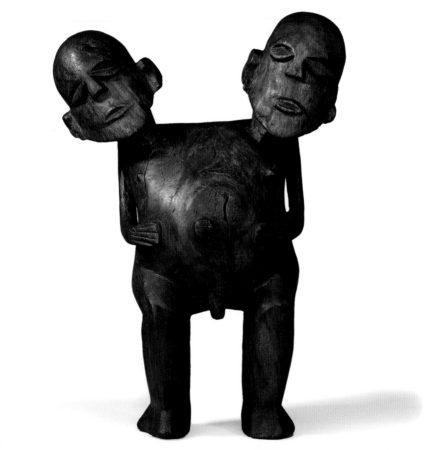

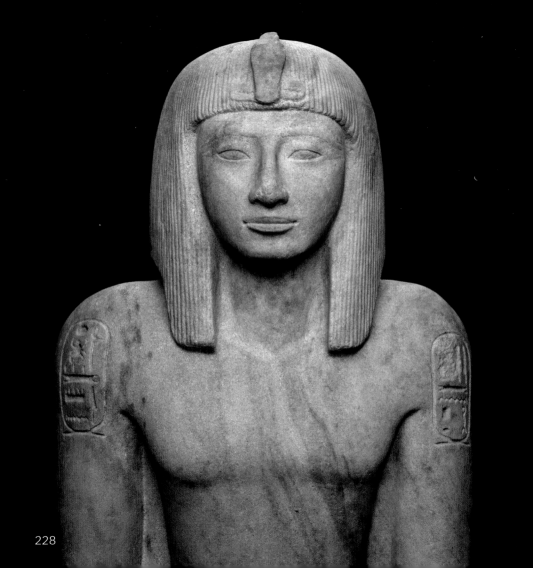

228

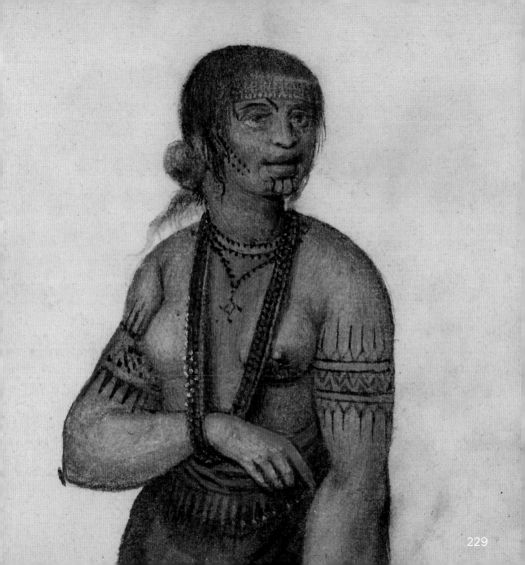

229

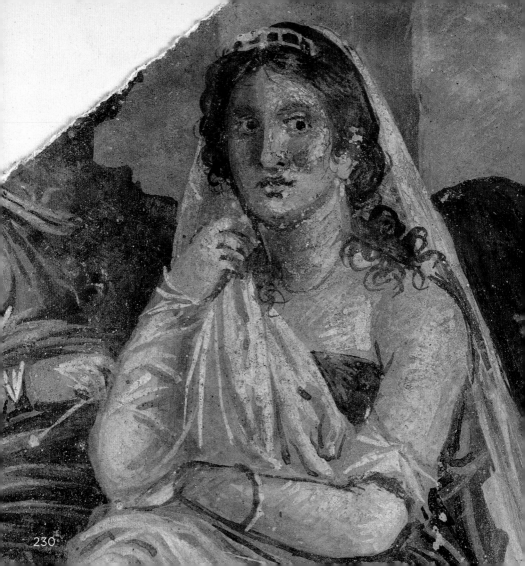

230

NOX

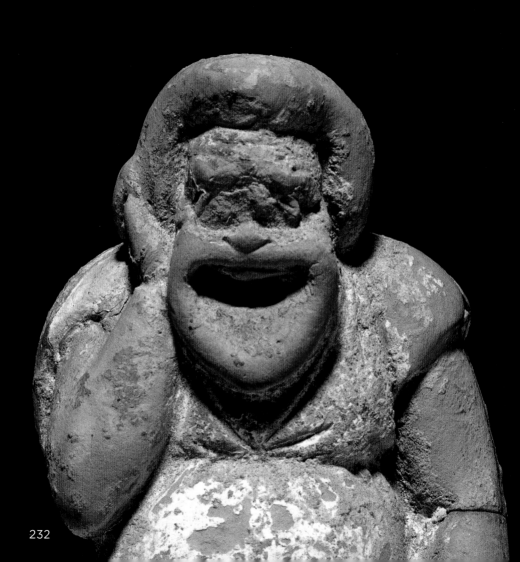

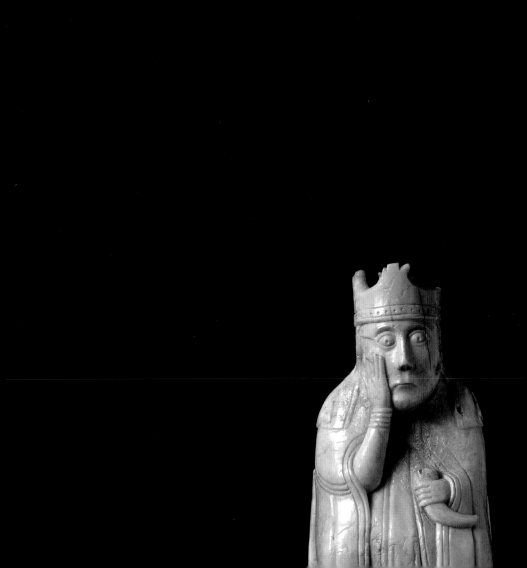

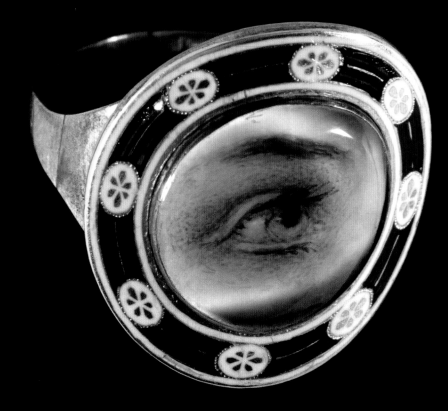

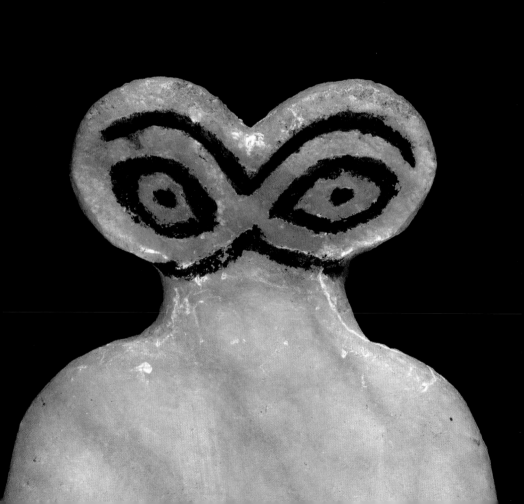

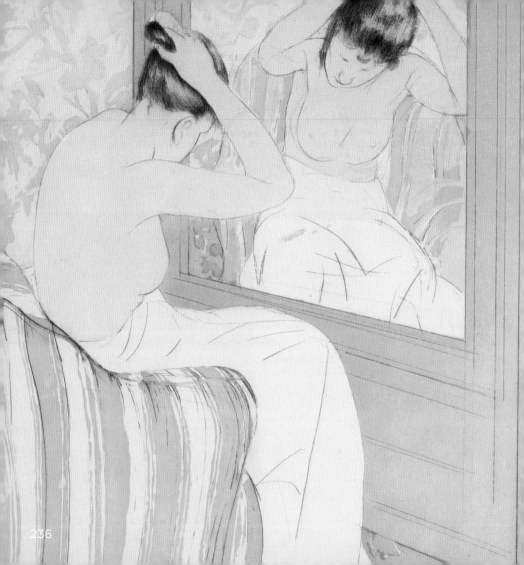

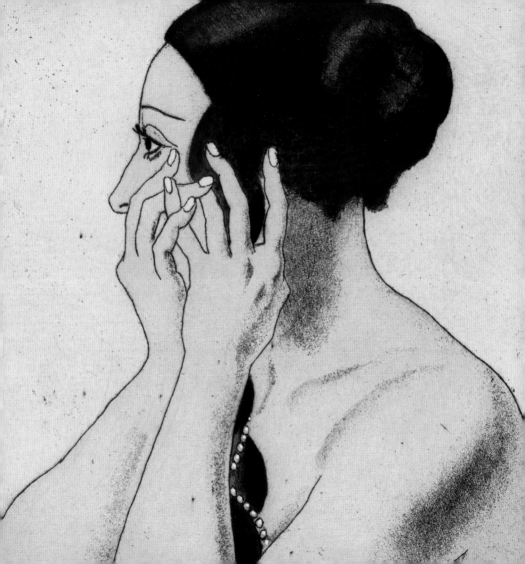

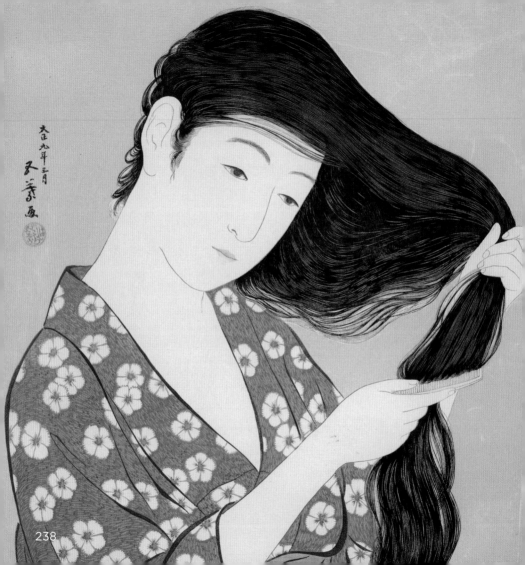

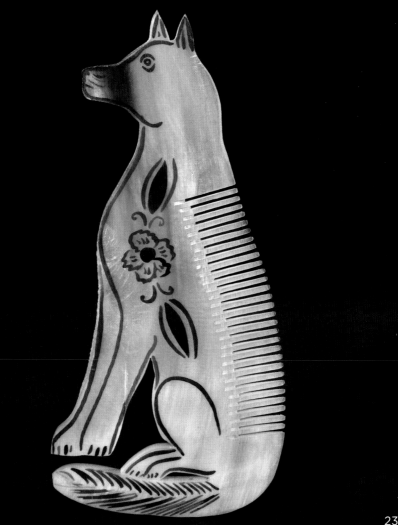

239

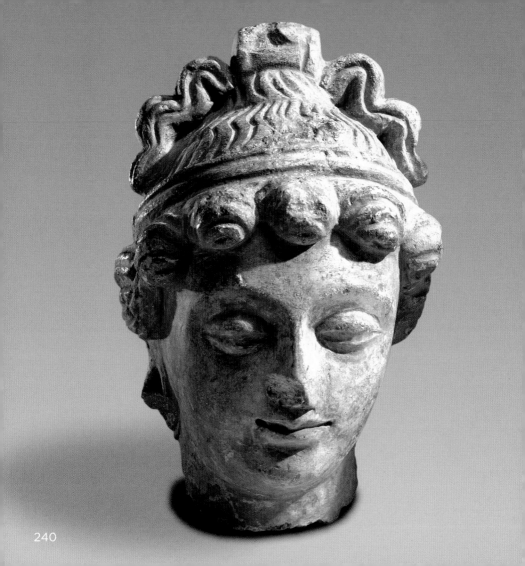
240

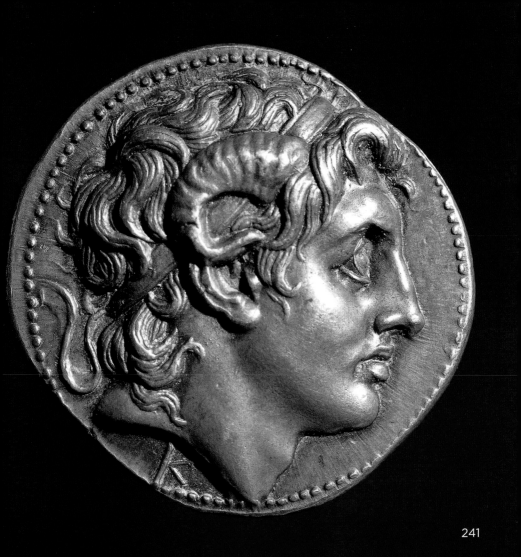

241

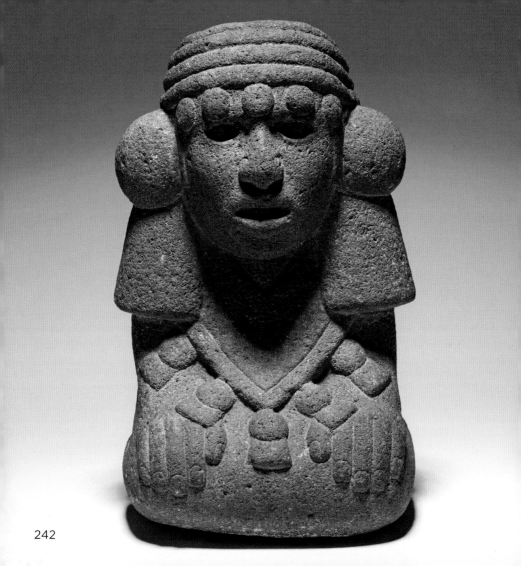

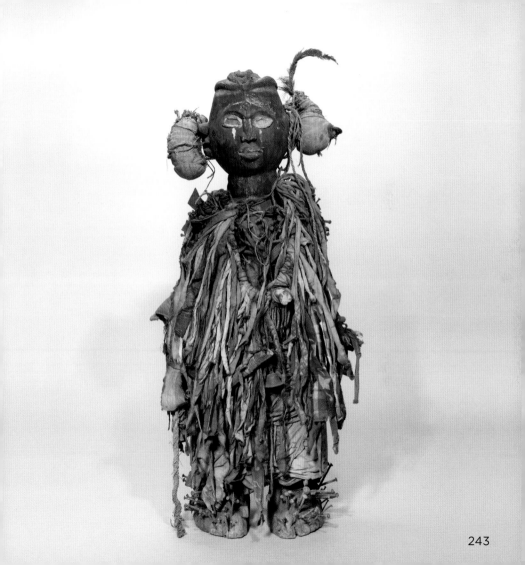

243

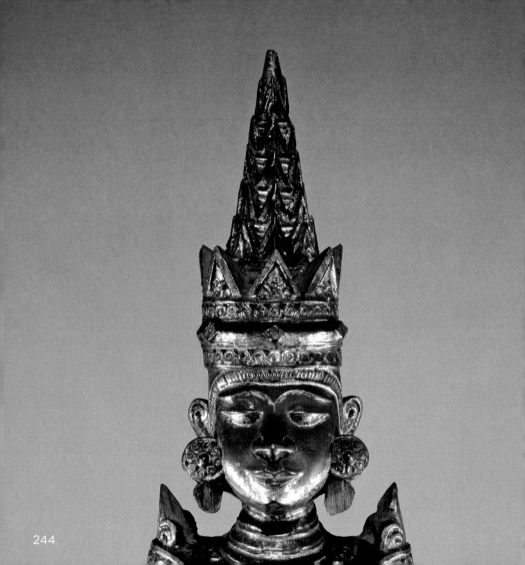

244

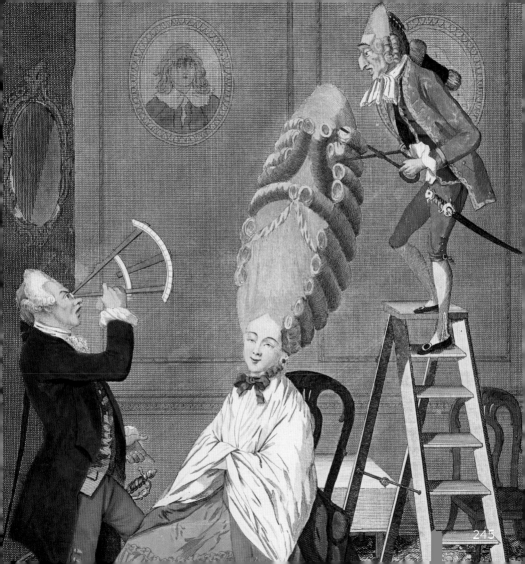

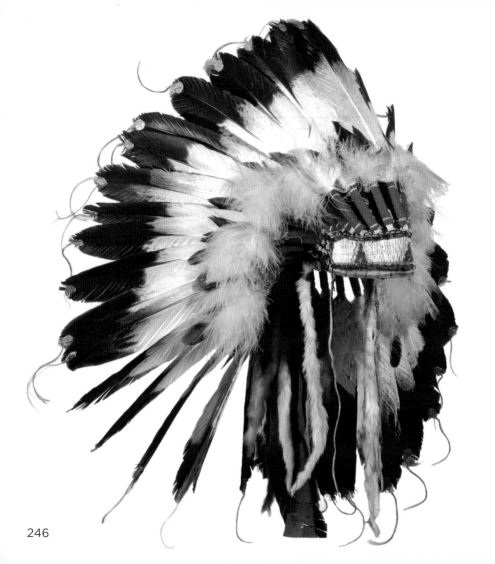

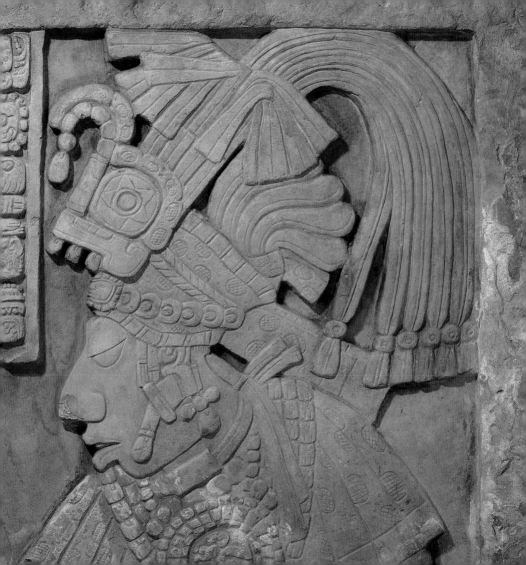

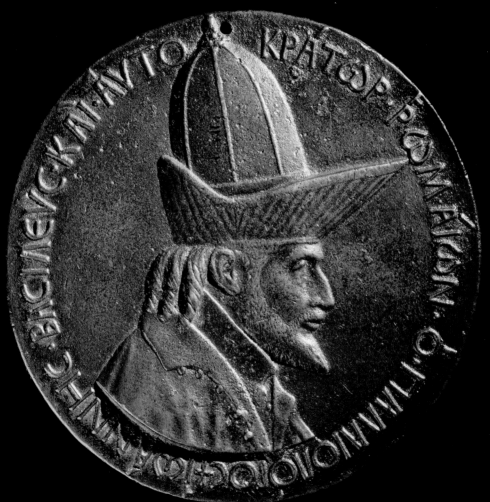

248

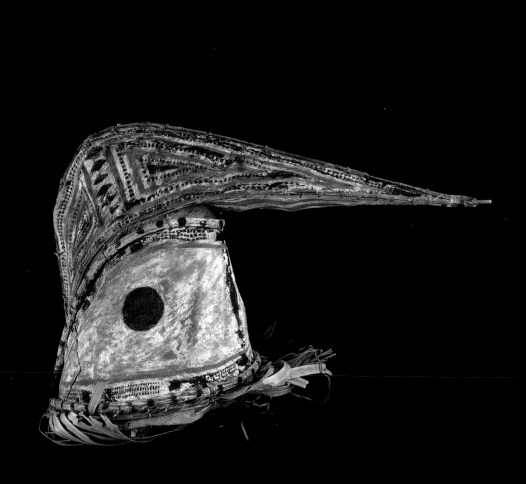

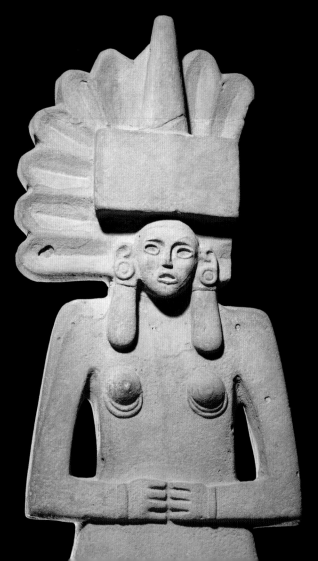

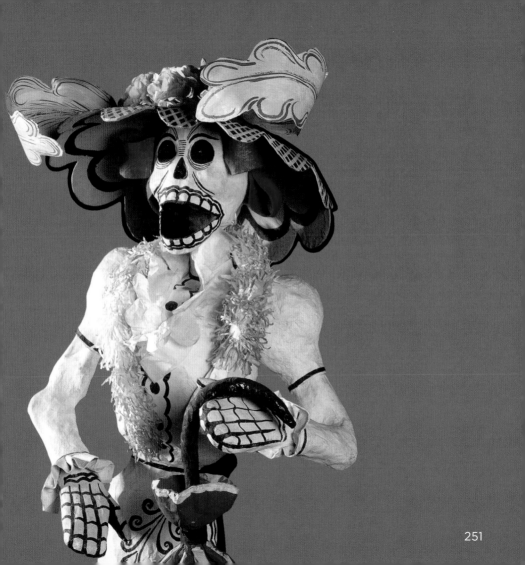

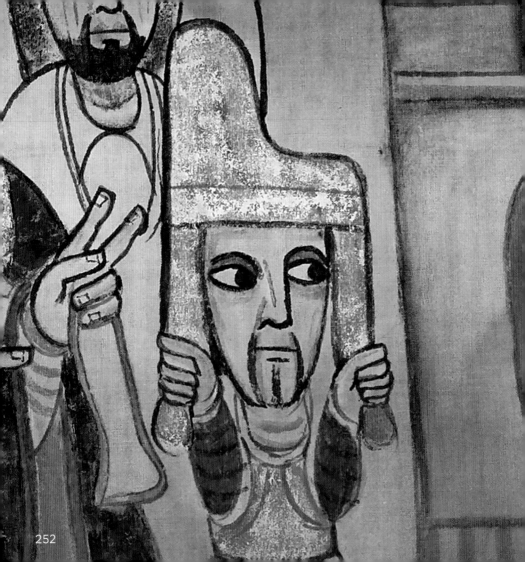

252

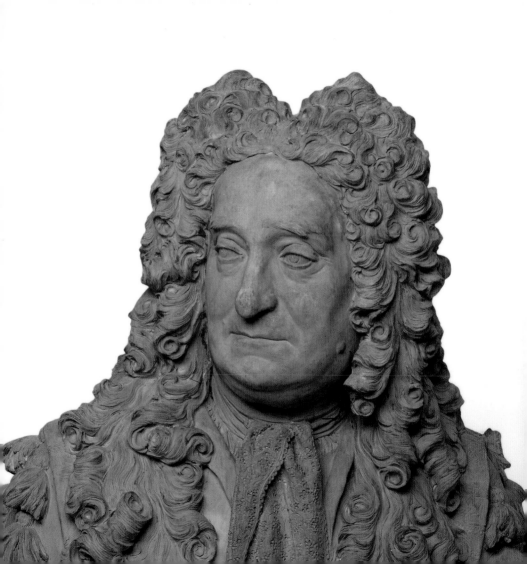

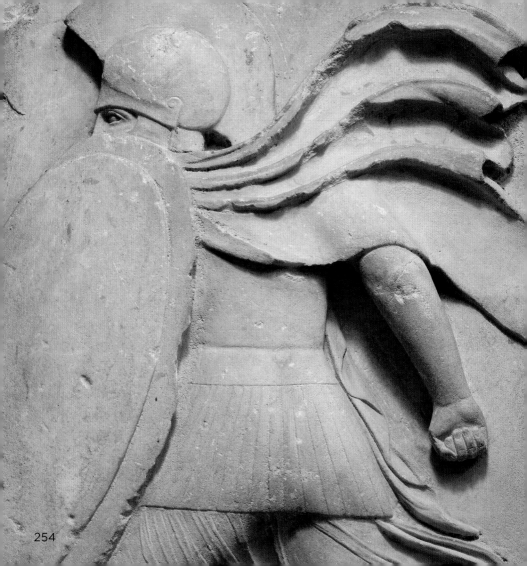

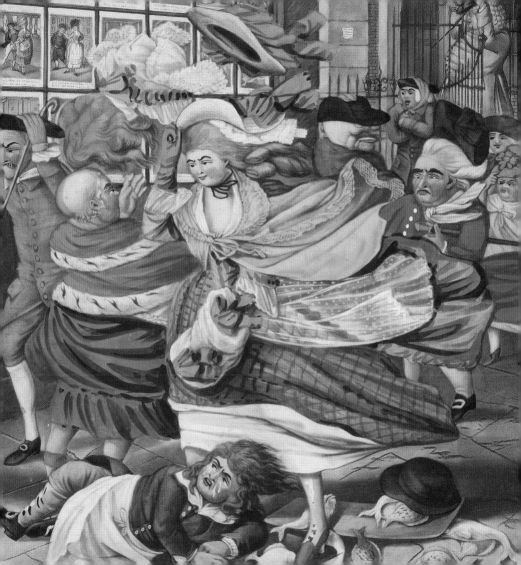

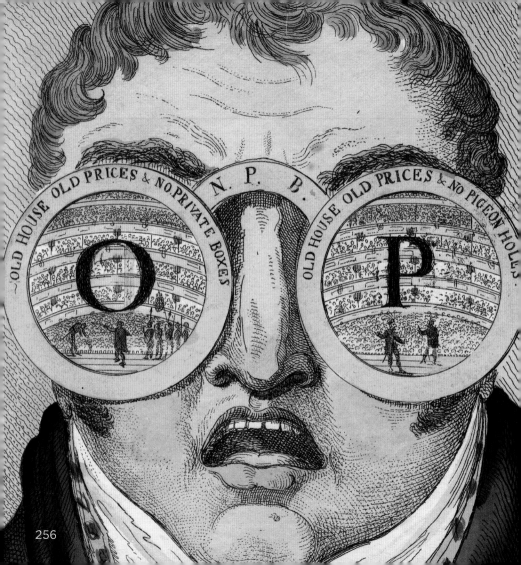

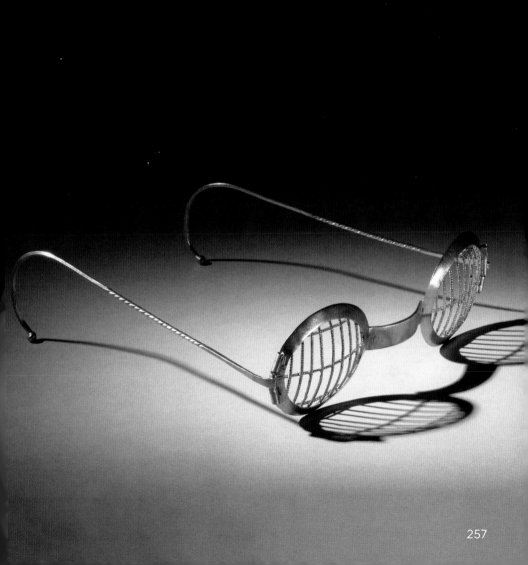

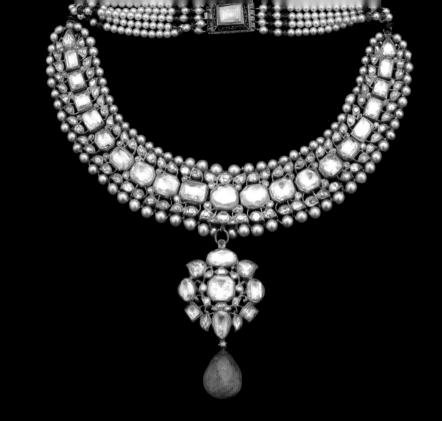

258

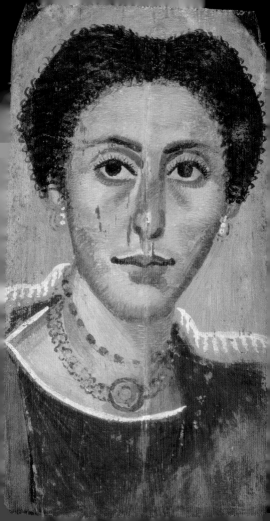

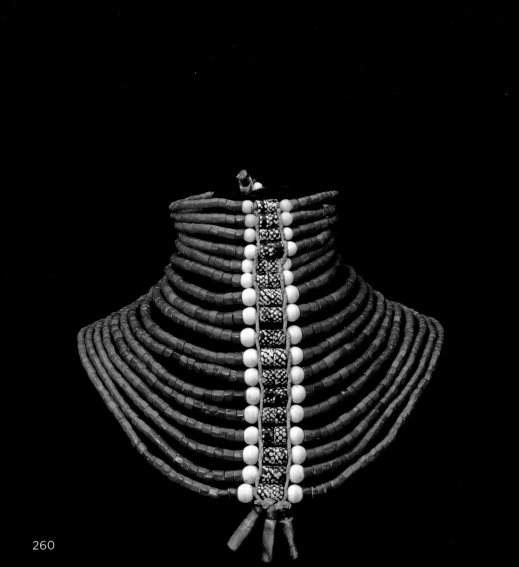

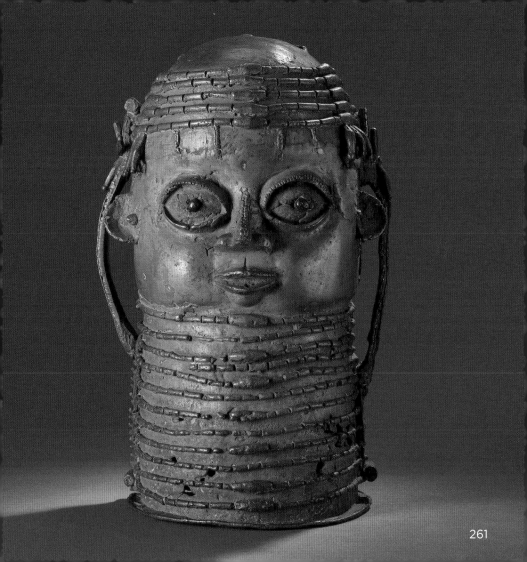

261

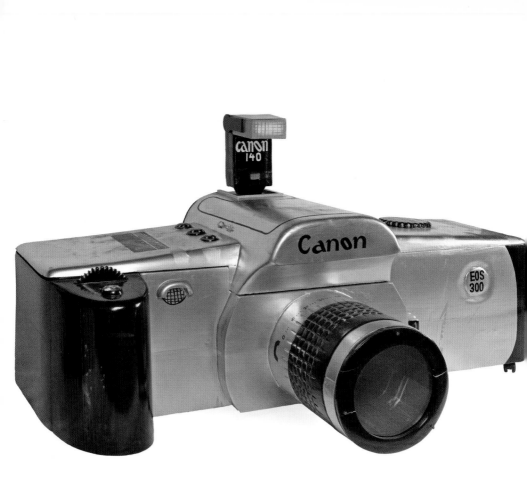

262

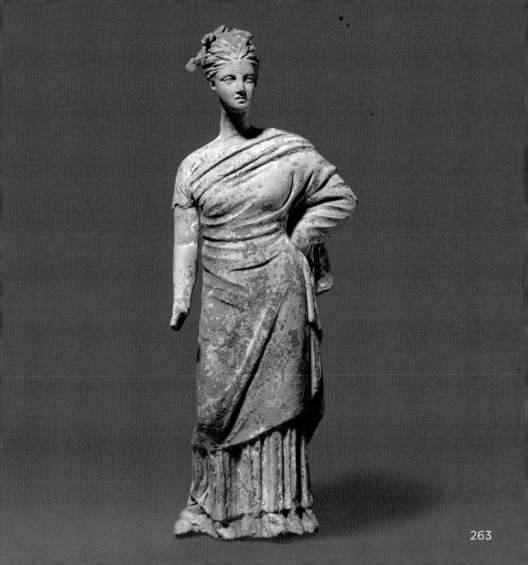

263

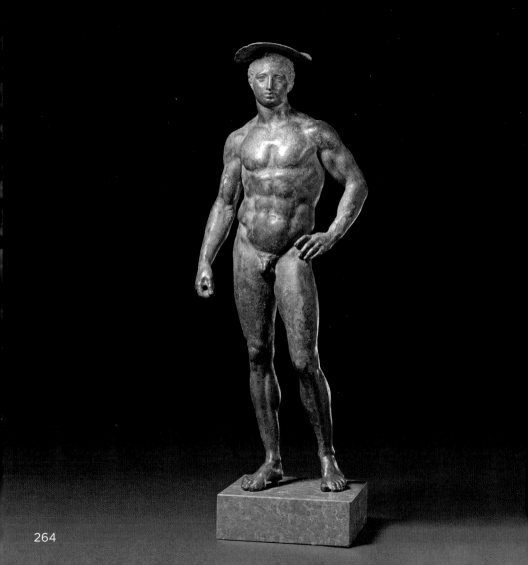

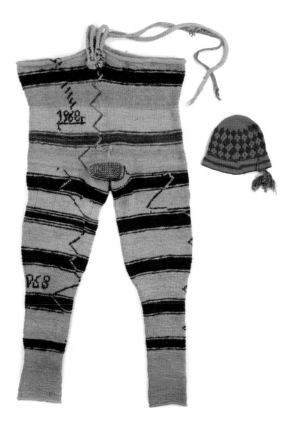

265

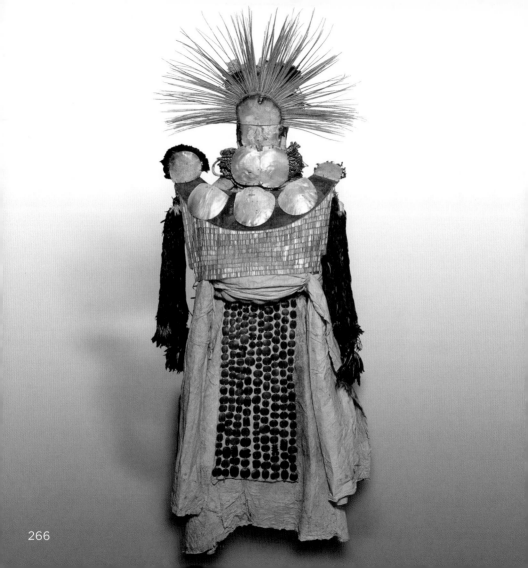

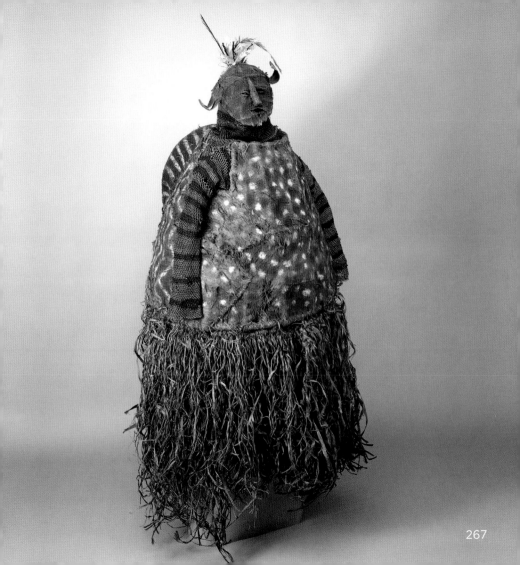

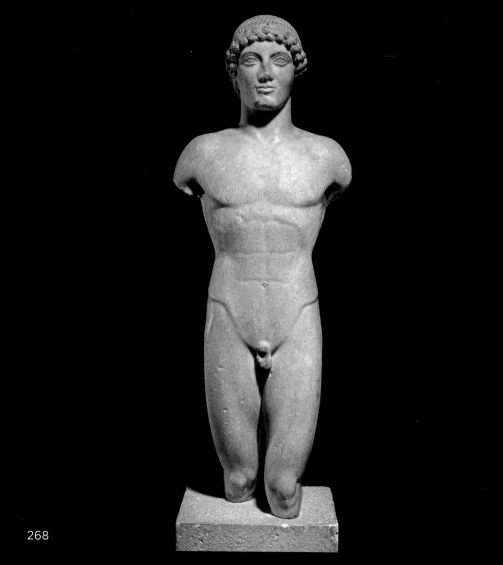

268

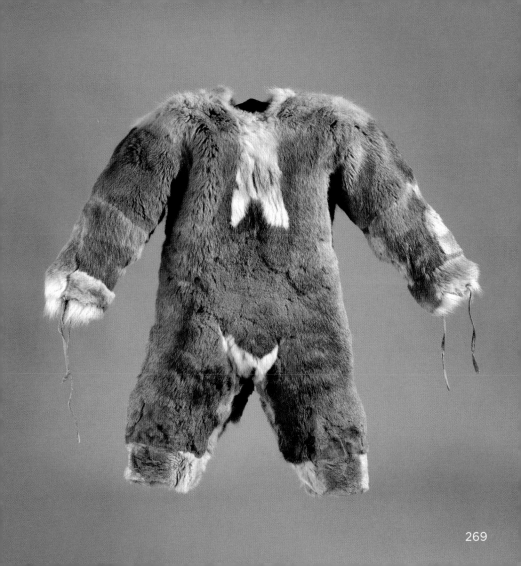

269

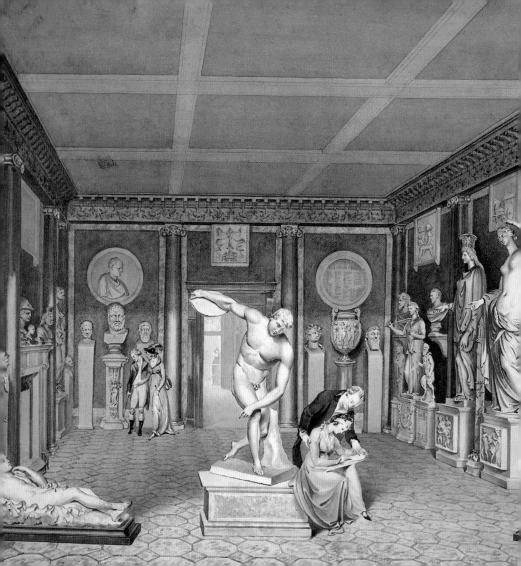

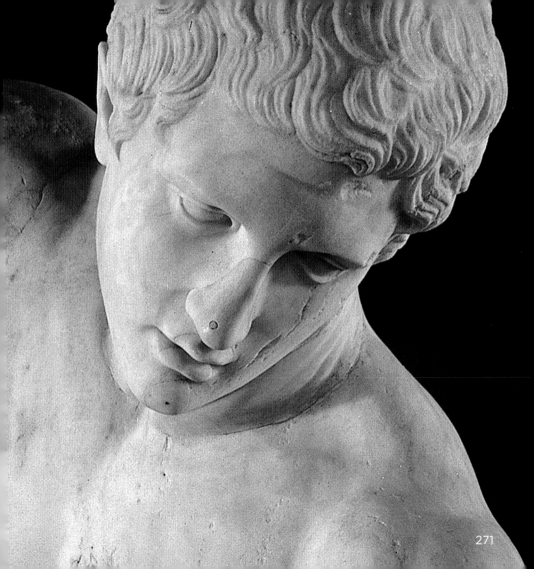

271

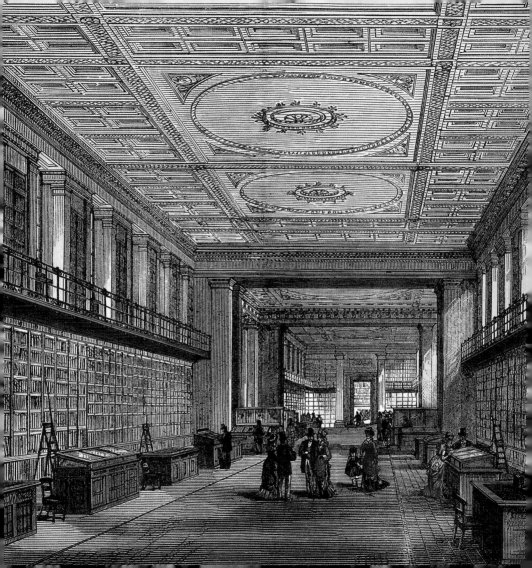

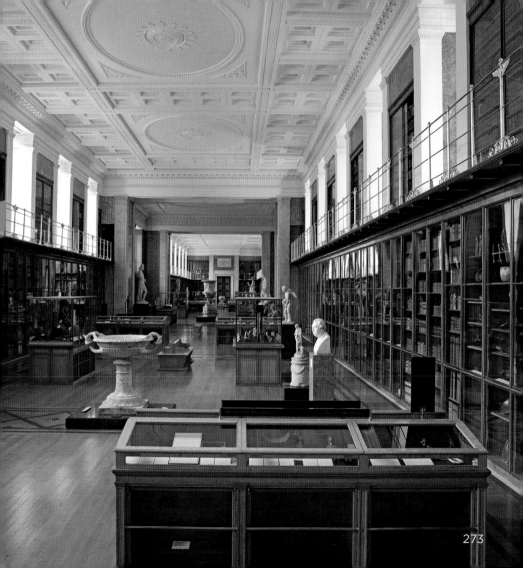

273

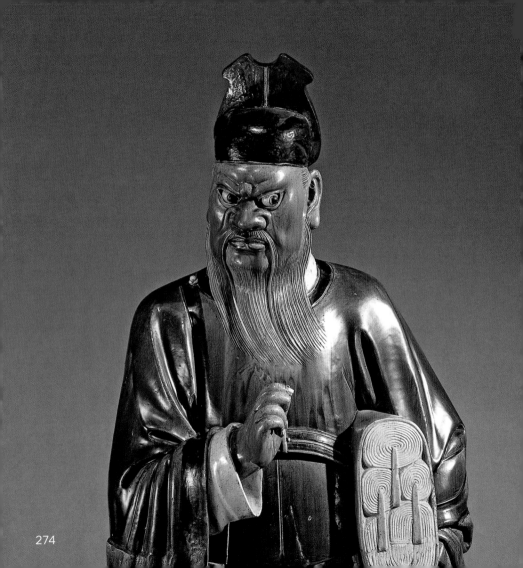

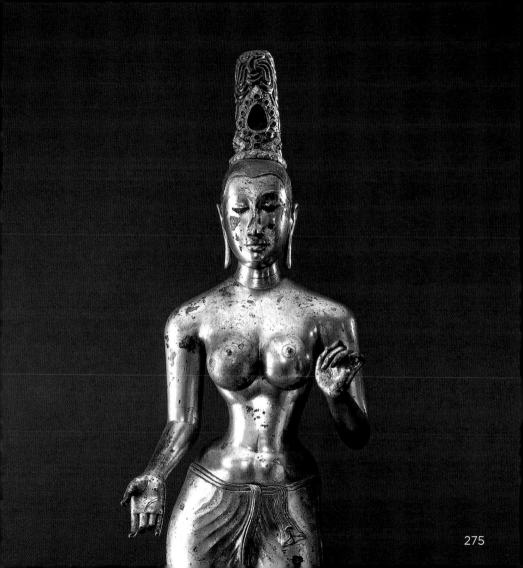

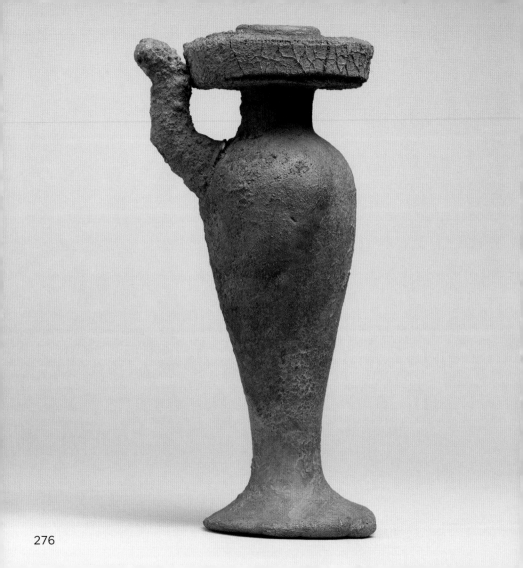

276

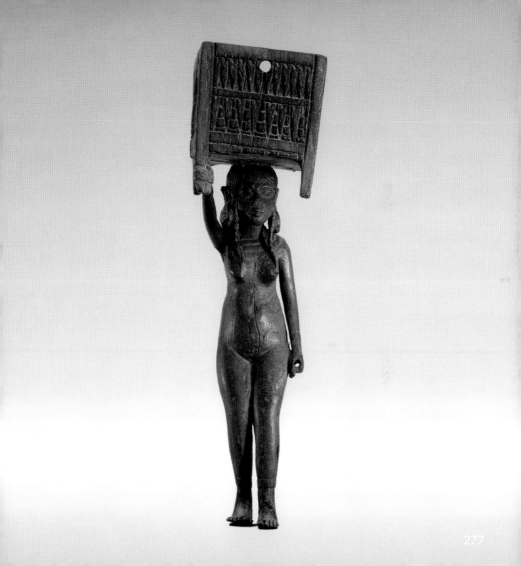

278

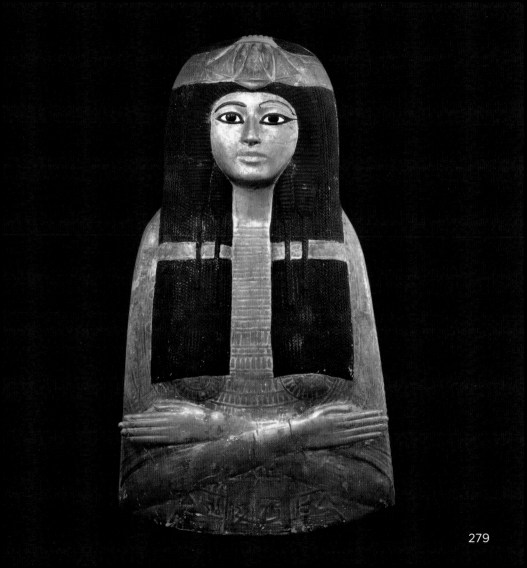

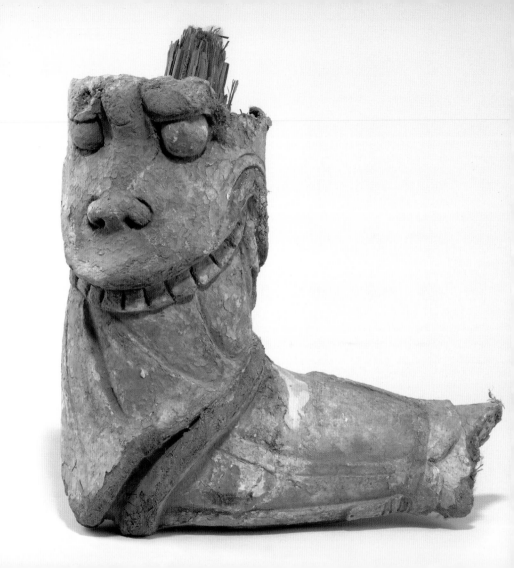

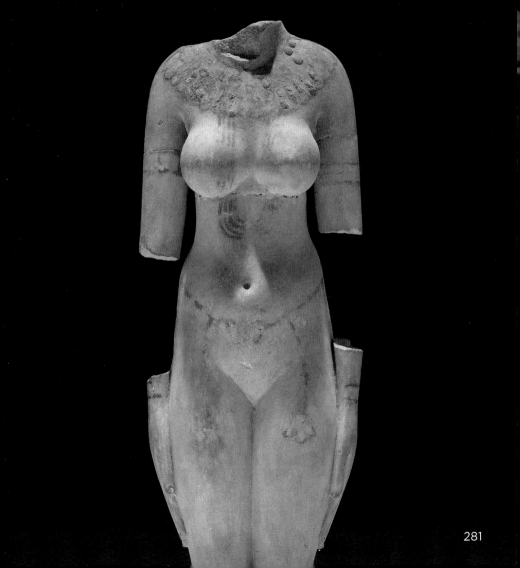

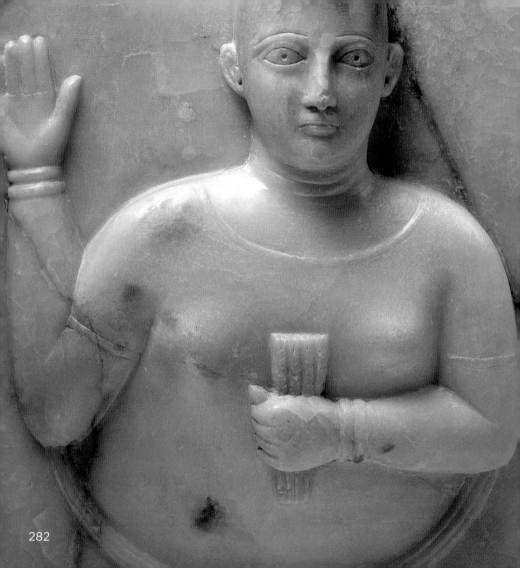

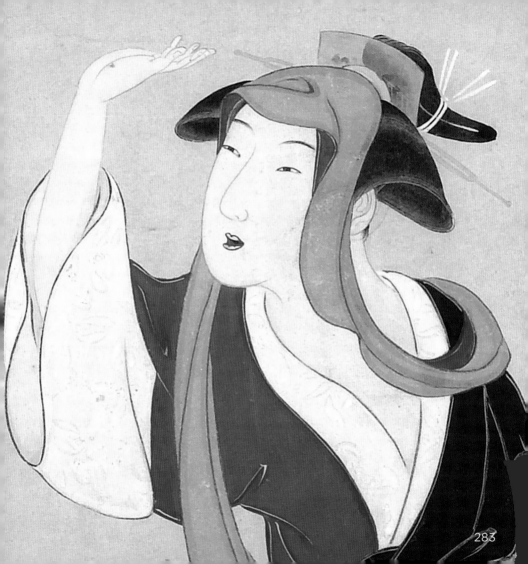

283

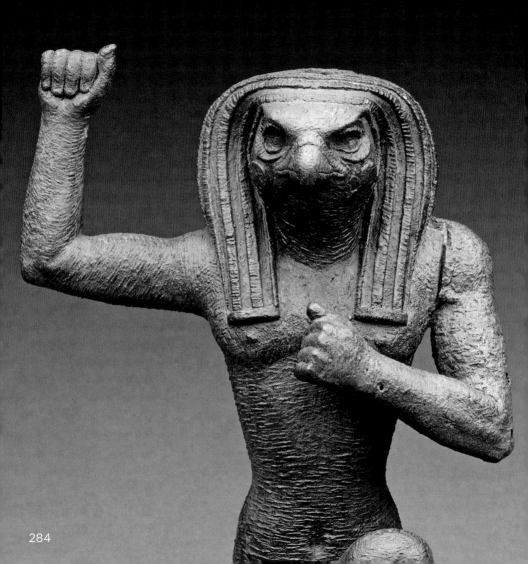

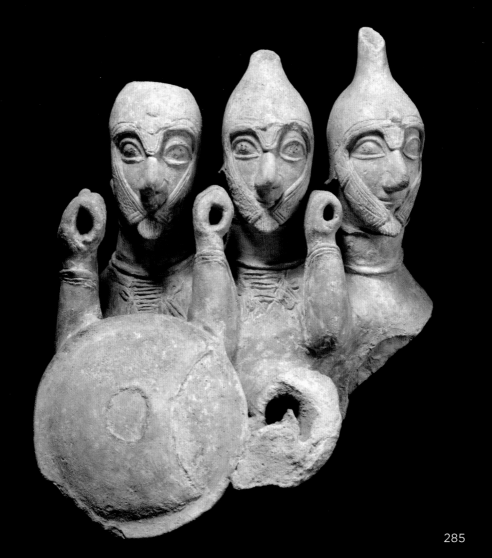

285

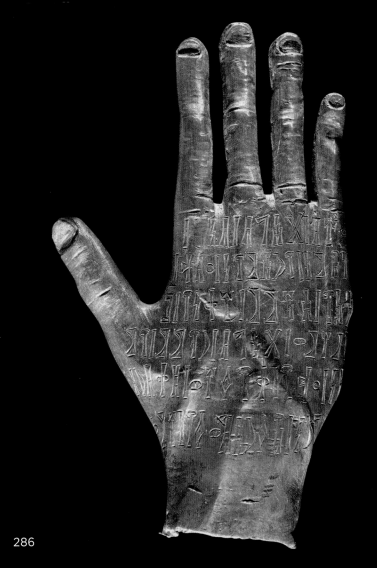

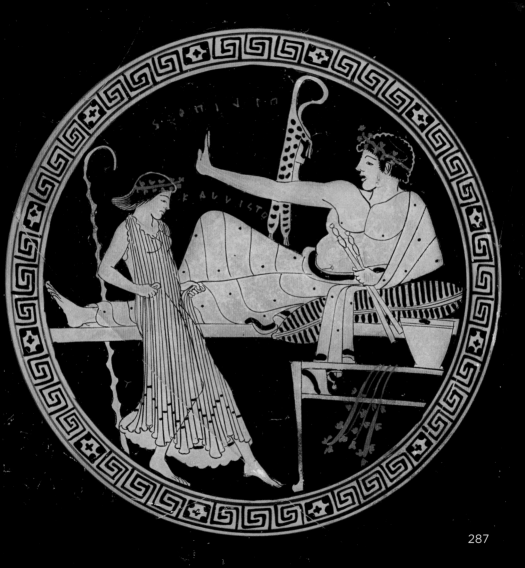

287

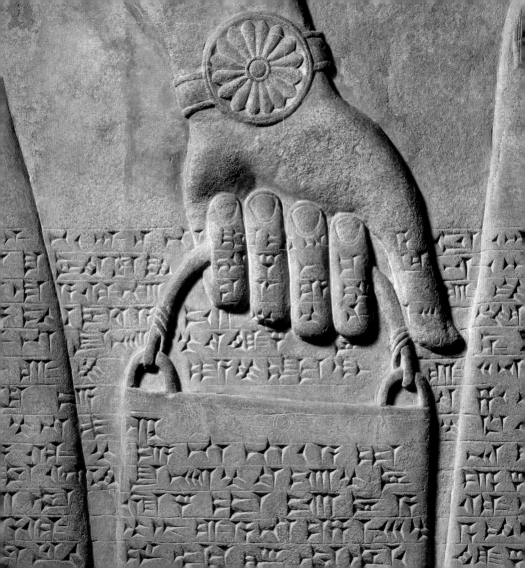

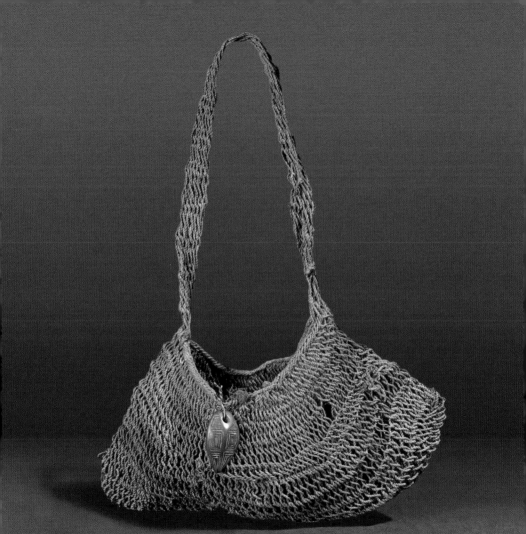

289

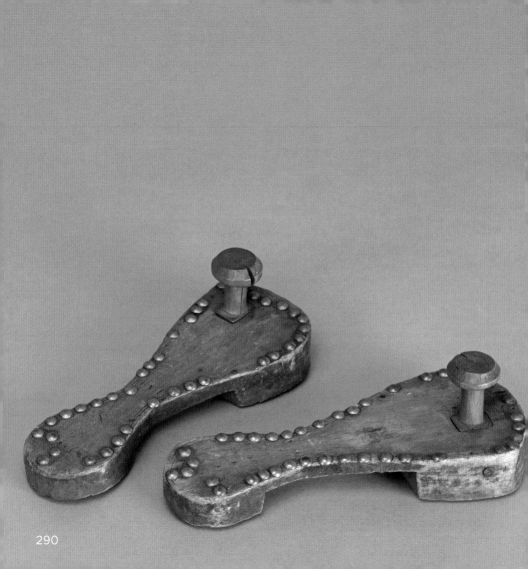

290

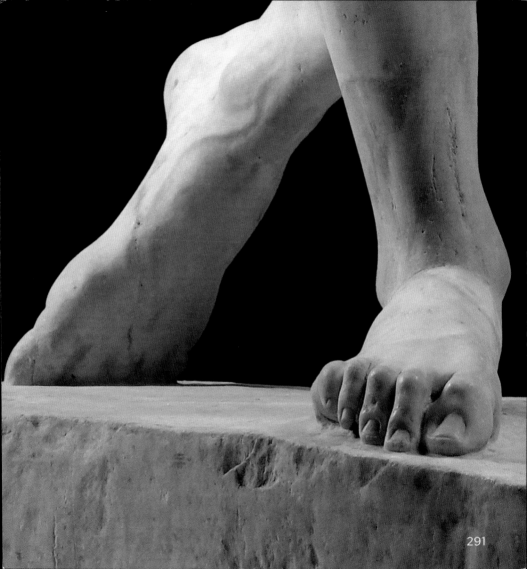

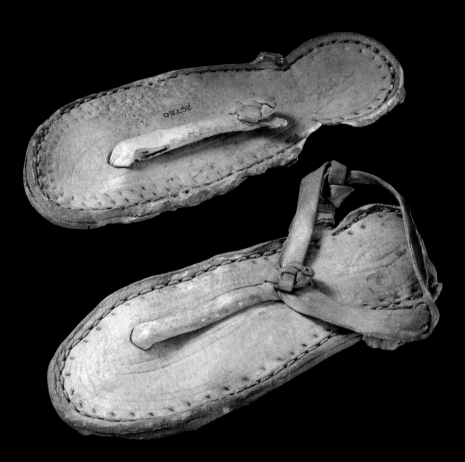

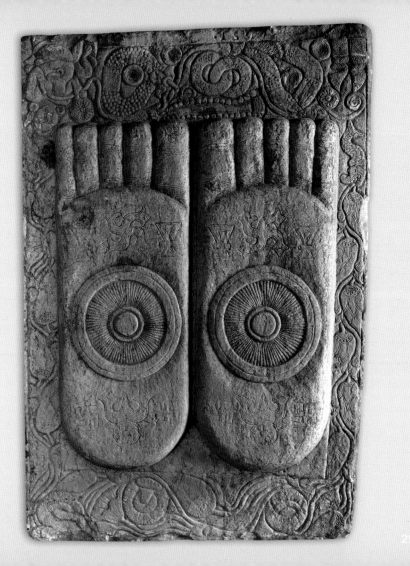

293

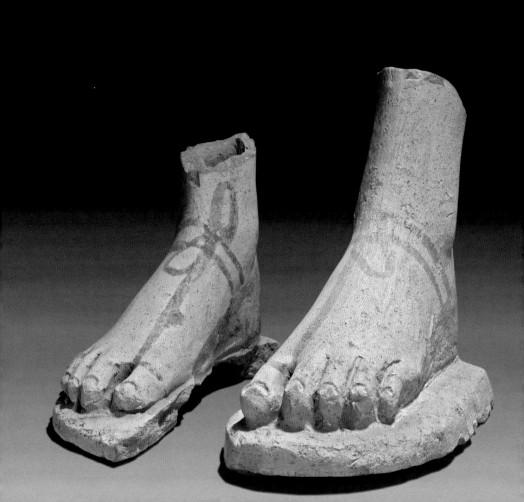

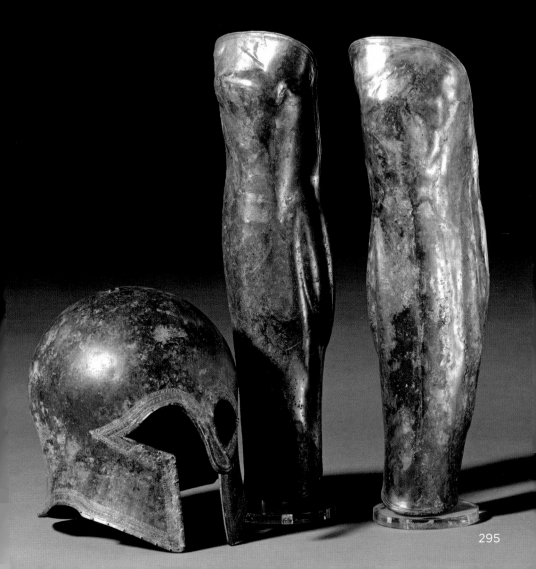

295

LIST OF ILLUSTRATIONS

Illustrations are © The Trustees of the British Museum
except where otherwise noted.

32 Ivory netsuke, rat with bean,
H. 3 cm, date unknown, Rantei,
Japan. Acquired between 1978 and
1984. Bequeathed by Anne Hull
Grundy. Asia HG.695

33 *Alice and the Cheshire Cat* (detail),
illustration for Lewis Carroll's *Alice in
Wonderland*, H. 13.6 cm, W. 10.1 cm,
1865, Sir John Tenniel, Britain.
PD 1913,0415.181.346

34 Alabaster wall panel relief showing
tribute bearers, 865–860 BC, Iraq.
ME 1850,1228.7

35 *Les Vieilles Histoires* (detail),
frontispiece for a series of song-
sheets, H. 33.8 cm, W. 54.1 cm, 1893,
Henri de Toulouse-Lautrec, France.
PD 1920,0522.42

36 Painted wooden toy horse on
wheels, L. 10.8 cm, Egypt, Roman
period. AES 1891,0430.54

37 *The Standard of Ur, War* (detail),
shell and limestone box, L. 49.5 cm,
2600 BC, Iraq. ME 1928,1010.3

38–39 Two-headed quadruped made
of wood and nails, c. 1850–1950,
Democratic Republic of Congo.
AOA Af1905,0525.6

40 Terracotta figure of a seated woman,
H. 54.6 cm, c. 625–600 BC, Italy.
GR 1873,0820.638

41 Brooch, silver enamelled head of
a dog, H. 4.8 cm, c. 1890, France.
Donated by Professor and Mrs Hull
Grundy. P&E 1978,1002.742

42–43 Snake-shaped breast-ornament
made of wood, turquoise and shell,
H. 20.5 cm, Mexico, Aztec. Christy
Collection. AOA Am1894,-.634

44 Polychrome tomb-painting rep-
resenting the pool in Nebamun's
garden (detail), H. 64 cm, W. 73 cm,
c. 1350 BC, Egypt. AES .37983

45 Crocodile from *The Gazi Scroll*,
painted paper mounted on
cotton, L. 13 m, c. 1800, India.
Asia 1955,1008,0.95

46 *The Codex Zouche-Nuttal* (detail),
painted deer-skin, H. 19 cm, W. 23.5
cm, 1200–1521, Mexico. Donated by
Ms Curzon. AOA Am1902,0308.1

47 Cloisonné enamel vase with a
domed cover, H. 62 cm, 1426–35,
China. Asia 1957,0501.1a & b

48 *Elefant*, 1965, etching, H. 39 cm, W. 49.1
cm, Friedrich Meckseper, Germany.
Donated by HM Treasury. © Friedrich
Meckseper PD 2007,7009.59

49 Album of South Indian paintings
on paper, c. 1820, India. Funded by
the Brooke Sewell Permanent Fund.
Asia 1992,0410,0.1

50 Cloak made of flax, peacock feathers
and wool (detail), date unknown, New
Zealand, Maori. AOA Oc1982,Q.733

51 *Two Peafowl*, (detail), colour wood-
cut, H. 26.1 cm, W. 41.6 cm,
1912, William Giles, Britain.
Bequeathed by Campbell Dodgson.
PD 1949,0411.2128

52 Jade pendant, H. 7.4 cm, date
unknown, New Zealand, Maori.
Donated by Rev R.L. Martyn-
Linnington. AOA Oc1922,0606.1

53 Silver coin of Athena, 450–406 BC,
Greece. Bequeathed by Richard
Payne Knight. CM Rpk,p032D.11.Ath

54 Red sandstone figure of Tirtham-
kara, H. 34.3 cm, 3rd century, India.
Asia 1901,1224.5

55 Printed cotton hanging (detail),
H. 46.9 cm, W. 24.3 cm, 1980–9,
India. Asia 1989,0201,0.72

56 Stone block with carving of a
bird-headed figure, date unknown,
Polynesia. Donated by W. Scoresby
Routledge. AOA Oc1920,0506.1

57 Wooden rattle carved in the form of
a bird, L. 40 cm, 1980–3, Pat Amos,
Canada. AOA Am1984,04.4

58 Bamboo kite in the form of a
butterfly, H. 182.5 cm, 1990s,
Indonesia. Asia 1997,41.17

59 *Papillons de France* (detail), print, H.
26.6 cm, W. 18.8 cm, 1806–62, Charles
Philipon, France. PD 1982,U.1398

60–61 Ivory netsukes, date unknown,
Japan. Acquired between 1978 and
1984. Donated by Professor and Mrs
Hull Grundy. Asia HG.236, HG.29 &
HG.221

62–63 *Oxen Ploughing*, etching,
H. 28.5 cm, W. 61.5 cm, c. 1888–1911,
Pieter Dupont, Dutch. Donated by
the Contemporary Art Society.
PD 1922,0708.46

64 Green glazed figure of a
hippopotamus, L. 20.4 cm,
Egypt. AES 1882,1127.121

65 *Head of a Walrus* (detail), pen
and ink with watercolour, H. 21.1 cm,
W. 31.2 cm, 1521, Albrecht Durer,
Germany. Bequeathed by Sir
Hans Sloane. PD SL,5261.167

66 *View of Houses in Naples* (detail),
oil on paper, 1782, Thomas Jones,
Britain. Funded by the H.L. Florence
Fund. PD 1954,1009.12

67 Design created on bark-cloth
showing the impact of HIV/AIDS
(detail), L. 101 cm, W. 31.2 cm, 2008,
Betty Ssetumba, Uganda. © Betty
Ssetumba, Nalumunye Women's
Group, Wakiso District, Kampala,
Uganda AOA 2008,2021.6

68 Limestone incense-burner, H. 23 cm,
1st century, Yemen. ME 1960,1011.1

69 Woodcut print showing the Doge of
Venice in a long procession (detail),
H. 49.3 cm, W. 117 cm, c. 1500,
Anonymous, Italy. PD 1866,0714.48

70 Study for *Semenal Sequences*, the head of Princess Diana seen through the spattered window of a car, acrylic on paper, H. 57 cm, W. 72 cm, 1995–6, Stuart Brisley, Britain. © Reproduced with permission of the artist PD 2008,7022.5

71 Woodblock print showing a young woman seated by a window, 1724–70, Suzuki Harunobu, Japan. Asia 1930,0510,0.3

72 *The Auxiliary Postman* (detail), a Valentine's Day card, photorelief print, H. 30.2 cm, W. 23 cm, 1874, Walter Crane, Britain. Donated by Edmund William Evans. PD 1933,0728.1

73 *The Warren Cup* (detail), silver, stemmed drinking-cup, H. 11cm, 50–70 AD, Levant. Funded by the Heritage Lottery Fund, The Art Fund, the British Museum Friends and the Caryatid Fund. GR 1999,0426.1

74 Tapestry representation of two erotes in a boat (detail), L. 112 cm, W. 90 cm, 4th century, Egypt. AES 1889,0511.1

75 *A Milk Sop* (detail), hand-coloured etching, H. 34 cm, W. 24 cm, 1811, Thomas Rowlandson, Britain. PD 1872,1012.4982

76 Ivory panel showing an amorous couple, 17th century, India. Asia 1878,1101.334

77 *Paolo and Francesca* (detail), graphite on paper, H. 22.6 cm, W. 16.7 cm, 1855, Dante Gabriel Rossetti, Britain. PD 1981,1107.17

78 Drawing of a mother and child, *c.* 1750, India. Bequeathed by Percival Chater Manuk and Miss G.M. Coles, funded by The Art Fund. Asia 1949,1008.0.23

79 Terracotta female figure holding an infant, H. 19.2 cm, 1450–1200 BC, Cyprus. Bequeathed by Miss Emma Tourner Turner. GR 1897,0401.1087

80 Stone eye-idol, L. 5 cm, 3300–3000 BC, Syria. ME 1939,0208.111

81 Woodblock print of a mother and child under a mosquito net (detail), 1754–1806, Kitagawa Utamaro, Japan. Asia 1906,1220,0.340

82 Girl seated at a table (detail), wood-engraving on proofing paper, H. 16.3 cm, W. 12.6 cm, *c.* 1870s, Otto Scholderer, Germany. Donated by J.V. Scholderer. PD 1920,0716.23

83 Doll, dressed in regional costume, pottery stuffed with fabric, H. 24 cm, 1929–31, China. Donated by Mrs Eve Horner. Asia As2003.19.1

84–85 Wooden wind-up doll (karakuri ningyo) shown dressed and undressed, H. 30 cm, 2005, Tamaya Shobei IX, Japan. Donated by the artist. © Tamaya Shobei IX Asia 2005,0702.1

86 Wooden kachina figure, date unknown, Southwest Peoples, America. Acquired in 1891. AOA Am1891,0612.29

87 Pottery figurine, H. 7.1 cm, date unknown, Mexico. Acquired in 1940. AOA 1940,02.52

88 Woodblock print from the series *Bijin Awase* (detail), 1811, Utagawa Toyokuni I, Japan. Asia 1920,1206,0.420

89 *Sportive Innocence* (detail), etching, H. 36.9 cm, W. 44.5 cm, *c.* 1780–1841, Richard Cosway, Britain. PD 1875,0814.1364

90 Carved wooden ceremonial figure, L. 50 cm, early 20th century, India. Donated by Maj Knyvett Romer-Lee. Asia As,1984,20.1

91 Rag-doll made from linen stuffed with rags and papyrus, H. 19 cm, 1st–5th century, Egypt. Donated by the Egypt Exploration Fund. GR 1905,1021.13

92 Terracotta group of two women playing knucklebones, H. 21.3 cm, *c.* 330–300 BC, Italy. GR 1867,0510.1

93 Women playing chess (detail), painting on paper, *c.* 1800, India. Donated by Mrs A.G. Moor. Asia 1940,0713,0.53

94 Set of fifty-one cardboard playing-cards, date unknown, Philippines. Acquired in 1872. Donated by Sir Augustus Wollaston Franks. AOA As,8171.a-ay

95 *The Five & Ten, or Who Shall* (detail), lithograph, H. 19.5 cm, W. 21.7 cm, 1820–8, Patick Ronan, Britain. PD 1896,0501.1623

96–97 *The Giant Stride*, colour wood-cut, H. 16.9 cm, W. 41 cm, 1918, John Edgar Platt, Britain. Donated by the artist. © The Estate of John Edgar Platt PD 1932,0714.3

98 *On the Beach* (detail), colour screenprint, H. 30.2 cm, W. 44.3 cm, 1945, Max Arthur Cohn, USA. Donated by Jane Waldbaum and Steve Morse. © Reproduced with permission of the artist's estate PD 2001,0930.14

99 Bone figure of a standing woman, H. 11.4 cm, Egypt. AES 1899,1016.1154

100 *La Passagère du 54* (detail), litho-graph, H. 61 cm, W. 45 cm, 1895, Henri de Toulouse-Lautrec, France. Donated by Campbell Dodgson. PD 1914,0324.16

101 Terracotta figure seated on a three-legged throne, H. 6.4 cm, *c.* 1300 BC, Greece. GR 1992,1015.1

102 Alabaster wall panel showing a scene of hunting (detail), H. 284.5 cm, 645–635 BC, Iraq. ME 1856,0909.58

103 One of four earthenware tiles painted in red lustre, L. 15 cm, c. 1880, Lewis Foreman Day, Britain. P&E 1980,0307.167

104 Alabaster wall panel showing a scene of hunting (detail), L. 170.2 cm, 645–635 BC, Iraq. ME 1856,0909.56

105 Fragment of a polychrome tomb-painting showing Nebamun fowling and fishing, H. 98 cm, W. 115 cm, c. 1350 BC, Egypt. AES .37977

106 Pottery amphora depicting a wrestling competition (detail), H. 77.5 cm, 332–331 BC, Greece. GR 1873,0820.370

107 Terracotta statue of African boxers, H. 24.5 cm, 2nd–1st century BC, probably from Italy. GR 1852,0401.1–2

108 Ivory netsuke depicting sumo wrestlers, H. 7 cm, date unknown, Japan. Bequeathed by Oscar Charles Raphael. Asia 1945,1017.596

109 Two wrestlers and their trainer (detail), watercolour and ink on paper, H. 21.4 cm, W. 29.9 cm, 1684–5, Iran. Bequeathed by Sir Hans Sloane. ME 1974,0617,0.1.19

110 Pottery amphora showing two boxers (detail), H. 77.5 cm, c. 336 BC, Greece. GR 1873,0820.371

111 Pottery amphora showing a running man (detail), H. 34 cm, 530–500 BC, Turkey. GR 1864,1007.156

112 Marble frieze from the Nereid Monument (detail), L. 132 cm, 400 BC, Turkey. GR 1848,1020.35

113 Round shield made from animal hide, Diam. 35 cm, date unknown, Somalia. Acquired in 1978. AOA 1978,22.677

114 Terracotta figure, H. 14 cm, date unknown, found in Cyprus. Acquired in 1870. GR 1870,0315.18

115 Walrus-ivory chess-pieces from *The Lewis Chessmen*, H. 9cm (max) c. 1150–75, British Isles. P&E 1831,1101.119 & 125

116 Shadow theatre representation of a battle scene, painted animal hide, L. 40 cm, c. 1800–16, Indonesia. Donated by Rev William Charles Raffles Flint. Asia As1859,1228.605

117 Gypsum wall-panel relief (detail), W. 121.9 cm, 645–635 BC, Iraq. ME 1856,0909.16

118 *Returning to the Trenches* (detail), etching on cream paper, H. 15.1cm, W. 20.2 cm, 1916, Christopher Richard Wynne Nevinson, Britain. Bequeathed by Campbell Dodgson. © Christopher Richard Wynne Nevinson, Bridgeman Art Library PD 1949,0411.356

119 Gypsum wall-panel depicting an attack on an enemy town (detail), W. 211 cm, 730–727 BC, Iraq. ME 1880,0130.7

120 *Punitive Campaign in Kagoshima*, colour woodblock triptych (detail), H. 36.9 cm, W. 24.4 cm, 1877, Toyohara Chikanobu, Japan. Asia 1983,0701,0.7.1–3

121 A native North American warrior riding down a white cavalryman, watercolour on paper (detail), H. 17.5 cm, W. 21 cm, 1874, Tall Bear, North America. AOA Am2006,dgr.11

122 *Tsuzoku Suikoden Goketsu Hyakuh-achi-nin no Hitori*, woodblock print, c. 1827, Utagawa Kuniyoshi, Japan. Asia 1906,1220,0.1299

123 *The Black George*, icon depicting the miracle of St George and the dragon (detail), painting on wood, H. 77.4 cm, W. 57 cm, 1400–50, Russia. P&E 1986,0603.1

124 Armour made of steel, iron and leather, H. 125 cm, 17th century, Japan. Asia OA+,13545.a–d

125 *Minamoto no Yorimitsu*, woodblock print from *Six Immortal Poets of the Warrior Class*, 1786–1868, Yashima Gakutei, Japan. Asia 1906,1220.0.601

126 Stylised, copper versions of iron throwing-knives, L. 39 cm (min), late 19th century, Sudan. Donated by the Wellcome Institute for the History of Medicine. AOA 1954,+ 23.940–942

127 Moses Keokuk, Principal Chief of the Sacs and Fox Nation, oil on canvas, H. 86.5 cm, W. 68.5 cm, 1870–5, Zeno Shindler, North America. AOA Am2006.ptg.8

128 *The Black Spot*, cast bronze medal, Natasha Ratcliffe, 2004, Britain. Funded by the British Museum Friends. © Natasha Ratcliffe CM 2005,0105.1

129 Printed cotton depicting the 'owuo atwedee' or 'ladder of death', representing mortality, H. 98 cm, W. 114 cm, 2005, by and donated by Akosombo Textiles Limited, Ghana. AOA 2006,15.130

130 Tin-glazed earthenware plate showing a story from Ariosto's *Orlando Furioso*, Diam. 26.1 cm, 1532, Francesco Xanto Avelli, Italy. Bequeathed by Rev A.H.S. Barwell. P&E 1913,1220.121

131 Fragment of a terracotta figure, L. 5.5 cm, date unknown, Turkey, Hellenistic period. GR 1867,1122.180

132 Marble frieze from the Nereid Monument (detail), H. 66.6 cm, 400 BC, Turkey. GR 1848,1020.37

133 Wooden figure, known as the 'Weeping Buddha', H. 10 cm, mid 20th century, Indonesia. Asia 1984,13.14

134 A woman worshipping at a shrine (detail), ink on paper, H. 13 cm, W. 20 cm, 18th century, Muhammad Ja`far, India. ME 1974,0617,0.15.23

135 Limestone wall panel showing kneeling Elamites welcoming the new king, Ummanigash (detail), L. 269.2 cm, 660–650 BC, Iraq. ME 1851,0902.7b

136 Limestone statue of a crouching child, H. 41 cm, c. 300 BC, Cyprus. GR 1917,0701.125

137 Terracotta flask showing a seated scribe, H. 15.3 cm, c. 1550–1295 BC, Egypt. AES 1893,0514.34

138 Deity figurine made of sandstone, Mexico, Aztec period. AOA Am1849,0629.2

139 Seated Buddha figure, bronze cast in copper alloy, H. 34 cm, 12th–13th century, Burma. Asia 1971,0727.1

140–141 Marble relief (Block IV) from the East frieze of the Parthenon, 447–432 BC, Greece. Elgin Collection. GR 1816,0610.18

142 Throne of Weapons, 2001, H. 101 cm, Cristóvão Estevão Canhavato Kester, Mozambique. © Cristóvão Estevão Canhavato Kester AOA Af2002,01.1

143 Chair made from Acacia wood, H. 59.7 cm, Egypt, New Kingdom. AES EA.2480

144 Vishnu as Vamana about to draw water from a well (detail), painting on paper, c. 1610, India. Asia 1960,0213,0.1

145 Gypsum wall-panel relief showing King Tiglath-pileser III in a chariot (detail), L. 188 cm, 730–727 BC, Iraq. ME 1851,0902.498

146 Wooden model of a chariot, H. 220 cm, c. 1790, India. Donated by Charles Marsh. Asia 1793,0511.1

147 Album leaf painting depicting Arjuna and Krishna on a chariot (detail), c. 1800, India. Asia 1974,0617.0.14.17

148 Marble statue of the forepart of a horse, from the Mausoleum at Halicarnassus, H. 233 cm, c. 350 BC, Turkey. GR 1857,1220.238

149 One of four bronze statuettes of boys dismounting from their horses, from the rim of a Campanian urn, c. 500–480 BC, Italy. GR 1873,0820.262

150 Gold-weight made of brass depicting a man on a horse, H. 11.9 cm, Ghana. Acquired in 1949. AOA Af1949,08.1

151 Off We Drove (detail), illustration for Mary Russell Mitford's Our Village, pen and black ink, H. 21.5 cm, W. 23.2 cm, 1893, Hugh Thomson, Britain. Bequeathed by Eric George Millar. PD 1967,1014.150

152 Cast brass motorbike and driver with passenger, L. 23 cm, 2006, Kofi Dwumfour, Ghana. © Kofi Dwumfour AOA Af2006,12.7

153 Wooden figure of a policeman riding a bicycle, date unknown, Kenya. Acquired in 1982. Donated by HRH Prince Richard, Duke of Gloucester. AOA Af1982,02.3

154 Quilted and embroidered cotton coverlet (detail), H. 28 cm, c. 1870, probably made in Bangladesh. Asia 2003,1025.0.1

155 Off to the Front (detail), print showing a steam train carrying soldiers to the front in the Mexican Revolution, lithograph, H. 23 cm, W 27.5 cm, 1939, Jesús Escobedo, Mexico. Funded by the Aldama Foundation. © The Estate of Jesús Escobedo PD 2008,7114.3

156 Wooden tribal figure, date unknown, Evenki, Siberia. Acquired in 1913. Asia As1913,1114.92

157 Figure made of painted papier mâché, inspired by the Day of the Dead Festival, H. 32.5 cm, 1989, Saulo Moreno, Mexico. © Saulo Moreno AOA Am1990,08.43

158 Bronze figure of a running girl, H. 11.4 cm, 520–500 BC, Greece, GR 1876,0510.1

159 Araignée (detail), lithograph, H. 27.8 cm, W. 21.6 cm, 1887, Odilon Redon, France. Donated by Société des Artistes Lithographes Français. PD 1888,0619.153

160 Glazed earthenware tile showing the Queen of Hearts from Alice in Wonderland, L. 15 cm, 1934, design by Charles Francis Annesley Voysey, Britain. P&E 1980,0307.125

161 Study of a boxer, drawing, H. 45 cm, W. 28.7 cm, date unknown, Sam Rabin, Britain. Donated by the artist. © The Estate of Sam Rabin PD 1974,0615.21

162 Earthenware sandwich tile, L. 15 cm, 1875–82, Campbell Brick & Tile Co, Britain. P&E 1980,0307.157

163 Sub-Porter and Lamp Lighter of Trinity College, Cambridge, etching, H. 18.8 cm, W. 13.5 cm, 1770, Edward Topham, Britain. PD 1851,0308.423

164 Theatrum Passionis Christi (detail), engraving on paper, H. 16 cm, W. 10.9 cm, 1599, Aegidius Sadeler II, Flemish School. PD 1970,0307.4

165 *Off She Goes* (detail), hand-coloured etching, H. 33.1 cm, W. 24.1 cm, 1808–15, Thomas Rowlandson, Britain. PD 1872,1012.5085

166 *Man Ascending Stairs*, bronze sculpture, H.29 cm, 1986, Chimei Hamada, Japan. Donated by the artist. © Chimei Hamada Asia 1994,0308.1

167 *Jacob's Ladder*, or *Jacob's Dream*, pen, ink and watercolour, H. 39.8 cm, W. 30.6 cm, c. 1799–1806, William Blake, Britain. Donated by W. Graham Robertson. PD 1949,1112.2

168 Colour woodcut showing a sunny scene in a park (detail), H. 26.2 cm, W. 38.9 cm, 1864–1918, Auguste Lepère, France. Donated by Campbell Dodgson. PD 1920,0131.4

169 Triptych showing the Deposition, the Entombment and the Resurrection (detail from central panel), painted enamel on copper, H. 21.9 cm, W. 25.8 cm, c. 1510, attributed to Nardon Pénicaud, France. Bequeathed by Rev A.H.S. Barwell. P&E 1913,1220.6

170 *L'oeuf* (detail), lithograph, H. 29.3 cm W. 22.5 cm, 1885, Odilon Redon, France. Bequeathed by Campbell Dodgson. PD 1949,0411.3488

171 Spoon made of wood and stone, date unknown, Philippines. Donated by Miss Hirst in 1927 AOA As1927,0107.3

172 *Cooking in a Pot* (detail), watercolour over graphite, H. 15 cm, W. 19.5 cm, 1585–93, John White, Britain/America. PD 1906,0509.1.11.a

173 Woodblock print showing soup bowls, 1760–1849 Katsushika Hokusai, Japan. Asia 1902,0212.0.365

174 The Asante Jug, copper alloy, H. 62.3 cm, c. 1390–9, England. P&E 1896,0727.1

175 *St Bibo Bulky* (detail), hand-coloured etching, H. 17.8 cm, W. 24.5 cm, 1773, Matthew Darly, Britain. PD 1877,1013.842

176 Drawing in pen and brown ink showing a man drinking (detail), H. 10.9 cm, W. 7.1 cm, 1625–85, Adriaen van Ostade, Dutch. PD 1836,0811.438

177 Ivory netsuke depicting the three effects of sake, Katsukei Gyokusai, Japan. Donated by Sir Augustus Wollaston Franks. Asia F.452

178 Creussen Stoneware tankard depicting the twelve apostles, H. 21.8 cm, 1682 (paint) 1833–4 (mount), Germany. Donated by J.B. Carrington. P&E 1910,0212.1

179 *The Bruiser* (detail), a re-working of Hogarth's self-portrait of 1749, etching and engraving, H. 38 cm, W. 28.4 cm, 1763, William Hogarth, Britain. Bequeathed by Felix Slade. PD 1868,0822.1590

180 *The Townley Greyhounds*, marble, H. 59.7 cm, 1st–2nd century, Italy. GR 1805,0703.8

181 Plate 4 from Les *Métamorphoses du Jour* (detail), hand-coloured lithograph, H. 17.8 cm, W. 20.4 cm, 1829, J.J. Grandville (J.I.I.Gérard), France. PD 1886,1012.262

182 Female-shaped earthenware vessel, South America. Donated by Gilbert Brandon in 1846. AOA 1846,1217.23

183 *Fragments On My Own Supper Table* (detail), watercolour, H. 21.2 cm, W. 17.2 cm, 1778–1822, John Samuel Hayward, Britain PD 1975,0118.21

184 Cardboard box for Gold Flake cigarettes, L. 7.6 cm, produced by W.D. & H.O. Wills of Bristol & London, 1920s, Britain. ME Eph-ME.229

185 Etching of a young man smoking a pipe and holding a glass (detail), H. 12 cm, W. 9.5 cm, 1635–68, Coryn Boe, Flemish School. PD S.4802

186–187 *Enseignement Mutuel de Chant* (detail), hand-coloured lithograph, H. 17.8 cm, W. 29 cm, 1819, Aaron Martinet, France. PD 1999,0627.106

188 Red chalk drawing of a curly-haired man with his eyes shut tight (detail), H. 25.2 cm, W. 18.1 cm, early 16th century, attributed to Giovanni Agostino da Lodi, Italy. PD 1895,0915.481

189 Painted pottery figurines from a larger group of musicians, inspired by the Day of the Dead Festival, H. 15.5 cm (max), 1980s, Francisco Flores, Mexico. © Fransisco Flores AOA Am1990,08.152a & n.

190–191 Figurines of painted papier mâché, one trimmed with fur. These 'Judas figures' are traditionally made for Holy Week, H. 26 cm (max), 1960s, Mexico. AOA Am1997,02.1; 6; 8 & 10

192 Two women dancing, colour aquatint, H. 19.7 cm, W. 16 cm, 1939, Carlos Orozco Romero, Mexico. Donated to the American Friends of the British Museum by Dave and Reba Williams in 2008, and deposited in the British Museum pending transfer as a gift in 2011. © American Friends of the British Museum/the Estate of Carlos Orozco Romero. PD 2008,7069.29

193 Opaque watercolour painting of the month of Magha, January/February (detail), H. 29 cm, W. 20.2 cm, c. 1700–25, India. Asia 1999,1210.0.1.3

194 Terracotta theatrical mask, female character, H. 9.2 cm, Cyprus, Hellenistic period. GR 1982,0729.94

195 Woodblock print depicting large fish (detail), c. 1832, Utagawa Hiroshige, Japan. Asia 1902,0212.0.382

196-197 *Quartette* (detail), colour screenprint, H. 37.9 cm, W. 50.8 cm, 1950, Max Arthur Cohn, USA. Donated by Jane Waldbaum and Steve Morse. © Reproduced with permission of the artist's estate PD 2001,0930.15

198 Painting showing a girl concealing her lover with her cloak (detail), c. 1790, India. Asia 1913,0415.0.6

199 Painting in watercolour of a rabab player (detail), H. 13 cm, W. 20 cm, c. 1590, India. ME 1974,0617.0.15.23

200 Painting depicting Śiva dancing the eternal dance of creation and destruction, H. 24.5 cm, W. 21.5 cm, c. 1820, India. Asia 2007,3005.26

201 *A Sprite. Curse Thee I'll Soon Spoil Thy Capering!* (detail), aquatint over etching, H. 35 cm, W. 23.2 cm, 1792, Richard Newton, Britain. Donated by the British Museum Friends. PD 1997,0928.67

202-203 Fragment of a polychrome tomb-painting representing a banquet scene, H. 88 cm, W. 119 cm, c. 1370 BC, Egypt. AES .37984

204 *Flamencos (Spanska Zigenardansar)* (detail), etching, H. 25.4 cm, W. 14.3 cm, c. 1906, Allan Österlind, Sweden. Donated by Campbell Dodgson. PD 1914,0808.69

205 Terracotta figures of dancing girls, H. 29.2 cm, 3rd-2nd century BC, Italy. GR 1836,0224.453 & 1863,0728.3419

206 *The Raven Addressing the Assembled Animals* (detail), watercolour, H. 26.9 cm, W. 19.3 cm, c. 1590, India Asia 1920,0917,0.5

207 Mask of wood-stained sepia, cardboard and metal, L. 35.6 cm, date unknown, Cote D'Ivoire. Acquired in 1956. Donated by Mrs Margaret Plass. AOA Af1956,27.290

208 Sculpture of a moon-faced man made of brown serpentine stone, H. 35.5 cm, late 20th century, Rayitoni, Zimbabwe. Donated by the executors of Frank McEwen. AOA Af1996,18.41

209 Untitled colour screenprint showing a half-length figure, H. 27 cm, W. 33.5 cm, 1960-90, Anonymous, Spain. Bequeathed by Alexander Walker. PD 2004,0602.76

210 Part of a bone face, H. 9 cm, 199-100 BC, Italy. Bequeathed by Sir William Temple GR 1856,1226.1487

211 *The Ife head* (detail), lead-brass head, H. 35 cm, 12th-14th century, Nigeria. Donated by The Art Fund. AOA 1939,34.4

212 *Pata Scroll*, watercolour on re-used paper, L. 89.5 cm, W. 20 cm, c. 1920-30, India. Asia 1998,0703.0.7

213 Pottery depicting a Gorgon, H. 41.1 cm, 490 BC, Greece. GR 1867,0508.1048

214-215 *'Namgis Mask* made of wood and leather (shown closed and open), H. 80 cm, date unknown, Canada. Acquired in 1944. Donated by Irene Marguerite Beasley. AOA Am1944,02.146

216 Eastern brown pelican (detail extracted from drawing), watercolour over graphite, H. 18.5 cm, W. 22.4 cm, 1585-93, John White, Britain/America. PD 1906,0509.1.58

217 War god figure made of wicker, cord, feathers, pearl-shell, seeds and dog teeth, H. 81 cm, 18th century, Hawaii. AOA Oc,HAW.80

218 Stone figurine of a deity, H. 11.4 cm, 3600-3000 BC, Mesopotamia. ME 1912,0511.240

219 The Hoxne *Empress* silver pepper pot, buried in the 5th century AD, England. Purchased with the assistance of The Art Fund, the British Museum Friends and the National Heritage Memorial Fund. P&E 1994,0408.33

220 War god's head figure, made of wicker, cord, feathers, pearl-shell, seeds and dog teeth, H. 81 cm, 18th century, Hawaii. AOA Oc,HAW.78

221 Mask (possibly representing Xiuhtecuhtli) made of cedro wood and covered in turquoise mosaic, H. 16.8 cm, c. 1400-1521, Mexico. Donated by Henry Christie. AOA Am,ST.400

222 Crystal Skull, H. 25 cm, date unknown, Mexico. Acquired in 1898. Christy Collection. AOA Am1898,-.1

223 Papier mâché skull, inspired by the Day of the Dead Festival, H. 38 cm, 1989, Felipe Linares, Mexico. © Felipe Linares Mendoza AOA Am1990,08.6

224 Glass bead in the shape of a head, H. 2.4 cm, 6th-5th century BC, Egypt. Bequeathed by Sir Robert Ludwig Mond. ME 1939,0324.135

225 Club made of wood and shell, L. 213.8 cm, date unknown, New Zealand, Maori. Acquired in 1903. Donated by Francis Brent. AOA Oc1903,1116.4

226 Wooden double-headed figure, H. 59 cm, 18th-19th century, Polynesia. AOA Oc1955,10.1

227 Pen-box made of silver and gold-inlaid brass, L. 19.7 cm, 1281, Iran. ME 1891,0623.5

228 Sandstone statue of Sety II, H. 164 cm, c. 1215 BC, Egypt. AES .26

229 *An Indian Woman and Child of Pomeiooc* (detail), watercolour over graphite, H. 26.3 cm, W. 14.9 cm, 1585–93, John White, Britain/ America. PD 1906,0509.1.13

230 Fragment of a wall painting showing Phaedra with an attendant (detail), H. 21.5 cm, L. 28.5 cm, AD 20–60, Italy. GR 1856,0625.5

231 Painted earthenware tile showing a woman on a bed (detail), L. 20.4 cm, 1878–80, Maw & Co, by Walter Crane, Britain P&E 1980,0301.165

232 Terracotta sculpture of a comic actor, H. 13 cm, 350–325 BC, Greece. GR 1979,0306.5

233 Walrus-ivory Queen chess-piece from *The Lewis Chessmen*, H. 9.6 cm, *c.* 1150–75, British Isles. P&E 1831,1101.84

234 Gold, glass and enamel mourning ring, Diam. 1.9 cm, *c.* 1794, England. Bequeathed by Sir Augustus Wollaston Franks. P&E Af.1732

235 Carved calcite eye-idol, H. 3.2 cm, date unknown, Syria. Acquired in 1938. ME 1938,0727.9

236 *The Coiffure* (detail), colour etching and aquatint, H. 36.5 cm, W. 26.3 cm, 1891, Mary Cassatt, USA. Bequeathed by Campbell Dodgson. PD 1949,0411.4143

237 *Gilding the Lily* (detail), colour etching and drypoint, H. 29.6 cm, W. 19.3 cm, 1926, Dame Laura Knight, Britain. Donated by David Strang. © Reproduced with the permission of the Estate of Dame Laura Knight DBE RA 2010. All rights reserved. PD 1960,0409.158

238 *Kamisuki* (detail), woodblock print, H. 44.8 cm, W. 34.8 cm, 1920, Hashiguchi Goyo, Japan. Asia 1930,0910.0.1

239 Comb, carved from horn, in the shape of a dog, H. 11 cm, 1970, Mexico. AOA 1978,15.920

240 Moulded stucco head probably depicting a deity, H. 15.5 cm, 4th–5th century, Pakistan. Asia 1931,0724.3

241 Silver coin depicting the head of Alexander the Great, *c.* 305–281 BC Turkey. GR 1919,0820.1

242 Granite kneeling figure of the goddess Chalchiuhtlicue, 1325–1521, Mexico. AOA 1825,1210.6

243 Ritual figure with wood, blades and charms, date unknown, Democratic Republic of Congo. Acquired in 1905. AOA 1905.0525.4

244 Crowned Buddha, made of gilded and lacquered wood, date unknown, Burma. Acquired in 1865. Christy Collection. Asia .5856

245 *Ridiculous Taste or The Ladies Absurdity* (detail), hand-coloured engraving, 1771, Matthew Darly, Britain. Donated by Dorothea Banks. PD J,5.130

246 Head-dress consisting of the tail feathers of a golden eagle, H.75 cm, *c.* 1927, North America, Arapaho peoples. Donated by Gregory M. Mathews. AOA Am1939,22.1

247 *Yaxchilan Lintel 41*, carved limestone lintel depicting Lord Bird Jaguar, AD 600–900, Mexico, Mayan. AOA Am1923,Maud.6

248 Bronze medal of John VIII Palaeologus, Diam. 10.3 cm, 1438–42, Italy. Donated by King George IV. CM G3,NapM.9

249 Hat made of tree-bark, wood and leaf, date unknown, Melanesia. Acquired in 1881. Donated by Baron Anatole von Hugel. Christy Collection. AOA Oc,+.1305

250 Female figure made of sandstone, H. 150 cm, Mexico, Huaxtec period. Christy Collection. AOA Am,+.7001

251 Painted papier mâché figurine of La Catrina, an elegantly dressed skeleton woman, inspired by the Day of the Dead Festival, H. 114cm, 1980s, Agustín Galicia, Mexico. © Agustín Galicia AOA Am1986.06.414 .

252 Painting on cotton depicting the crucifixion of Jesus Christ and scenes from the life of Bishop Selama (detail), H. 230 cm, W. 180 cm, 1855–93, Ethiopia. Donated by James Theodore Bent. AOA Af1893,1112.1

253 Terracotta bust of Sir Hans Sloane, H. 68.5 cm, date unknown, J. Michael Rysbrack, Britain. Acquired in 1756. Donated by Elizabeth, Lady Cadogan and Mrs Stanley. P&E 1756,0619.1

254 Frieze from the Nereid Monument (detail), L. 137.2 cm, *c.* 400 BC, Turkey GR 1848,1020.37

255 *A Real Scene in St Paul's Church-yard on a Windy Day* (detail), hand-coloured mezzotint, H. 35 cm, W. 25 cm, 1782–4, after Robert Dighton, Britain. PD 1935,0522.1.30

256 *The OP Spectacles* (detail), hand-coloured etching, H. 34.3 cm, W. 24.9 cm, 1809, George and Isaac Cruikshank, Britain. PD 1868,0808.7886

257 Pair of gold-plated spectacles, H. 4.2 cm, *c.* 1980, Baule, Cote D'Ivoire. AOA Af1987.03.1

258 Portrait of a woman in wax on oak, H. 33 cm, W. 18 cm, *c.* AD 200, Egypt. Bequeathed by Sir Robert Ludwig Mond. AES 1939,0324.208

259 Necklace of diamonds set in gold with a teardrop emerald, Diam. 18 cm, 19th–20th century, South Asia. Anonymous Gift. Asia 2001,0521.34

260 Collar made of seventeen strings of blue-glass beads, H. 23 cm, date unknown, Dinka, Sudan. Acquired in 1934. Donated by Maj Percy Horace Gordon and Mrs Hannah Powell-Cotton. AOA 1934,0308.109

261 Human-head figure made of brass, H. 37.5 cm, Nigeria. Acquired in 1954. Donated by the Wellcome Institute for the History of Medicine. AOA 1954,23.1514

262 Coffin in the shape of a Canon EOS camera, W. 196 cm, 2006, Ghana. AOA Af2006,12.2

263 Terracotta figure of a standing woman, H. 26 cm, 250–230 BC, Greece. GR 1895,1029.7

264 Bronze statuette of Hermes, H. 48.2 cm, c. 150 BC, Italy. Donated by Robert Goff. GR 1849,0622.1

265 Child's woollen hat from Egypt and men's woollen trousers from Morocco, dates unknown. Acquired in 1969 (hat) and 1991 (trousers). AOA Af1991,23.8 & Af1969,37.25

266 Mourner's dress made of bark-cloth, feathers, pearl-shell, wood and coconut shell, H.21.4 cm, late 18th century, Society Islands. AOA Oc,TAH.78

267 Bark-cloth costume with mask used in circumcision ceremonies, L. 66 cm, date unknown, Zambia. Acquired in 1949. AOA Af1949,35.2

268 The Strangford Apollo, marble statue, H. 101 cm, c. 490 BC, Greece. GR 1864,0220.1

269 Child's all-in-one suit, made of fur, date unknown, Canada. Acquired in 1986. AOA 1986,10.28.a

270 The Townley Collection in the Dining Room at Park Street, pen, ink and watercolour, H. 39 cm, W. 54 cm, 1794, William Chambers, Britain PD 1995,0506.8

271 The Townley Discobolus (detail), marble statue, H. 170 cm, 2nd century, Italy. GR 1805,0703.43

272 Print showing the British Museum King's Library in 1880, date unknown. Unassigned PD material

273 The British Museum King's Library in 2009. Photography by Stephen Dodd.

274 Earthenware figure of a scholarly attendant or judge of Buddhist Hell (detail), H. 136 cm, 1522–1620, China. Funded by The Art Fund. Asia 1917,1106.1

275 Gilded bronze figure of the goddess Tara (detail), H. 143 cm, 9th–10th century, Sri Lanka. Asia 1830,0612.4

276 Bronze vase, H. 19.8 cm, date unknown, Egypt. Acquired in 1902. AES 1902,0412.18

277 Wooden cosmetics-box held by a female figure, Egypt, 18th Dynasty. AES 1867,0812.34

278 Kachina figure made of wood, date unknown, New Mexico. Acquired in 1891. AOA Am1891,0612.30

279 Gilded plaster mummy-case, H. 173 cm, Egypt, New Kingdom. AES 1907,1212.1

280 Fragment of the right arm of a large stucco figure, L. 27 cm, 6th–7th century, China. Stein Collection. Asia Mas.1100

281 Naked female figurine of limestone, date unknown, Egypt. Acquired in 1886. Donated by the committee of the Egypt Exploration Fund. AES 1886,0401.1394

282 Calcite funerary stela showing the torso of a female figure, H. 32 cm, 1st century BC, Yemen. ME 1951,0212.1

283 Painted scroll showing a girl collecting mushrooms (detail), H. 11 cm, W. 37.2 cm, 1768–72, Tsukioka Settei, Japan. Donated

by Sir William Gwynne-Evans. Asia 1913,0501,0.380

284 Bronze kneeling figure of Horus, H. 26 cm, after 600 BC, Egypt. AES 1880,0210.4

285 Terracotta figurine of a three-bodied warrior, once holding spears, H. 24 cm, 650–600 BC, Cyprus. ME 1866,0101.298-299

286 Life-size copper alloy hand, H. 18.5 cm, 2nd–3rd century, Yemen. ME 1983,0626.2

287 Pottery cup, W. 39.7 cm, attributed to the Brygos Painter, 490–480 BC, Greece. GR 1848,0619.7

288 Gypsum wall panel relief (detail), H. 232.4 cm, 865–860 BC, Iraq. ME 1850,1228.10

289 Netted bag made of brown fibre string, L. 20 cm, date unknown, Papua New Guinea. Acquired in 1851. Donated by Capt Owen Stanley. AOA Oc1854,0103.91a

290 Wooden clogs with toe-pegs and brass studs, L. 25 cm, after 1880, Uganda. AOA Af1952,07.210.a & b

291 The Townley Discobolus (detail), marble statue, 170 cm, 2nd century, from Hadrian's Villa, Italy. GR 1805,0703.43

292 Pair of child's leather sandals, L. 14 cm, date unknown, Egypt, New Kingdom. Acquired in 1891. AES 1891,0430.147

293 Rectangular slab of limestone carved with the footprints of the Buddha, H. 67.5 cm, 2nd century, India. Asia 1880,0709.57

294 Feet of a hollow terracotta figure, H. 11.6 cm, 650–575 BC, Cyprus. GR 1909,0310.126

295 Bronze helmet and greaves, H. 41.9 cm, 520–480 BC, Italy. Bequeathed by Sir William Temple. GR 1856,1226.710